Index of Japanese Painters

Index of Japanese Painters

Index of
JAPANESE PAINTERS

compiled by the

Society of Friends of Eastern Art

CHARLES E. TUTTLE COMPANY
Rutland, Vermont Tokyo, Japan

Representatives
Continental Europe: BOXERBOOKS, INC., *Zurich*
British Isles: PRENTICE-HALL INTERNATIONAL, INC., *London*
Australasia: PAUL FLESCH & CO., PTY. LTD., *Melbourne*
Canada: M. G. HURTIG LTD., *Edmonton*

Published by the Charles E. Tuttle Company, Inc.
of Rutland, Vermont & Tokyo, Japan
with editorial offices at
Suido 1-chome, 2-6, Bunkyo-ku, Tokyo, Japan

Library of Congress Catalog Card No. 58-9985

International Standard Book No. 0-8048-0262-9

Originally published, 1940 by the
Society of Friends of Eastern Art
c/o Institute of Art Research, Tokyo

First Tuttle edition published 1958
Sixth printing, 1973

PRINTED IN JAPAN

PUBLISHER'S NOTE

The *Index of Japanese Painters* has long been an invaluable source of reference to Westerners interested in knowing more about Japanese painters and paintings. Unfortunately, this little volume has been out of print for some years as the Society of Friends of Eastern Art, which first published the book, has since been disbanded.

The members of the Institute of Art Research who compiled the material for the text are presently making plans for a revised and enlarged edition. In the meantime, to meet the current demand for a book of this kind, we are pleased to be able to present this offset reprint of the original edition. We feel sure that, in spite of the misprints and minor errors that cannot be eliminated in this photographic reproduction, it will be of use to both students and connoisseurs of Japanese paintings.

For permission to reprint the Index in its original form our thanks are due to Mr. Moritatsu Hosokawa, former President of the now defunct Society of Friends of Eastern Art; to Professor Yukio Yashiro, former Director of the Institute of Art Research, Tokyo; and to Mr. Ichimatsu Tanaka, present Director of the Institute. Acknowledgments are also due to the late Mr. Sumio Ogushi, without whose editorial efforts, under the supervision of Professor Yashiro, the original book could not have been produced.

In order to give a clearer idea of the beginnings of the book and the people involved in its making, we are reproducing also the Preface and Introduction to the original edition.

1958 *CHARLES E. TUTTLE COMPANY*

PREFACE

Since the Society of Friends of Eastern Art was organized in Tokyo in February, 1940, it has been engaged in various activities such as lecture meetings, special art-exhibitions, visits to private collections, and the publication of the monthly *Bulletin of Eastern Art*, etc., and we believe that it has contributed something to the advancement of the study of Eastern Art in general and to the promotion of international cooperation in artistic and intellectual work. What are still badly lacking at present seem to be the handy and elementary books such as concise biographical dictionaries of artists, guidebooks, dictionaries of subjects of paintings, and the like, which all lovers and scholars of Eastern art can use as convenient references. The Society of Friends of Eastern Art is planning to compile these much needed publications. It is our great joy that the *Index of Japanese Painters* is herewith published as the first fruit of our plan. The compilation of this Index was entrusted to the Institute of Art Research. The Society would like to express profound thanks to those members of the research staff who have been in charge of this work under the leadership of Professor Yashiro, Director of the Institute.

1940 *Moritatsu Hosokawa, President*

INTRODUCTION

At the time when the appreciation and the study of
Eastern art has become world wide, it is the duty of
Japanese scholars to publish reference books to aid
students of all countries. To our regret we often find
that the foreigners who study Eastern art or who
come to Japan to study it have rather a difficult time
because of the lack of any index or dictionaries of
Japanese painters. So the Institute of Art Research
expresses deep gratitude regarding this plan of the
Society of Friends of Eastern Art to publish this book,
Index of Japanese Painters, and the staff members of
the Institute are glad to collaborate in every way possi-
ble.

The Index contains about six hundred names, with
short biographies, of painters who are familiar in the
reproductions and the articles which have been
published for the past several years in important
publications of the country. It is compiled on a far
smaller and incomplete scale than was our ideal for
this sort of book, which we hope to realize at some
future time. But as it contains most of the famous
painters whom we meet often in the study of Japanese
art, we can recommend it with some conviction as a
convenient book for all lovers and students of Japa-
nese art.

1940 *Yukio Yashiro, Director*
 Institute of Art Research

Notes

N." Name" Full name or family name. Used chiefly
on particularly ceremonious occassions. Sometimes
used as the signature in the painting.

A.字 " Azana" Another name used instead of the real
name as it was considered impolite to use the family
name.

F. N. ..." Familiar Name" The name by which the painter
was commonly called.

Gō.號 " *Gō* " Pseudonyme. In most cases a painter has
more than one and often many *gō*.

S." School" School, relation between master and pupil.
Sometimes, characteristics or tendency of styles. (See
Table and Explanation of Schools at the end of this
book.)

L & C. .." Life and Career" The life and career of the artist
is given as briefly as possible. The names of places
connected with the painters before the Meiji Restora-
tion are given in the names of the time which were
often different from their present names. (See List
of Names of Places, at the end of this book.)

Sp." Speciality" Special subjects in which the painter
particularly excelled.

Repr. ..." Reproduction" The publication in which the repro-
ductions are found. But only those works acknowl-
edged as genuine in one of the three publications
Bijutsu Kenkyū 美術研究 (abbr. B) Kokka 國華 (abbr.
K), and Nippon Kokuhō Zenshū 日本國寶全集 (abbr. N)
are selected. When there are special albums of repro-
ductions of the painter, their names are also given.
For large albums of reproductions by various artists,
see the list at the end of this book.

Index of Japanese Painters

Aigai 靄厓 (1796–1843) *N.* Takahisa Chō 高久徴 *A.* Shien
子遠 *F. N.* Akisuke 秋輔 *Gō.* Aigai 靄厓 Sorin-gaishi
疎林外史 Joshō 如樵 Sekisō 石巣 *S.* Nanga school. Pupil
of Tani Bunchō. Influenced by I Fu-chiu (I Fukyū) and
Taiga. His pupils: Ryūko, Aizan, etc. Adopted Ryūko
his son. *L & C.* Born in Shimotsuke. After studying
under Tani Bunchō, travelled to many places, settled
at Kyōto, and later moved to Edo. *Sp.* landscape.

 Repr. K. 228, 370, 583.

Aimi 相見 (flourished at the beginning of 10th cent.) *N.*
Kose Aimi 巨勢相見 *S.* Yamatoye school. *L & C.* Lived
in Kyōto. Served the Court as a painter.

Aiseki 愛石 (flourished at the beginning of 19th century) Priest
Name: Shinzui 眞瑞 *Gō.* Aiseki 愛石 *S.* Nanga school.
Pupil of Kaiseki. *L & C.* Born in Kishū. *Sp.* landscape.

Ando 安度 (flourished in the beginning of 18th cent.) *N.* Kai-
getsudō Ando 懷月堂安度 *Gō.* Kaigetsudō 懷月堂 *S.*
Ukiyoye school. The first painter of Kaigetsudō school.
L & C. Lived in Edo. *Sp.* female figures.

 Repr. K. 27, 135, 366, 388, 443, 447.

Andō Nakatarō 安藤仲太郎 (1861–1913) *N.* Andō Nakatarō
安藤仲太郎 *S.* Western style. Pupil of Takahashi Yuichi.
L & C. Born and lived in Tōkyō. As the head of Tenkai-
gakusha, (a private art school founded by his teacher),
he educated many disciples. Later founded Hakubakai
(association of painters) with Kuroda Seiki and
others. *Sp.* portraits.

Ankei 安慶 (flourished at the beginning of 18th cent.) *N*. Okazaki Genshichi 岡崎源七(or Ankei 安慶) *Gō*. Kaigetsudō 懷月堂 *S*. Said to be the founder of Kaigetsudō school in Ukiyoye, but none of his works remains. *L & C*. It is said that Ankei is another name of Ando. See Ando.

Aōdō 亞歐堂 (1747–1822) *N*. Nagata Zenkichi 永田善吉 *Gō*. Aōdō Denzen 亞歐堂田善 *S*. Yōga school. Studied Nanga painting under Gessen and later learned painting in Western style from Kōkan or from a Dutchman in Nagasaki. *L & C*. Born at Sukagawa in Iwashiro. Served Lord Matsudaira as a painter. *Sp*. landscape (copperplate prints, and paintings in Western style).

 Repr. B. 49, 51. K. 172, 376.

Aoki Shigeru 青木繁 (1882–1911) *N*. Aoki Shigeru 青木繁 *S*. Western style. Pupil of Koyama Shōtarō. *L & C*. Born in Fukuoka Prefecture. Lived in Tōkyō and later in Fukuoka. Graduated from the Tōkyō Art School. Won a prize in Hakubakai Exhibition. *Sp*. figures.

 Repr. Aoki Shigeru Gashū 青木繁畫集.

Aoyama Kumaji 青山熊治 (1886–1932) *N*. Aoyama Kumaji 青山熊治 *S*. Western style. *L & C*. Born in Hyōgo Prefecture, and lived in Tōkyō. Graduated from Tōkyō Art School. Later travelled and stayed in Europe for a long time. Liked painting big pictures. Member of Hanging Committee of Teiten Exhibition.

 Repr. Aoyama Kumaji Gashū 青山熊治畫集.

Arihisa 有久 (flourished in the beginning of 14th cent.) *N*.

Kose Arihisa 巨勢有久 *L & C.* Painter of the Edokoro at Kyōōgokokuji Temple in Kyōto. *Sp.* Buddhistic painting.

Arina See Taiga.

Asai Chū 浅井忠 (1856–1907) *N.* Asai Chū. 浅井忠 *Gō.* Mokugo 黙語 Mokugyo 木魚 *S.* Western style. Pupil of Kunisawa Shinkurō. Studied under Antonio Fontanesi at Tōkyō Art School. *L & C.* Born in Chiba Prefecture, lived in Tōkyō and later in Kyōto. Professor at Tōkyō Art School and later in Technological School in Kyōto. Member of Hanging Committee of Teiten Exhibition. *Sp.* landscape.

Repr. Mokugo Seiyō-gashū. 黙語西洋畫集, Mokugo Nihon-gashū 黙語日本畫集 Asai Chū. 浅井忠.

Ayatari See Ryōtai.

Baigai 梅厓 (1733–1804) *N.* Totoki Shi 十時賜 *A.* Shi-u 子羽 *F. N.* Hanzō 半藏 *Gō.* Baigai 梅厓 Kotei 顧亭 Seimuken 淸夢軒 *S.* Nanga school. *L & C.* Born in Ōsaka. Confucian. Served Lord Masuyama Sessai at Nagashima in Ise. *Sp.* landscape.

Baiitsu 梅逸 (1783–1856) *N.* Yamamoto Shinryō 山本親亮 *A.* Meikei 明卿 *Gō.* Baiitsu 梅逸 Shun-en 春園 Tendō-gai-shi 天道外史 Gyokuzen 玉禪 Baika 梅華 Yūchiku-sōkyo 友竹艸居 *S.* Nanga school. Pupil of Kamiya Ten-yū. Later learned Chinese technique of paintings of the Ming and Ch'ing dynasties. *L & C.* Born in Nagoya. Went to Kyōto where he became famous. Chikutō was one of his intimate friends. Came back to Nagoya in his later years and served the lord of the clan of Nagoya. *Sp.* landscape, flowers-and-birds.

Repr. B. 38, 39, K. 132, 309, 325, 341, 355, 362, 377, 385, 399, 413, 472.

Baikan See Tōsai.

Bairei 楳嶺 (1844–1895) *N*. Kōno Naotoyo 幸野直豐 *A*. Shijun 思順 *Gō*. Bairei 楳嶺 *S*. Japanese style. Pupil of Nakajima Raishō, Shi-okawa Bunrin. (Shijō school.) *L & C.* Lived in Kyōto. Professor of Kyōto Art school. Member of the Imperial Art Committee. *Sp.* landscape, flowers-and-birds.

Repr. B. 62, K. 459. Bairei Ikō 楳嶺遺稿.

Baitei 梅亭 (1734–1810) *N*. Ki-no Bin 紀敏 (or Jibin 時敏) *A*. Shikei 子惠 *Gō*. Baitei 梅亭 Kyūrō-sanjin 九老山人 *S*. Nanga school. Said to be a pupil of Buson. *L & C.* Born in Kyōto. Lived in Ōmi and was called "Ōmi Buson." *Sp.* flowers-and-birds.

Bakusen 麥僊 (1887–1936) *N*. Tsuchida Kinji 土田金二 *Gō*. Bakusen 麥僊 *S*. Japanese style. Pupil of Takeuchi Seihō. Graduate of the Kyōto Art school. *L & C.* Lived in Kyōto. Member of the Kokuga Sōsaku Kyōkai and the Teikoku Bijutsu-in. *Sp.* figures.

Repr. Bakusen Gashū, 麥僊畫集, Bakusen Isaku-shū 麥僊遺作集.

Bashō 芭蕉 (1644–1694) *N*. Matsuo Munefusa 松尾宗房 *F. N.* Chūzaemon 忠左衞門 *Gō*. Mumei-an 無名庵 Fūra 風蘿 Hyōchūan 瓢中庵 Tōsei 桃靑 *S*. Studied Suiboku painting under Morikawa Kyoroku (his pupil in *haikai*). *L & C.* Born in Iga. The most distinguished *haikai* poet in Japan. Painted suiboku pictures as a hobby.

Beisanjin 米山人 (1744–1818) *N*. Okada Koku 岡田國 *A*.

Shigen 子彥 *F. N.* Hikobē 彥兵衞 *Gō.* Beisanjin 米山人 *S.* Nanga school. *L & C.* Born in Ōsaka. Served the lord of the clan of Tsu. His son, Hankō, was also a nanga-painter. *Sp.* landscape.

Repr. K. 354, 394, 478.

Beisen 米僊 (1852–1906) *N.* Kubota Hiroshi 久保田寬 *Gō.* Beisen 米僊 *S.* Japanese Style. Pupil of Suzuki Hyaku-nen. *L & C.* Lived in Tōkyō. Known as an illustrator. *Sp.* figures and landscape.

Repr. Beisen Iboku-shū 米僊遺墨集.

Bōkanshi See Ritsuō.

Bokkei 墨溪 (c. 15th cent.) Priest name: Bokkei 墨溪 *L & C.* Unknown. Seems to have been the same person as Bokusai.

Bokusai 墨齋 (d. 1492) *N.* Shōtō 紹等 *A.* Motsurin 没倫 *Gō.* Bokusai 墨齋 *S.* Muromachi Suiboku school. Said to be the pupil of Dasoku. Zen-priest. *L & C.* Distinguished disciple of Zen-priest Ikkyū. Became a chief priest in Shūon-an Monastery. Lived in Daitokuji Temple at Murasakino in Kyōto.

Repr. N. 1.

Bokusai See Donkyō.

Bokusen 墨僊 (1736–1824) *N.* Maki Nobumitsu 牧信盈 *F. N.* Suke-emon 助右衞門 *Gō.* Hokusen 北僊 Bokusen 墨僊 Hokutei 北亭 Gekkōtei 月光亭 Hyakusai 百齋 Tokōrō 斗岡樓 *S.* Ukiyoye school. Pupil of Utamaro and of Hokusai. *L & C.* Lived in Nagoya.

Bokushinsai. See Yasunobu.

Bokushō 牧松 (c. 1394–c. 1469) *N.* Shūsei 周省 *A.* Isan 惟參 *Gō.* Bokushō 牧松 *S.* Muromachi Suiboku School.

L & C. Lived in Kyōto and later in Yamaguchi. Zen-priest. Lived at Shōkokuji Temple and at Nanzenji Temple in Kyōto.

Repr. K. 385. N. 5.

Bompō. See Gyoku-en.

Bōsai 鵬齋 (1752–1826) *N.* Kameda Chōkō 龜田長興 *A.* Sairyū 犀龍 Kōryū 公龍 *F. N.* Bunzaemon 文左衞門 *Gō.* Bōsai 鵬齋 Zenshindō 善身堂 *S.* Suiboku school. *L & C.* Confucian. Painting was his hobby. Born and lived in Edo.

Repr. K. 441.

Bummei 文鳴 (d. 1813) *N.* Oku Sada-aki 奧貞章 *A.* Hakki 伯熙 *F. N.* Junzō 順藏 *Gō.* Bummei 文鳴 Seika 栖霞 Rikuchinsai 陸沈齋 *S.* Maruyama school. Pupil of Ōkyo. *L & C.* Lived in Kyōto.

Bumpō 文鳳 (beginning of 19th cent.) *N.* Kawamura Ki 河村龜 *A.* Shunsei 駿聲 *Gō.* Bumpō 文鳳 Basei 馬聲 Goyū 五游 Shuyōkan 首陽館 *S.* Pupil of Ganku. *L & C.* Lived in Kyōto. *Sp.* figures.

Bunchō 文晁 (1764–1840) *N.* Tani Bunchō 谷文晁 and later Bunchō 文晁 *F. N.* Bungorō 文五郎 *Gō.* Shazanro 寫山樓 Gagakusai 壽學齋 Shōsō 蜻叟 Muni 無二 Ichijo 一恕 Bun-ami 文阿彌 *S.* Nanga school. Pupil of Bunrei and Kangan. Created his own style, studying old paintings of both Japan and China. *L & C.* Born in Edo. Served Lord Tayasu and became a painter. Called the greatest painter in Edo at that time. But, now, his works are not so valued as in his time, because he was too prolific. Wrote "Honchō Gasan" 本朝畫纂 etc. *Sp.* landscape, figures, flowers-and-birds.

Repr. B. 8, 16, 30, 47. K. 61, 90, 92, 134, 152, 160, 220, 224, 232, 254, 261, 265, 273, 279, 322, 326, 395, 444, 457, 482, 498, 502, 506, 524, 560, 567. N. 28, 64, 77.

Bunchō 文調 (1725–1794) *N.* Ippitsusai Bunchō 一筆齋文調 *F. N.* Kishi Uemon 岸右衞門 *Gō.* Sōyōan 桑楊庵 Hajintei 巴人亭 *S.* Ukiyoye shool. Studied Kanō school, and later influenced by Harunobu. *L & C.* Lived in Edo. In 1770 painted with Shunshō in three volumes a pictorial book " Butai Ōgi ". 舞臺扇 *Sp.* female figures, and actors.

Repr. K. 242.

Bun-ichi 文一 (1787–1818) *N.* Tani Bun-ichi 谷文一 *Gō* Chisai 痴齋 *S.* Nanga school. Pupil of his father-in-law Bunchō. *L & C.* Son of a doctor in Edo. Lived in Edo. Adopted by his teacher Bunchō as his son. Followed the style of Ōkyo, and made his own style.

Repr. K. 98.

Bunkadō See Sukenobu.

Bunkaku See Masanobu (Okumura).

Bunkei See Kangan.

Bunkyo See Naokata.

Bunrin 文麟 (1808–1877) *N.* Shiokawa Bunrin 鹽川文麟 *A.* Shion 子温 *F. N.* Zusho 圖書 *Gō.* Unshō 雲章 *S.* Japanese style. Pupil of Okamoto Toyohiko. *L & C.* Lived in Kyōto.

Repr. K. 75.

Bunsei 文清 (flourished in the middle of 15th cent.) *Gō.* Bunsei 文清 *S.* Muromachi Suiboku school. *L & C.* Zen-priest. Lived in Daitokuji Temple in Kyōto.

Repr. B. 77, 102. K. 144, 388. N. 2.

Busei 武清 (1776–1856) *N.* Kita Busei 喜多武清 *A.* Shishin 子愼 *Gō.* Ka-an 可庵 Goseidō 五清堂 Kakuō 鶴翁 *S.* Nanga school. Pupil of Bunchō. *L & C.* Lived in Edo. Excelled in appreciating old paintings. Copied many old pictures of Japan and China.

Buson 蕪村 (1716–1783) *N.* Taniguchi In 谷口寅 later Chōkō 長庚 *A.* Shinshō 信章 *Gō.* (Yosa) Buson (與謝)蕪村 Chōko 潮湖 Shunsei 春星 Sha Shunsei 謝春星 Yahantei 夜半亭 Busei 蕪菁 Sanka 三果 Tōsei-saichō 東成宰鳥 Gasendō 雅仙堂 Shimei 四明 Shain 謝寅 Hajin 巴人 Hekiundō 碧雲洞 Hakuundō 白雲洞 *S.* Nanga school. Seems to have followed the style of Hyakusen, and to have been influenced by Itchō and Nan-p'in. Distinguished painter of that time. *L & C.* Born in Settsu. When young, went to Edo, where studied *haikai* (short poem) and became very famous as a poet. As he loved travelling he visited many places. Began to paint earnestly from the age of 40. At about 50 years old he was influenced by Nan-p'in's technique, and created his own style at Kyōto from the age of 55 to 60. Later, painted cartoons. *Sp.* landscape and *haiga* (sort of cartoon with short poem). *Repr.* B. 15, 49. K. 47, 87, 96, 119, 120, 148, 234, 240, 247, 271, 298, 344, 378, 388, 404, 451, 471, 477, 489, 492, 505, 537, 547, 549, 559, 566, 574 590, 600. N. 68, 73. Buson Ihō 蕪村遺芳

Byakurenshi See Tan-yū.

Chi See Totsugen.

Chiden 智傳 (c. 1500) *Gō.* Tan-an 單庵 *Imina.* Chiden 智傳

S. Muromachi Suiboku school. Said to be pupil of Sōami. *L & C.* Priest of Shōkokuji Temple in Kyōto (?) *Repr.* B. 16. K. 42.

Chikuden 竹田 (1777–1835) *N.* Tanomura Kōken 田能村孝憲 (or Ken 憲) *A.* Kun-i 君彝 *F. N.* Kōzō 行藏 *Gō.* Chikuden 竹田 Kyūjō-senshi 九疊仙史 Ran-sui-kyōkaku 藍水狂客 Kōtōshijin 紅荳詞人 Kachikuyūsō-shujin 花竹幽窓主人 Setsugetsu-shodō 雪月書堂 Hosetsuro 補拙盧 *S.* Nanga school. In 1801 went to Edo where studied the technique of Tani Bunchō. Distinguished painter of the Edo period. *L & C.* Born at Takeda in Bungo and lived there. Confucian of the clan of Oka. Went to Ōsaka and Kyōto many times. Associating with San-yō, Shōchiku, Mokubei, Unge, became the greatest painter of Nanga school at the time. His books about painting: "Sanchūjin-jōzetsu" 山中人饒舌 (Talks on Painting) etc. *Sp.* landscape, flowers, and figures.

Repr. B. 21. K. 120, 147, 165, 222, 290, 327, 332, 342, 350, 357, 364, 393, 401, 412, 419, 433, 449, 457, 458, 475, 481, 490, 501, 506, 512, 516, 543, 558, 570, 577. N. 71, 80. Chikuden-sensei Gafu 竹田先生畫譜.Chikuden-sensei Gafu-zokuhen 竹田先生畫譜續篇.

Chikudō 竹堂 (1826–1897) *N.* Kishi Shōroku 岸昌祿 *A.* Shiwa 子和 *F. N.* Hachirō 八郎 *Gō.* Chikudō 竹堂 *S.* Japanese style. Pupil of Kishi Renzan. *L & C.* Lived in Kyōto. Member of the Imperial Art Committee. *Sp.* animals.

Repr. K. 115. Chikudō Gafu 竹堂畫譜.

Chikuha 竹坡 (1878–1936) *N.* Odake Somekichi 尾竹染吉 *Gō.*

Chikuha 竹坡 *S*. Japanese style. Pupil of Kawabata Gyokushō. *L. & C*. Lived in Tōkyō. Associate member of Teiten Exhibition. *Sp*. figures.

Chikukei 竹溪 (1816–1867) *N*. Nakabayashi Narishige 中林成業 *A*. Shōfu 紹夫 *F. N*. Kingo 金吾 *Gō*. Chikukei 竹溪 *S*. Nanga school. Pupil of his father, Chikutō. *L & C*. Lived in Kyōto. *Sp*. landscape.

Repr. K. 403, 465, 503, 510.

Chikukyo. See Taiga.

Chikuō 竹翁 (flourished in the middle of 17th cent.) *N*. Katsuta Teikan 勝田貞寛 (Sadanori 定則) *A*. Shisoku 士則 *F. N*. Inosuke 伊之助 Okinojō 冲之丞 *Gō*. Chikuō 竹翁 Tōhin 東濱 Suichikuan 翠竹庵 Shūyūsai 秋友齋 *S*. Kanō school. Pupil of Kyūhaku. *L & C*. Lived in Edo. Served Tokugawa Iyemitsu as a painter.

Repr. K. 144.

Chikuseki 竹石 (1747–1805) *N*. Nagamachi Ki 長町徽 *A*. Kin-ō 琴翁 *Gō*. Chikuseki 竹石 Kinken 琴軒 *S*. Nanga school. Pupil of Takebe Ryōtai. *L & C*. Born in Sanuki. *Sp*. landscape.

Chikutō 竹洞 (1776–1853) *N*. Nakabayashi Seishō 中林成昌 *A*. Hakumei 伯明 *Gō*. Chikutō 竹洞 Taigen-an 太原庵 Tōzan-inshi 東山隱士 Chūtan 冲澹 *S*. Nanga school. Pupil of Yamada Un-sho and Kamiya Ten-yū. *L & C*. Born in Nagoya. Lived in Kyōto. Art-theorist as well as painter. Wrote many books such as " Gadō-kongō-gine " 畫道金剛杵. " Chikutō-garon " 竹洞畫論. " Chikutō Gakō," 竹洞畫稿. " Bunga-yūeki " 文畫誘掖. etc.

Repr. B. 38, 48. K. 88, 134, 275, 279, 347, 389, 417, 425, 469, 504, 552.

Chikuyō 筑陽 (flourished in the former half of the 17th cent.) *N.* Chikuyō 筑陽 *S.* Muromachi Suiboku school. *L & C.* Zen-priest? *Repr.* B. 63. K. 565.

Chinchō 珍重 (d. 1754) *N.* Hakawa Chinchō 羽川珍重 (Manaka Chinchō 眞中珍重) *A.* Chūshin 冲信 *F. N.* Ōta Bengorō 太田辨五郎 *Gō.* Sandō 三同 Chinchō 珍重 *S.* Ukiyoye school. Pupil of Kiyonobu. *L & C.* Lived in Edo. *Sp.* female figures.

Chinkai 珍海 (1092–1152) *N.* Chinkai 珍海 *L & C.* Priest of Zenrinji Temple in Yamashiro. Seemed to be fond of painting "Tokai Monju" 渡海文殊 (Monju crossing the Sea.)

Chinnen 椿年 (1792–1851) *N.* Ōnishi Chinnen 大西椿年 *A.* Taiju 大壽 *F. N.* Yukinosuke 行之助 *Gō.* Unkadō 運霞 堂 Sonan 楚南 Kaō 霞翁 *S.* Nanga school. Studied under Watanabe Nangaku and later followed the technique of Bunchō. *L & C.* Lived in Edo. Samurai attached to the Tokugawa Government.

Chinzan 椿山 (1801–1854) *N.* Tsubaki Hitsu 椿弼 *A.* Tokuho 篤甫 *F. N.* Chūta 忠太 *Gō.* Takukadō 琢華堂 Kyūan 休菴 Shikyūan 四休庵 Hekiin-sambō 碧蔭山房 *S.* Nanga school. Pupil of Kaneko Kinryō and Kazan. His pupils: Baidō etc. *L & C.* Born in Edo. Lived at Koishikawa in Edo. Samurai attached to the Tokugawa government. Excelled in playing reed-organ and in the art of using spear. Educated Shōka, son of Kazan, after the death of Kazan.

Repr. B. 62, 65, 100. K. 108, 218, 283, 306, 315, 375, 398, 414, 499, 520, 525, 529, 534, 551, 558.

Kyōsho & Chinzan 杏所・椿山.

Chisai See Bun-ichi.

Chishin 致眞 (flourished in the latter half of the 11th cent.) *N.* Hata Chishin 秦致眞 or Chitei 致貞 *L & C.* Lived in Settsu. Painted on the walls in Edono of Hōryūji Temple in 1069. *Repr.* K. 415.

Chitei See Chishin.

Chō See Aigai.

Chōbunsai See Eishi.

Chōdensu See Minchō.

Chōeiken See Harunobu.

Chōko See Buson.

Chōko See Itchō.

Chokuan 直庵 (d. c. 1610) *N.* Soga Chokuan 曾我直庵 *Gō.* Shin-yo 心譽 *S.* Soga school (founder). *L & C.* Lived in Sakai in Izumi. *Sp.* birds (hawks).

Repr. B. 35, 68. K. 39, 45, 179, 231, 339, 465. Ń. 8, 33.

Chokunyū 直入 (1814–1907) *N.* Tanomura Chi 田能村癡 *A.* Shōko 小虎 *Gō.* Chokunyū 直入 *S.* Japanese style. Nanga school. Pupil of Tanomura Chikuden. *L & C.* Lived in Kyōto. Professor of Kyōto Art School. *Sp.* landscape. *Repr.* Chokunyū-koji Myōseki-shū. 直入居士妙蹟集 Chokunyū-koji Ihō 直入居士遺芳.

Chōshun 長春 (1682–1752) *N.* Miyagawa Chōshun 宮川長春 *S.* Ukiyoye school. Studied the technique of Tosa school and later that of Ukiyoye school. *L & C.* Born in Owari and died in Edo. The Scroll painting " Engeki-zukan " 演

劇圖卷 (Scenes of Dramas.) (Coll. Imperial Household Museum) is one of his masterpieces. *Sp.* female figures.

Repr. B. 1, 28. K. 8, 14, 21, 40, 52, 66, 112, 145, 184, 210.

Chūan 仲安 (flourished in the middle of the 15th cent.) *N.* Shinkō 眞康 *A.* Chūan 仲安 *Gō.* Kōseidō 康西堂 Kyūka-sanjin 九華山人 Isoku-dōjin 意足道人 *S.* Muromachi Suiboku school. *L & C.* Zen-priest. Lived in Sairaian Monastery of Kenchōji Temple in Kamakura.

Repr. K. 43, 77, 112, 461.

Chūsen See Chikutō.

Chūsen See Ōkyo.

Daigoryu See Kaiseki.

Daikōsai See Totsugen.

Dainen 大年 (d. 1795) *N.* Nakagawa Tenju 中川天壽 *A.* Da-inen 大年 *F. N.* Chōshirō 長四郎 *Gō.* Suishinsai 醉晋齋 Kantenju 韓天壽 *S.* Nanga school. *L & C.* Born and lived at Matsuzaka in Ise. Famous for calligraphy as well as painting. Went to Edo and Kyōto. Associated with Taiga and Fuyō. Made pictorial books " Taiga-dō Gafu " 大雅堂畫譜 (Pictures of Taiga), "Ifukyū Gafu " 尹孚九畫譜 (Pictures of Ifukyū) etc.

Daini See Tangen.

Daizan 臺山 (1752–1813) *N.* Hirose Seifū 廣瀨淸風 *A.* Bokuho 穆甫 *F. N.* Shūzō 周蔵 Undayū 雲太夫 Daizan 臺山 Shogasai 書畫齋 Haku-unka 白雲窩 Rokumusai 六無齋 *S.* Nanga school. Pupil of Gogaku. *L & C.* Samurai of the clan of Tsuyama in Mimasaka. Lived in Kyōto and Edo. *Sp.* landscape.

Repr. K. 338, 569, 578.

Dasoku 蛇足 (flourished in the latter half of 15th cent.) *N.* Sōyo 宗譽 *Gō.* Dasoku 蛇足 *S.* Muromachi Suiboku school. *L & C.* Born in Echizen. Lived in Kyōto. Said to have been intimate friend of Ikkyū.

Repr. K. 77, 136, 405.

Dasokuken See Shōhaku.

Dasokuken See Sansetsu.

Denki 田騏 (1784–1827) *N.* Yasuda 安田. *Gō.* Tōgaku 東嶽 Denki 田騏 *S.* Yōga school. Pupil of Aōdō. Learned Nanga and Western style paintings. *L & C.* Born at Sukagawa in Iwashiro. Served Lord Matsudaira as a painter.

Denzen See Aōdō.

Dōan 道安 (d. 1571) *N.* Yamada Junsei 山田順清 *F. N.* Tarōzaemon 太郎左衞門 *Gō.* Dōan 道安 *S.* Muromachi Suiboku school. *L & C.* Lord of Yamada castle in Yamato. *Sp.* flowers-and-birds, figures.

Repr. B. 41. K. 41, 78, 247, 279. N. 18.

Dōan II & III 道安 *L & C.* Dōan II was a painter in the middle of 16th cent., and Dōan III, in the end of 16th cent. Both were *samurai* and suiboku-painters.

Donchō 曇徴 (7th cent.) *N.* Donchō 曇徴 *L & C.* Korean priest. Naturalized as a Japanese in the Asuka period. Distinguished painter of that time.

Donkyō 呑響 (d, 1810) *N.* Ōhara Yoku 大原翼 *A.* Unkei 雲卿 *F. N.* Sakingo 左金吾 *Gō.* Bokusai 墨齋 Donkyō 呑響 *S.* Studied by himself, following the style of Chang Jui-t'u. *L & C.* Born at Tsugaru in Mutsu, and lived in Matsumae. *Sp.* landscape.

Doun See Matabē.

Ehō 慧廂 (15 cent.) Priest Name: Ehō Tokuṭei 慧廂德鼎 *S.* Muromachi Suiboku school. *L&C.* Zen-priest. *Sp.* figures.
 Repr. K. 487.

Eiga 榮賀 (c. 1310) *N.* Yūshin 有信 (Takuma Eiga 詫摩榮賀) *S.* Buddhistic painting *L & C.* Said to have been one of the pioneer of Muromachi Suiboku painting.
 Repr. K. 3, 68, 397, 465.

Eikai 永海 (1802–1874) *N.* Satake Aisetsu 佐竹愛雪 *F. N.* Ei-shi 衞司 *Gō.* Eikai 永海 *S.* Japanese style. Pupil of Tani Bunchō. *L & C.* Lived in Tōkyō. *Sp.* landscape.

Eiko 永湖 (1835–1909) *N.* Satake Kintarō 佐竹金太郎 *Gō.* Eiko 永湖 *S.* Japanese style. Pupil of Oki Ichiga and Satake Eikai. *L & C.* Lived in Tōkyō. Member of Nippon Bijutsu Kyōkai. *Sp.* landscape, figures.
 Repr. Eiko Iboku-shū 永湖遺墨集.

Eikyū 映丘 (1881–1938) *N.* Matsuoka Teruo 松岡輝夫 *Gō.* Eikyū 映丘 *S.* Japanese style. Pupil of Hashimoto Gahō, Yamana Kangi. Graduate of the Tōkyō Art School. *L & C.* Lived in Tōkyō. Member of the Kinrei-sha. Head of the Shinkō Yamatoye-kai. Professor at the Tōkyō Art School. Member of the Teikoku Bijutsu-in. Head of Kokuga-in. *Sp.* figures.
 Repr. Matsuoka Eikyū Gashū 松岡映丘畫集.

Einō 永納 (1634–1700) *N.* Kanō Yoshinobu 狩野吉信 *A.* Ha-kuju 伯受 *F. N.* Nuinosuke 縫殿助 *Gō.* Einō 永納 Ichi-yōsai 一陽齋 Baigaku 梅岳 Sojunken 素絢軒 Sansei 山靜 Kyo-ō 居翁 *S.* Kanō school. Pupil of his father, Sansetsu.

L & C. Lived in Kyōto. Known as the author of " Hon-
chō Gashi " (Book of Biographies of Japanese Painters)
Repr. K. 76, 34ธ.

Eiri 榮理 (flourished in the beginning of the 19th cent.) *N.*
Hosoda Eiri 細田榮理 *Gō.* Meikyūsai 鳴鳩齋 *S.* Ukiyoye
school. Pupil of Eishi.

Eisen 榮川 (1696–1731) *N.* Kanō Koshin 狩野古信 *F. N.*
Shōzaburō 庄三郎 *Gō.* Eisen 榮川 *S.* Kanō school.
Pupil of his father Shūshin. *L & C.* Lived in Edo. The
fourth painter of the Kanōs at Kobikichō.

Eisen II 榮川二代 (1730–1790) *N.* Kanō Sukenobu 狩野典信
Gō. Eisen 榮川 Hakugyokusai 白玉齋 *S.* Kanō school. Pupil
of Genshin (adopted son of Koshin). *L & C.* Lived in
Edo. The fifth painter of the Kanōs at Kobikichō.

Eisen 英泉 (1790–1848) *N.* Ikeda Yoshinobu 池田義信 *A.* Kon-
sei 混聲 *F. N.* Zenshirō 善四郎 later Teisuke 呈介 *Gō.*
Eisen 英泉 Keisai 溪齋 Ippitsuan 一筆庵 Kokushunrō 國
春樓 Hokugō 北豪 Mumeiō 無名翁 Kakō 可候 *S.* Ukiyoye
school. Pupil of Eizan. Studied Kanō and Tosa schools.
L & C. Lived in Edo. *Sp.* female figures.

Eishi 榮之 (1756–1829) *N.* Hosoda Jibukyō Tokitomi 細田治部
郷時富 *Gō.* Eishi 榮之 Chōbunsai 鳥文齋 (On paintings,
used the name Hosoi 細井, not Hosoda) *S.* Kanō school.
Later painted Ukiyo-ye. *L & C.* Lived in Edo. Served
Tokugawa Iyeharu. *Sp.* female figures (hand paintings
and prints) *Repr.* K. 79, 103, 258, 487.

Eishin See Yasunobu.

Eishun 永春 (15 th cent.) *Gō.* Eishun 永春 *S.* Yamatoye
school. *L & C.* In 1414, painted a part of the scroll

" Yuzū-nembutsu-engi " 融通念佛緣起 (Coll. Seiryōji Temple in Kyōto) *Repr.* K. 169. N. 32.

Eitaku 永濯 (1843–1890) *N.* Kobayashi Tokusen 小林德宣 *F. N.* Hidejirō 秀次郎 *Gō.* Sensai 鮮齋 Eitaku 永濯 *S.* Japanese style. Kanō school. Later established a new realistic school. *L & C.* Lived in Tōkyō. *Sp.* historical subjects and figures.

Eitoku 永德 (1543–1590) *N.* Kanō Kuninobu 狩野州信. *F. N.* Genshirō 源四郎 *Gō.* Eitoku 永德 *S.* Kanō school. Studied under his father, Shōei. The most distinguished painter in the Azuchi-Momoyama period. *L & C.* Lived in Kyōto. Served Oda Nobunaga and Toyotomi Hideyoshi. Painted on the walls of Azuchi-jō Castle and of Jurakudai. *Sp.* flowers-and-birds, figures.

Repr. B. 24, 36. K. 13, 48, 123, 142, 152, 208, 335, 418.

Eitoku 永鳷 (1814–1891) *N.* Kanō Tatsunobu 狩野立信 *Gō.* Seisetsusai 晴雪齋 Eitoku 永鳷 *S.* Japanese style. Son of Kanō Isen-in. *L & C.* Lived in Tōkyō. Member of the Imperial Art Committee. *Sp.* landscape and figures.

Eizan 英山 (1787–1867) *N.* Kikukawa Toshinobu 菊川俊信 *F. N.* Mangorō 萬五郎 *Gō.* Chōkusai 重九齋 *S.* Ukiyoye school. Pupil of Hokukei. *L & C.* Lived in Edo. Associated with Toyokuni, famous Ukiyoye painter. *Sp.* female figures, portraits of actors.

Emosaku 右衞門作 (beginning of 17th cent.) *N.* Yamada Emosaku 山田右衞門作 *S.* Pioneer of painting in Western style. Seems to have studied oil-painting under a foreign missionary who stayed in Nagasaki at that time. *L & C.* Born in Nagasaki. Served Lord Matsu-

kura as a painter. Caught by the Shogunate Government
in the Rebellion of Shimabara (the war between the
Christians and the Shogunate Government). Said to
have been in Edo until his death. *Sp.* Christian subjects.

En-i 圓伊 (flourished in 13th cent.) *Gō.* En-i 圓伊 *S.*
Yamatoye school. *L & C.* Life is unknown. His name is
found in the inscription of the scroll-painting " Pictorial
Biography of Priest Ippen " 一遍上人繪傳 done in 1299
(Coll. Kanki-koji Temple). *Repr.* K. 73, 148, 206, 334.

Enkachōsō See Nanko.

Entaku 遠澤 (1643–1730) Katō Moriyuki 加藤守行 *Gō.* En-
taku 遠澤 *S.* Kanō school. Pupil of Tan-yū. *L & C.*
Born in Aizu, and lived in Edo.

Eshinsōzu See Genshin.

Fūgai 風外 (1779–1847) *Gō.* Fūgai 風外 *S.* Nanga school.
L & C. Zen-priest of Kōjakuin Temple in Mikawa.

Fūko 楓湖 (1840–1923) *N.* Matsumoto Takatada 松本敬忠 *Gō.*
Fūko 楓湖 *S.* Japanese style. Pupil of Satake Eikai
and Kikuchi Yōsai. *L & C.* Lived in Tōkyō. Member
of the Teikoku Bijutsu-in. *Sp.* historical subjects.

Fuyō 芙蓉 (1722–1784) *N.* Ōshima Mōhyū 大島孟彪 *A.* Juhi
孺皮 *F. N.* Ikki 逸記 or Kondō Itsuki 近藤齋宮 *Gō.*
Fuyō 芙蓉 Chūgakugashi 中岳畫史 Hyōgaku-sanjin 氷嶽
山人 Kantan-no-kyo 薗蓍居 Kō Fuyō 高芙蓉 *S.* Nanga
school. *L & C.* Born in Kai. Confucian. Was skilled
in engraving seals. Taiga and Tenju were his intimate
friends. Lived in Kyōto and died in Edo. *Sp.* landscape.
Repr. K. 515.

Fuyō 芙蓉 (1749–1816) *N.* Suzuki Yō 鈴木雍 *A.* Bunki 文熙

F.N. Shimbē 新兵衞 *Gō.* Fuyō 芙蓉 Rōren 老蓮 *S.* Nanga school. Pupil of Bunchō. *L & C.* Born in Shinano. Went to Edo where studied under Bunchō. Later served Lord of Awa. Skilled in writing prose and poetry. *Sp.* landscape, figures.

Gagakusai See Bunchō.

Gahō 雅邦 (1835–1908) *N.* Hashimoto Masakuni 橋本雅邦 *Gō.* Gahō 雅邦 Shōen 勝閫 *S.* Japanese style. Studied Kanō school under Kanō Shōsen-in. *L & C.* Lived in Tōkyō. Professor of the Tōkyō Art School. Chief member of Nippon Bijutsu-in. Member of the Imperial Art Committee. *Sp.* landscape and figures.

Repr. K. 7, 69. Gahō Taikan 邦雅大觀, Gahō Shū 雅邦集.

Gakoken See Tōrei.

Gakuō 岳翁 (flourished in c. 1500) *Gō.* Gakuō 岳翁 Zōkyū 藏丘 *S.* Muromachi Suiboku school. *L & C.* Zen-priest.

Repr. K. 81, 206, 300, 312, 391, 417, 440, 523. N. 21.

Ganku 岸駒 (1749–1838) *N.* Saeki Masaaki 佐伯昌明 (another name: Kishi Ku 岸駒) *A.* Funzen 賁然 *Gō.* Kayō 華陽 Dōkōkan 同功館 Kakandō 可觀堂 Kotōkan 虎頭館 Tenkaikutsu 天開窟 *S.* First painted in Chin Nan-p'in style, but later in his original style, taking different kinds of technique of other painters. *L & C.* Born at Kanazawa in Kaga. After travelling to many places settled in Kyōto. Served Prince Arisugawa and later attended the Court. Appointed lord of Echizen.

Repr. K. 117, 151, 164, 191, 258, 262, 362, 466, 527.

Gantai 岸岱 (1782–1865) *N.* Saeki Tai 佐伯岱 *A.* Kunchin 君鎭 *F.N.* Chikuzen-nosuke 筑前介 *Gō.* Takudō 卓堂 Dōkōkan

同功館 *S.* Pupil of his father, Ganku. *L & C.* Lived in Kyōto.

Gantoku 岸徳 (1805–1859) *N.* Aoki Toku 青木徳 *A.* Shidō 士道 *Gō.* Gantoku 岸徳 Shishin 士進 Renzan 連山 *S.* Shijō school. Pupil of his father-in-law, Ganku. Later painted in Shijō style. *L & C.* Lived in Kyōto. Son of Aoki. Adopted by Ganku as his son.

Geiami 藝阿彌 (1431–1485) *N.* Shingei 眞藝 *F. N.* Geiami 藝 阿彌 *Gō.* Gakusō 學叟 *S.* Muromachi Suiboku school. Pupil of his father, Nōami. *L & C.* Lived in Kyōto. Served Ashikaga Shogunate.

Repr. K. 29, 114. San-ami 三阿彌

Gekkei See Gōshun.

Gekkō 月耕 (1859–1920) *N.* Tai Masanosuke 田井正之助 *Gō.* Ogata Gekkō 尾形月耕 *S.* Japanese style. Studied Uki-yoye by himself. *L & C.* Lived in Tōkyō. Known as an illustrator. *Sp.* genre.

Repr. K. 236. Gekkō Gashu 月耕畫集.

Gen See Kien. **Gembē** See Katsushige.

Genkei 元慶 (the end of 18th cent.) *N.* Araki Shūhō 荒木秀邦 *A.* Genkei 元慶 *S.* Nagasaki school. Pupil of Shūseki. *L & C.* Lived in Nagasaki. Interpreter of Dutch language.

Genki 元規 (c. 1671) *N.* Kita Genki 喜多元規 *S.* Yōga school. *L & C.* Lived in Nagasaki. *Sp.* portraits of priests.

Repr. B. 12.

Genki 源琦 (1747–1797) *N.* Komai Ki 駒井琦 (Genki 源琦) *A.* Shi-on 子韞 *F. N.* Yukinosuke 幸之助 *S.* Maruyama

school. Important pupil of Ōkyo. *L & C.* Lived in Kyōto. *Sp.* figures, flowers, and animals.

Repr. K. 12, 178, 286, 448, 478, 560, 581.

Gennai 源內 (1723–1779) *N.* Hiraga Kokurin 平賀國倫 Priest name: gennai 源內 *Gō.* Kyūkei 鳩溪 Kyūkei 休蕙 *S.* Yōga school. *L & C.* Born in Sanuki. Learned the Dutch language. Known also as a botanist and fiction writer.

Genshin 源信 (942–1017) *N.* Genshin 源信 *F. N.* Eshin Sōzu 惠心僧郗 *L & C.* Lived on Mt. Hieizan as a great priest of Tendai-sect. Said to have made many Raikō 來迎 paintings according to his own ideas. Wrote many good books as "Ōjōyōshū," 往生要集 "Ichijō-yōketsu," 一乘要決, etc. *Repr.* K. 158, 224.

Genshin See Sekiho.

Genshiro See Eitoku.

Genshō 玄證 (1146–1206) *F. N.* Kankambō 閑觀房 *Gō.* Genshō 玄證 *L & C.* Priest of Getsujōin Monastery on Mt. Kōyasan. *Sp.* Buddhistic painting. *Repr.* K. 59.

Gensuke See Mokubei.

Gentai 玄對 (1749–1822) *N.* Watanabe Ei 渡邊瑛 *A.* Enki 延輝 *F. N.* Matazō 又藏 *Gō.* Shōdai 松臺 Rinroku 林麓 Sōdō 草堂 *S.* Nanga school. Pupil of Bunchō. *L & C.* Born and Lived in Edo. Uchida Gentai is his name as a priest. *Sp.* landscape, flowers-and-birds.

Gentan 元旦 (1778–1840) *N.* Shimada Gentan 島田元旦 *F. N.* Kiin 季允 Kampo 寬怖 *S.* Maruyama school. Associated with Tōrei. *L & C.* Said to be a younger brother of Bunchō. Succeeded the Shimadas of the clan of Tottori. Served the lord.

Gen-ya 玄也 (the middle of 16th cent.) *N.* Kanō Gen-ya 狩野玄也
S. Kanō school. Pupil of Motonobu and Shōei. Said
to be the teacher of Eitoku when Eitoku was young.

Gen-yū 元融 (1733–1799) *N.* Araki Gen-yū 荒木元融 *A.* Shi-
chō 士長 *F. N.* Tamenoshin 爲之進 *Gō.* Enzan 圓山
S. Studied under Gentoku, and learned oil-painting from
a Dutchman. *L & C.* Lived in Nagasaki. Succeeded
the house of Genkei, and so his family name is Araki.

Geppō 月峯 (1760–1839) *N.* Shinryō 辰亮 *Gō.* Geppō 月峯
Kikukan 菊間 *S.* Nanga school. Pupil of Taiga. Priest.
L & C. Lived in Kyōto.

Gessen 月僊 (1721–1809) *N.* Tan-ke Genzui 丹家玄瑞 *A.*
Gyokusei 玉成 *Gō.* Gessen 月僊 Jakushō-shujin 寂照主
人 *S.* Pupil of Sekkan and later of Ōkyo, developed
his technique by the old paintings of the Yüan and
Ming dynasties. *L & C.* Born in Owari. Priest of Jakushōji
Temple at Yamada in Ise. He repaired the temple,
by selling his paintings.

Gessen See Shabaku.

Gesshō 月樵 (1772–1832) *N.* Chō Yukisada 張行定 *A.* Genkei
元啓 *F. N.* Shinzo 晉蔵 Kaisuke 快助 *Gō.* Gesshō 月樵 Sui-
kadō 醉霞堂 *L & C.* Lived in Ōmi. A famous local
painter of that time. His works were praised by Bun-
chō. *Sp.* figures, flowers-and-birds.

Gibokusai 戲墨齋 (16th century) *A.* Shinzaburō 新三郎 *Gō.*
Gibokusai 戲墨齋 *S.* Kanō school. Pupil of Suibokusai.
L & C. Lived in Kyōto.

　Repr. K. 52.

Gitō 義董 (1780–1819) *N.* Shibata Gitō 柴田義董 *A.* Ichū 威

仲 *F. N.* Kitarō 喜多郎 *Gō.* Kincho 琴緒 Kinkai 琴海 Kitarō 喜多樓 *S.* Shijō school. Pupil of Gekkei. *L & C.* Born in Bizen. Went to Kyōto. *Sp.* figures.

Gōda Kiyoshi 合田清 (1862–1938) *N.* Gōda Kiyoshi 合田清 *S.* Western style. In 1880 travelled in France where studied wood-engraving in Western style. *L. & C.* Born and lived in Tōkyō. Introduced Western style wood-engraving.

Gogaku 五岳 (1730–1799) *N.* Fukuhara Genso 福原玄素 *F. N.* Daisuke 大助 *Gō.* Gogaku 五岳 Gyokuhō 玉峰 *S.* Nanga school. Pupil of Taiga. *L & C.* Born in Bingo. Lived in Ōsaka. *Sp.* landscape, figures.

Gogaku 五岳 (1809–1893) *N.* Hirano Bunkei 平野閑慧 *Gō.* Gogaku 五岳 Kochiku 古竹 *S.* Japanese style. Nanga school. Studied by himself. *L & C.* Lived in Ōita. Zen priest. *Sp.* landscape.

Repr. Gogaku-shōnin Shimpin 五岳上人神品.

Gogaku See Seiki.

Gōkoku 豪谷 (1850–1897) *N.* Kinugasa Shinkō 衣笠縉侯 *A.* Shinkei 紳卿 *Gō.* Gōkoku 豪谷 Tenchū-sanjin 天柱山人 *S.* Japanese·style. Pupil of Satake Eiko and Nakanishi Kōseki. *L & C.* Lived in Tōkyō. *Sp.* landscape.

Repr. Gōkōkū Gaen Iboku-shū 毫谷畫莚遺墨集.

Gomon 梧門 (1809–1860) *N.* Miura Korezumi 三浦惟純 *A.* Sōryō 宗亮 *F.N.* Sōsuke 惣助 *Gō.* Gomon 梧門 Shūsei 秋聲 Karyō 荷梁 *S.* Nanga school. Pupil of Kakushū. Later influenced by the technique of Chinese paintings of the Ch'ing dynasty. *L & C.* Famous painter in Nagasaki. *Sp.* landscape, flowers-and-birds.

Goseda Iwakichi 五姓田岩吉 (1827–1892) *N.* Goseda Iwakichi 五姓田岩吉 *F. N.* Genjirō 源次郎 Denjirō 傳次郎 Kinjirō 金次郎 *Gō.* Hōryū 芳柳 *S.* Western style. Studied painting in Japanese style under Higuchi Tangetsu, and later learned Western style by himself. *L & C.* Born in Tōkyō and lived in Yokohama and Tōkyō. Taught pupils at his private school. *Sp.* figures (in mixed style of Western and Japanese).

Goseda Yoshimatsu 五姓田義松 (1855–1915) *N.* Goseda Yoshimatsu 五姓田義松 *S.* Western style. Pupil of Charles Wirgman. Studied under Antonio Fontanesi in Engineering Art School. Later travelled in France where studied under J. L. Bonnat. *L & C.* Born in Yokohama. Lived in Tōkyō and Yokohama. As an attendant of Emperor Meiji travelled in Hokuriku district and painted landscapes of many famous places. Painted both in oil and in water-colour.

Gōshin 豪信 (flourished in the former half of 14th cent.) *N.* Fujiwara Gōshin 藤原豪信 *S.* Yamatoye school. *L & C.* Descendant of Nobuzane. Son of Tamenobu, courtier. Later became a priest. Works: portrait of Emperor Hanazono 花園天皇宸影. (coll. Chōfukuji Temple) etc. *Sp.* portrait. *Repr.* N. 3.

Goshun 呉春 (1752–1811) *N.* Matsumura Toyoaki 松村豐昌 *A.* Hakubō 伯望 *F. N.* Bunzō 文藏 Kaemon 嘉右衞門 *Gō.* Yūho 裕甫 Katen 可轉 Sompaku 存白 Sonjūhaku 存壽白 Sonseki 孫石 Shōutei 蕉雨亭 Hyakushōdō 百昌堂 Gekkei 月溪 Goshun 呉春 *S.* Shijō school. (founder) Studied under Ōnishi Suigetsu and later Buson. After

the death of Buson, associated with Ōkyo. *L & C.* Born in Owari. Lived in Settsu and Kyōto. Founded a new school, taking good points of Buson and Ōkyo. Skilled in making *haikai* poems and in calligraphy. *Sp.* landscape, figures, flowers-and-birds.

 Repr. B. 62. K. 19, 63, 80, 93, 157, 174, 201, 226, 228, 233, 243, 249, 256, 266, 281, 288, 294, 324, 340, 349, 358, 380, 454, 460, 487, 513, 540, 552.

Gototei See Kunisada.

Go-un 五雲 (1877–1938) *N.* Nishimura Genjirō 西村源次郎 *Gō.* Go-un 五雲 *S.* Japanese style. Pupil of Takeuchi Seihō. *L & C.* Lived in Kyōto. Professor of the Kyōto Art school Member of the Teikoku Bijutsu-in and of the Teikoku Geijutsu-in. *Sp.* landscape, flowers-and-birds.

Gukei 具慶 (1631–1705) *N.* Sumiyoshi Hirozumi 住吉廣澄 *F. N.* Naiki 內記 Priest name: Gukei 具慶 *S.* Sumiyoshi school. Pupil of his father Jokei. *L & C.* Lived in Edo. Painter attached to the Tokugawa government. Painted many pictorial scrolls. The scroll of "Rakuchū Rakugai" 洛中洛外 (Kyōto and its Suburb) (coll. the Imperial Household Museum) is one of his good works. Appointed Hōgen. *Sp.* genre.

 Repr. K. 23; 50, 131, 248.

Gyo See Rosetsu.

Gyokudō 玉堂 (1745–1821) *N.* Uragami Hitsu 浦上弼 *A.* Kumpo 君輔 *F.N.* Heiyemon 兵右衞門 *Gō.* Gyokudō 玉堂 Gyokudō-kinshi 玉堂琴士: *S.* Nanga school. *L & C.* Born in Bizen. Served Ikeda Masaka, lord of the branch clan of Bizen; later retired from the service on the death of

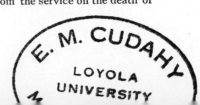

his lord in 1798 and started on a long journey through the country. Later settled at Kyōto and was intimate with Chikuden and others. Shunkin is his son. Was also good at calligraphy, poetry, and especially at playing *koto* (instrument something like a harp) and called himself Gyokudō-kinshi (Gyokudō the *koto*-player). Belonged to the old family of Ki and sometimes called himself Ki no Gyokudō. Both his painting and calligraphy breathe an unworldly taste. *Sp.* landscape.

Repr. B. 19, 31, 104. K. 345, 369, 380, 463. Gyokudō Kinshi Gafu 玉堂琴士畫譜.

Gyokuen 玉畹 (1344–c.1420) *N.* Gyokukei (玉桂 later Bompō 梵芳) *A.* Gyokuen 玉畹 *Gō.* Shōrin 少林 *S.* Muromachi Suiboku school. Teacher is unknown, but it is possible that he followed Tesshū Tokusai. *L & C.* Lived in Kamakura first. Later became the head priest of Manjuji Temple in Bungo, Kenninji Temple in Kyōto, and in 1413, of Nanzenji Temple in Kyōto. But his later life is unknown. *Sp* flowers (orchids.)

Repr. B. 15. K. 49, 384, 515.

Gyokukei See Kien.

Gyokuraku 玉樂 See Sōyū.

Gyokuran 玉瀾 (1728–1784) *N.* Ikeno Machi 池野町 *Gō.* Gyokuran 玉瀾 Kattankyo 葛覃居 *S.* Nanga school. Wife of Taiga. Studied under her husband. *L & C.* Born in Kyōto. *Sp.* landscape, flowers.

Gyokusen 玉蟾 (1692–1755) *N.* Mochizuki Shigemori 望月重盛 *A.* Gyokusen 玉蟾 *F. N.* Tōbē 藤兵衞 *S.* Studied under Tosa Mitsushige and later Yamaguchi Sekkei.

Influenced also by Motonobu. *L & C.* Lived a free and easy life in Kyōto. Loved literature.

Gyokusen 玉泉 (1834–1913) *N.* Mochizuki Shigemine 望月重岑 *A.*Shuitsu 主一 *F. N.* Shunzō 駿三 *Gō.* Gyokusen 玉泉 Gyokkei 玉溪 *S.* Japanese style. Pupil of his father Gyokusen. *L.& C.* Lived in Kyōto. Member of Imperial Art Committee *Sp.* flowers-and-birds.

Gyokusen See Naotake.

Gyokushō 玉章 (1842–1913) *N.* Kawabata Gyokushō 川端玉章 *Gō.* Gyokushō 玉章 Keitei 敬亭 *S.* Japanese style. Studied Shijō school under Nakajima Raishō. *L & C.* Lived in Tōkyō. Member of Nippon Bijutsu Kyōkai and Imperial Art Committee. Professor of Tōkyō Art School. *Sp.* landscape, flowers-and-birds.

Repr. K 7. Gyokushō-ō Iboku-shū 玉章翁遺墨集, Gyokushō Gafu 玉章畫譜.

Gyokushū 玉洲 (1743–1799) *N.* Kuwayama Shisan 桑山嗣燦 *A.* Meifu 明夫 *F. N.* Sanai 左内 *Gō.* Gyokushū 玉洲 Kakuseki-en 鶴跡園 Chō-udō 聽雨堂 Kasetsudō 珂雪堂 *S.* Nanga school. *L & C.* Born and lived in Kii. Intimate friend of Taiga. His art theory: " Gyokushū-Gashu " 玉洲畫趣, "Kaiji-higen" 繪事鄙言. *Sp.* landscape, flowers-and-birds.

Repr. K. 353.

Gyokuzan 玉山 (1737–1812) *N.* Okada Shōyū 岡田尚友 *A.* Shitoku 子德 *Gō.* Gyokuzan 玉山 *S.* Ukiyoye school. *L & C.* Lived in Ōsaka. Nominated to Hokkyō. Painted illustrations in " Taikōki " 大閤記 (or Biography of Toyotomi Hideyoshi). *Sp.* illustration of story-book.

Gyōsai 曉齋 (1831–1889) *N.* Kawanabe Nobuyuki 河鍋陳之
 F. N. Tōyū 洞郁 *Gō.* Gyōsai 曉齋 Kyōsai 狂齋 *S.* Japa-
 nese style. Kanō school. Pupil of Maemura Tōwa and
 Kanō Tōwa. *L & C.* Lived in Tōkyō. *Sp.* figures.
 Repr. K. 24. 109. Shōjō-Gyōsai Meigashū 狸々曉齋名畫
 集, Gyōsai Gashū 曉齋畫集.

Gyoshū 御舟 (1894–1935) *N.* Hayami Eiichi 速水榮一 *Gō.*
 Gyoshū 御舟 *S.* Japanese style. Pupil of Matsumoto
 Fūko. *L & C.* Lived in Tōkyō. Member of the Nippon
 Bijutsu-in. *Sp.* flower and birds.

Hachigaku See Shukuya.

Hakuin 白隱 (1685–1768) Priest name: Ekaku 慧鶴 *Gō.*
 Hakuin 白隱. *S.* Nanga school. *L & C.* Born in Hara
 in Suruga. Zen-priest. Painted in rough style. Fond
 of travelling and wrote many books.

Hakukyo See Shunkin.

Hakuryū 白龍 (1833–1898) *N.* Sugawara Motomichi 菅原元道
 Gō. Hakuryū 白龍. *S.* Japanese style. Nanga school.
 L & C. Lived in Tōkyō. *Sp.* landscape.
 Repr. Hakuryū Ikō 白龍遺稿.

Hakyō 波響 (1764–1826) *N.* Kakizaki **Hiro**toshi 蠣崎廣年. *A.*
 Seyū 世祐. *F. N.* Shōgen 將監. *Gō.* Hakyō 波響 Kyōu
 杏雨. *S.* Maruyama school. Pupil of Sōshiseki and
 Ōkyo. *L & C.* Lived at Matsumae in *Sp.* flowers and
 birds.
 Repr. K. 427.

Hanko 半古 (1870–1917) *N.* Kajita Jōjirō 梶田錠次郎. *Gō.*
 Hanko 半古. *S.* Japanese style. Shijō school. Pupil of

Nabeta Gyokuei, and later established a style of his
own by himself. *L. & C.* Lived in Tōkyō. Member of
the Nippon Kaiga Kyōkai and the Nippon Bijutsu-in.
Head instructor of the Technological School of Toyama.
Sp. portraits.

Hankō 半香 (1804–1864) *N.* Fukuda Kitsu 福田佶. *A.* Kitsu-
jin 吉人. *F. N.* Kyōzaburō 恭三郎. *Gō.* Hankō 半香.
Gyōsai 曉齋 Gyōmusei 曉夢生. *S.* Nanga school. Pupil
of Tairei and Kazan. *L & C.* Born at Mitsuke in
Tōtōmi. Went to Edo where he became distinguished
follower of Kazan. Lived in Edo. *Sp.* landscape,
flowers and birds.

Hankō 半江 (1782–1845) *N.* Okada Shuku 岡田肅. *A.* Shi-u
子羽. *F. N.* Uzaemon 宇左衞門. *Gō.* Hankō 半江 Kan-
zan 寒山. Dokushōrō 獨松樓. *S.* Nanga school. Pupil
of his father Beisan-jin. *L & C.* Born in Ōsaka. Clans-
man in Tsu. Lived in Ōsaka after his resignation.
Sp. landscape.

Repr. K. 121, 213, 227, 264, 286, 321, 328, 405, 474, 539.

Hara Kumatarō 原熊太郎 (c. 1861–1907) *N.* Hara Kumatarō. 原
熊太郎. *Gō.* Bushō 撫松 *S.* Western style. Studied under
Tamura Muneyuki in Kyōto Art School. *L & C.* Born in
Okayama, and lived in Tōkyō. Travelled in England and
lived in London in 1904. *Sp.* portraits.

Harada Naojirō 原田直次郎 (1863–1899) *N.* Harada Naojirō
原田直次郎. *S.* Western style. Pupil of Takahashi Yuichi.
Later studied under Gabriel Max in Germany. *L & C.*
Born and lived in Tōkyō. Founded a private art

school called Shōbi-kan, and taught painting in western style. *Sp.* figures.

Repr. Harada Naojirō Kinenjō 原田直次郎記念帖.

Haritsu See Ritsuō.

Harumachi See Shunchō.

Harunobu 春信 (1724–1770) *N.* Suzuki Harunobu 鈴木春信 *F. N.* Jihē 治兵衞. *Gō.* Chōeiken 長榮軒. *S.* Ukiyoye school. Pupil of Shigenaga. Influenced by Toyonobu. *L & C.* Lived in Edo. *Sp.* female figures.

Repr. B. 84. K. 49.

Harushige See Kōkan.

Hassendō See Hyakusen.

Hekishōkyū See Matabē.

Hekiundō See Buson.

Hideyori 秀頼 (d. 1557) *N.* Kanō Hideyori 狩野秀頼. *S.* Kano school. Pupil of his father, Motonobu. *L & C.* Lived in Kyōto. *Repr.* K. 45, 67, 93, 185. *N.* 48.

Hinrakusai See Shōkei.

Hirochika 廣周 (flourished 1459–1492) *N.* Tosa Hirochika 土佐廣周. *S.* Tosa school. *L & C.* Painter of Edokoro of the Court. Said to be uncle of Mitsunobu. The scroll painting " Dōjōji Engi " 道成寺緣起繪卷 (Coll. Count Sakai) is attributed to him. *Repr.* K. 174.

Hiromasa 廣當 (1729–1797) *N.* Itaya Hiromasa 板谷廣當 or Hiroyoshi 廣慶. *Gō.* Keishū 慶舟. *S.* Yamatoye school. Pupil of Sumiyoshi Hiromori. *L & C.* Lived in Edo. Painter attached to the Tokugawa government. *Sp.* genre.

Hiromichi See Jokei.

Hiroshige 廣重 (1797-1858) *N*. Andō Hiroshige 安藤廣重 *F.N.*
Jūemon 重右衞門 Tokubē 德兵衞. *Gō*. Ichiyūsai 一幽齋
Ichiyūsai 一遊齋 Ichiryūsai 一立齋 Ryūsai 立齋 Tōkaidō-
utashige 東海堂歌重. *S*. Ukiyoye school. Pupil of Uta-
gawa Toyohiro. Distinguished landscape-painter of the
Edo period. *L & C*. Lived in Edo. His works: "Tōkaidō
Gojūsantsugi " 東海道五十三次 (Fifty five sights along
the Tōkaidō) "Tōto Meisho " 東都名所 (Famous places
in Edo) etc. *Sp*. landscape.

Repr. K. 78, 203, 214, 237, 443.

Hirotaka 弘高 (flourished in c. 1000) *N*. Kose Hirotaka 巨勢弘
高. *S*. Yamatoye school. *L & C*. Famous as a Court
painter. But all his works are lost.

Hiroyuki 廣行 (1755-1811) *N*. Sumiyoshi Hiroyuki 住吉廣行
F. N. Naiki 内記. *Gō*. Keikin-en 景金園. *S*. Sumiyoshi
school. Pupil of Sumiyoshi Hiromori. *L & C*. Son
of Itaya Hiromasa. Adopted by Hiromori as his son.
Painter attched to the Tokugawa government. Excel-
led in judging old Japanese paintings. *Sp*. genre.

Repr. K. 71.

Hirozumı See Gukei.

Hitsu See Chinzan.

Hō See Kaioku.

Hōbun 芳文 (1862-1918) *N*. Kikuchi Tsunejirō 菊池常次郎.
Gō. Hōbun 芳文. *S*. Japanese style. Shijō school.
Pupil of Kōno Bairei. *L & C*. Lived in Kyōto. Pro-
fessor of Kyōto Technological School. *Sp*. landscape
and flowers-and-birds.

Hōchū 芳中 (18-19 cent.) *N.* Yamanaka Hōchū 山中芳中. *S.* Kōrin school. Influenced by Kōrin. *L & C.* Born in Kyōto, and lived in Ōsaka. *Repr.* K. 367.

Hōen 芳園 (1804–1867) *N.* Nishiyama Seishō 西山成章. *A.* Shitatsu 子達. *Gō.* Hōen 芳園. *S.* Shijō school. Pupil of Keibun. *L & C.* Lived in Ōsaka. *Sp.* figures, flowers-and-birds.

Repr. K. 362, 384, 433, 450.

Hōgai 芳崖 (1828–1888) *N.* Kanō Enshin 狩野延信. *Gō.* Hōgai 芳崖 *S.* Japanese style. Pupil of Kanō Shōsen-in. *L & C.* Lived in Tōkyō. *Sp.* figures and landscape.

Repr. B. 12, 87. K. 2, 30, 206, 433, Hōgai-sensei Iboku Zenshū 芳崖先生遺墨全集.

Hōhei 蓬平 (1750–1807) *N.* Satake Seii 佐竹正衛. *Gō.* Hōhei 蓬平 Kibun-shujin 龜文主人. *S.* Nanga School. Pupil of Taiga. *L & C.* Born in Shinano. *Sp.* landscape.

Hōitsu 抱一 (1761–1828) *N.* Sakai Tadamoto 酒井忠因. *A.* Kishin 暉眞. *Gō.* Ōson 鶯村 Keikyodōjin 輕擧道人 Nison-an 二尊庵 Uka-an 雨華庵 Hōitsu 抱一. *S.* Kōrin school. Studied the technique of Kanō school under Eitoku, and that of Ukiyoye school under Toyoharu, and the technique of Chin Nan-p'in under So-shiseki. Later painted in Kōrin style, upon the advice of Buncho. *L & C.* Born in Edo as the second son of lord Sakai of the Himeji castle in Harima. Went to Kyōto, and became a priest in 1793. In 1810, went to Edo and publish-ed "Kōrin Hyakuzu" 光琳百圖 (100 Masterpieces of Kōrin) "Kenzan's Works," 乾山畫譜 etc. *Sp.* flowers-and-birds, and cartoons.

Rep. B. 40, 59, 90. K. 11, 19, 23, 57, 83, 91, 106, 114, 124, 139, 161, 173, 191, 209, 218, 224, 229, 323, 345, 375, 387, 392, 406, 410, 417, 434, 442, 456, 463, 471, 499, 526, 546, 551, 558. Hōitsu-shōnin-gashū 抱一上人畫集.

Hokkei 北溪 (1780–1850) *N.* Iwakubo Tatsuyuki 岩窪辰行. *F. N.* Hatsugorō 初五郎 later Kin-emon 金右衞門. *Gō.* Totoya Hokkei 魚屋北溪 Kōsai 拱齋 Kikō 葵岡. *S.* Ukiyoye school. Pupil of Kanō Masanobu, and later of Hokusai. *L & C.* Lived in Edo. *Sp.* cartoon.

Hokuba 北馬 (1771–1844) *N.* Hoshino 星野. *F. N.* Arisaka Gorōhachi 有坂五郎八. *Gō.* Teisai 蹄齋 Hokuba 北馬 Shunshuntei 駿々亭 Shunshunsai 駿々齋 Shūen 秋闌. *S.* Ukiyoye school. Pupil of Hokusai. *L & C.* Lived in Edo. It is said that he helped Bunchō in colouring pictures. Illustrated many story books.

Hokuju 北壽 (19th cent.) *N.* Kazumasa 一政. *Gō.* Shōsai 昇齋 Shōtei 昇亭 Hokuju 北壽. *S.* Ukiyoye school. Pupil of Hokusai. *L & C.* Lived in Edo. *Sp.* Ukiye (Ukiyoye in perspective).

Hokusai 北齋 (1760–1849) *N.* Nakajima Tamekazu 中島爲一. *F. N.* Tokitarō 時太郎 Tetsuzō 鐵藏. *Gō.* Katsukawa Shunrō 勝川春朗 Sōshunrō 叢春朗 Gumbatei Gyobutsu 群馬亭魚佛 Sōri 宗理 Shinsai 辰齋 Kintaisha 錦袋舍 Tamekazu 爲一 Raito 雷斗 Raishin 雷震 Gakyōjin 畫狂人 Manji-ō 卍翁 Manjirōjin 卍老人. *S.* Ukiyoye school. Pupil of Shunshō. Distinguished painter of Edo period. *L & C.* Lived in Edo. Painted "Fugaku Hyakkei" 富嶽百景 (100 pictures of Mt. Fuji) *Sp.* landscape.

Repr. K. 126, 190, 198, 238, 240, 246, 284, 354, 423, 429.

Hokusen See Bokusen.

Hokusō-ō See Itchō.

Honda Kinkichirō 本多錦吉郎 (1850-1921) *N.* Honda Kin-
kichirō 本多錦吉郎. *Gō.* Keizan 契山. *S.* Western style.
Pupil of Kunisawa Shinkurō. *L & C.* Born and lived in
Tōkyō. Professor at Military Academy. Succeeded
Shōgidō (private art school founded by his teacher),
and taught painting to his many pupils. *Sp.* land-
scape.

 Repr. Honda Kinkichirō 本多錦吉郎. Nihon Meien Zufu
日本名園圖譜.

Hōshū See Hyakusen.

Hyakkoku See Kaisen.

Hyakunen 百年 (1825-1890) *N.* Suzuki Seiju 鈴木世壽. *A.*
Shikō 子孝. *F. N.* Zusho 圖書. *Gō.* Hyakunen 百年. *S.*
Japanese style. Studied by himself, and completed his
own style. *L & C.* Lived in Kyōto. *Sp.* landscape.

 Repr. Hyakunen Gaei 百年畫影.

Hyakusen 百川 (1698-1753) *N.* Sakaki Shin-en 彭城眞淵. *A.*
Hyakusen 百川. *Gō.* Hōshū 蓬洲 Hassendō 八仙堂. *S.*
Nanga school. One of the distinguished Nanga painters
in the early period. His teacher is unknown. *L & C.*
Born in Owari. *Haikai* poet. Excelled in painting and
Buson was influenced by him. Lived in Kyōto. *Sp.*
landscape, flowers-and-birds, figures.

 Repr. K. 484, 499, 550.

Hyakusui 百穗 (1877-1933) *N.* Hirafuku Teizō 平福貞藏. *Gō.*
Hyakusui 百穗. *S.* Japanese style. Pupil of Kawabata

Gyokushō. Graduate of the Tōkyō Art School. *L & C.*
Lived in Tōkyō. Member of the Kinrei-sha. Professor
of the Tōkyō Art School. Member of the Teikoku
Bijutsu-in. *Sp.* landscape, figures, flowers-and-birds.
Repr. B. 27. Hirafuku Hyakusui Gashū 平福百穗畫集

Hyakutake Kenkō 百武兼行 (1842–1887) *N.* Hyakutake Kenkō
百武兼行. *S.* Western style. Studied under Richard-
son, Leon Bonnard, Maccari. *L & C.* Lived in Tōkyō.
Diplomat.

Ichian 一庵 (d. c. 1590) *N.* Kanō Ichian. 狩野一庵 *S.* Kanō
school. Said to be the father of Ichiō. *L & C.* Served
lord Hōjō (?).

Ichibetsusai　See Toyokuni II.

Ichiga 一峨 (1830–1855) *N.* Oki Tei 沖貞. *A.* Shikei 子卿.
Gō. Ichiga 一峨 Seisai 靜齋. *S.* Kanō school. Pupil of
his adoptivefather, Oki Tanchū. Painter of Tottori clan.
L & C. Son of Kodama in Edo.

Ichiō 一翁 (1550–1616) *N.* Kanō Jūgō 狩野重郷. *F. N.* Kyūzō
久藏. *Gō.* Ichiō 一翁. *S.* Kanō school. *L & C.* Lived in
Odawara. Served Lord Hōjō.

Ichiryūsai　See Hiroshige.

Ichiryūsai　See Toyoharu.

Ichiryūsai　See Toyohiro.

Ichiryūsai　See Toyokuni II.

Ichiyōan　See Settan.

Ichiyōsai　See Einō.

Ichiyōsai　See Toyokuni.

Ichiyūsai　See Kuniyoshi.

Ijū 以十 (flourished in 18th cent.) *N*. Konishi Mitsukore 小西光是. *Gō*. Ijū 以十. *S*. Kōrin school. *L & C*. Lived in Kyōto.

Ikkei 一溪 (1599–1662) *N*. Shigeyoshi 重良. *F. N*. Naizen 内膳. *Gō*. Ikkei 一溪. *S*. Kanō school. Pupil of Kanō Mitsunobu. *L & C*. Lived in Odawara. Served Lord Hōjō. Wrote " Tansei Jakuboku Shū " 丹青若木集 which is known as the oldest book of biographies of painters in Japan.

Ikkei 一蕙 (1795–1859) *N*. Toyotomi Kiminobu 豐臣公信. *F. N*. Kuranosuke 内藏允. *Gō*. Ukita Ikkei 浮田一蕙. *S*. Fukko Yamatoye school. *L & C*. Loyalist. Made a speech questioning the future of Japan and was put into prison by the feudal government. Lived in Kyōto. *Sp*. figures. *Repr*. K. 111, 121, 132, 204, 504.

Ikki See Fuyō.

Ikkyū 一休 (1394–1481) *N*. Sōjun 宗純. *A*. Ikkyū 一休. *Gō*. Kyōunshi 狂雲子 Mukei 夢閨 Kokukei 國景. *S*. Muromachi Suiboku school. *L & C*. Priest in Daitokuji Temple at Murasakino in Kyōto.
Repr. K. 119, 234, 415, 426.

Ikkyū 一丘 (flourished at the beginning of 19th cent.). *N*. Ōkubo Kōko 大久保好古 *A*. Toshio 敏夫 *Go*. Ikkyū 一丘. *S*. Yōga school. Pupil of Kōkan. *L & C*. Samurai. Served the lord of the clan of Yokosuka. *Repr*. B. 2.

Impo 筠圃 (1717–1774) *N*. Miyazaki Ki 宮崎奇. *A*. Shijō 子常. *F. N*. Jōnoshin 常之進. *Gō*. Impo 筠圃. *S*. Nanga school. Pioneer of Japanese Nanga school. *L & C*.

Born in Owari. Lived in Kyōto. Known also as Confucian. *Sp.* bamboos.

Inen See Sōsetsu, Sōtatsu.

Ippō 一鳳 (1798–1871) *N.* Mori Takayuki 森敬之. *A.* Shikō 子交. *F. N.* Bumpei 文平. *Gō.* Ippō 一鳳. *S.* Maruyama school. Studied under his adoptive father, Mori Tetsuzan. *L & C.* Born and lived in Ōsaka. Had the honour of painting on the *fusuma* (sliding doors) of the Imperial Palace in the Ansei era. *Sp.* figures, flowers-and-birds.

Repr. K. 84, 312, 333, 426, 495, 523.

Iryō See Kōrin.

Isei 意精 (flourished in the middle of 16th cent.) *N.* Eihaku 榮博. *Gō.* Isei 意精. *S.* Kanō school. Pupil of Kanō Motonobu. *L & C.* Lived in Higo. *Sp.* landscape.

Isen 伊川 (1775–1828) *N.* Kanō Eishin 狩野榮信. *Gō.* Isen 伊川 Genshōsai 玄賞齋. *S.* Kanō school. Pupil of his father Korenobu. *L & C.* Sixth painter of the family of Kanō at Kobikichō in Edo.

Ishibashi Wakun 石橋和訓 (1876–1928) *N.* Ishibashi Wakun 石橋和訓. *S.* Western style. *L & C.* Born in Shimane prefecture. Lived in London and in Tōkyō. Studied painting in Japanese style under Taki Katei, and went to Europe, and learned painting in Western style in the Royal Academy. A hanging committee of Teiten Exhibition. The Royal Academician.

Ishū 伊洲 (1791–1852) *N.* Kikuta Hideyuki 菊田秀行. *Gō.* Shōu 章羽 Shōu 松塢 Ishū 伊洲. *S.* Pupil of Isen. In-

fluenced by Bunchō. *L & C.* Born in Sendai, and lived in Edo. Said to be the great-grand-child of Haritsu.

Issa 一茶 (1763–1827) *N.* Kobayashi 小林. *F. N.* Yatarō 彌太郎. *Gō.* Issa 一茶. *L & C.* Lived in Shinano and Edo. Being a *haikai*-poet, his pictures show free and unconventional style. "Oraga Haru" is one of his poetical works. *Sp.* cartoon (*Haiga*).

Isshi 一之 (beginning of 15th cent.) *F. N.* Kōzasu 江藏主. *Gō.* Isshi 一之. *S.* Muromachi Suiboku school. *L & C.* Said to have lived in Nanzenji Temple in Kyōto.

Repr. K. 35

Isshi 一絲 (1608–1646) *N.* Iwakura Fumimori 岩倉文守. *A.* Isshi 一絲. *Gō.* Tōkō 桐江. *L & C.* Zen-priest. Studied Zen doctrine under Takuan. Restored Eigenji Temple at Yamagami in Ōmi. *Sp.* portraits.

Isshō 一笑 (18th cent.) *Gō.* Miyagawa Isshō 宮川一笑. *S.* Ukiyoye school. Pupil of Chōshun. *Sp.* female figures. *Repr.* K. 291.

Itchō 一蝶 (1652–1724) *N.* Taga Shinkō 多賀信香. *A.* Kunju 君受. *F. N.* Sukenoshin 助之進. *Gō.* Hanabusa Itchō 英一蝶 Chōko 朝湖 Sasuiō 簑翠翁 Kyūsōdō 舊草堂 Ippō-kanjin 一蜂閑人 Rin-shōan 隣樵庵 Rin-tōan 隣濤庵 Gyōun 曉雲 Kansetsu 澗雪 Sesshō 雪蕉 Waō 和央 Undō 雲堂 Hokusō-ō 北窓翁. *S.* Studied under Kanō Yasunobu and founded Hanabusa school. *L & C.* Born in Ōsaka, and lived in Edo. As he was a man of fashion, visited gay quarters. Excelled in painting cartoons. Exiled to Miyakejima Island at the age of forty-seven, and lived there for many years. Painted many works while

on the island and later in Edo. *Sp.* genrepainting.
Repr. K. 10, 33, 55, 76, 82, 85, 93, 99, 130, 135, 140, 206,
222, 229, 304, 310, 320, 342, 494, 511, 514.

Itsu-un 逸雲 (1799–1866) *N.* Kinoshita Shōsai 木下相宰. *A.*
Kōsai 公宰. *F. N.* Shiganosuke 志雅之助. *Gō.* Itsu-un
逸雲 Butsubutsushi 物々子 Yōchiku-sanj'n 養竹山人 Jora-
sanjin 如螺山人. *S.* Nanga school. Pupil of Ishizaki
Yūshi. Mastered the technique of Chiang Chia-pu
(Kōkaho) who was in Japan at that time. *L & C.* Born
in Nagasaki, went to Kyōto and Edo. Lived in Naga-
saki. Skilled in making poetry. *Sp.* landscape.
Repr. K. 502.

Ittoku 一得 (flourished at the beginning of 17th cent.). *Gō.*
Ittoku 一得. *S.* Tosa school. Pupil of Mitsuyoshi (?)
Repr. K. 62, 141, 493.

Jakuchū 若冲 (c. 1713–1800) *N.* Itō Shunkyō 伊藤春教 Itō
Jokin 伊藤汝鈞. *A.* Keiwa 景和. *Gō.* Jakuchū 若冲 To-
bei-an 斗米庵. *S.* Made his own style by combining
good points of Kanō and Kōrin schools and paintings of
the Ming dynasty. *L & C.* Born and lived in Kyōto. *Sp.*
flowers-and-birds.
Repr. K. 19, 129, 153, 191, 313, 432, 453, 559.

Jakusai 寂済 (1348-1424) *N.* Rokkaku Jakusai 六角寂済. *S.*
Yamatoye school. *L & C.* Belonged to Edokoro of the
Court. Painted a part of the pictorial scroll, "Yuzū-
nembutsu Engi" 融通念佛緣起 in 1414. Later became
priest. *Repr.* K. 21.

Jakusai See Nobuzane.

Jakushōshujin See Gessen.

Jiboku See Sōtan.

Jitekisai See Naonobu.

Jitokusai See Sukenobu.

Jō See San-yō.

Jōchi 定智 (flourished in the middle of 12th cent.) *N.* Jōchi 定智. *S.* Buddhistic painting. *L & C.* Lived on Mt. Kōya as a Priest. Painted on the pillars in Daidempō-in Monastery, when it was founded in 1147. "Zennyo Ryūō" 善女龍王 (coll. Kongōbuji Temple) is his good work.

Jōen 乘圓 (1628–1673) *N.* Okamoto 岡本 Priest name: Jōen 乘圓 *Gō.* Gengenshi 玄々子. *S.* Pupil of Shōkadō. *L & C.* Born in Ōsaka. Lived in Kyōto. Priest. *Sp.* figures, flowers-and-birds.

Jōga 淨賀 (flourished in c. 1295) *N.* Jōga 淨賀. *S.* Buddhistic painting. *L & C.* The scroll, "Biography of Priest Shinran" 親鸞上人繪傳 is attributed to him. Priest of Kōrakuji Temple in Shinano. *Repr.* N. 79.

Jogen 如元 (1765–1824) *N.* Araki Jogen 荒木如元. *F. N.* Zenjūrō 善十郎. *S.* Yōga school. Pupil of his father-in-law, Gen-yū. *L & C.* Born and lived in Nagasaki. Known as an excellent connoisseur. *Sp.* Western subjects (in oil-painting). *Repr.* B. 12.

Jokansai See Sosen.

Jokei 如慶 (1599–1670) *N.* Sumiyoshi Hiromichi 住吉廣通. *F. N.* Naiki 內記. Priest name: Jokei 如慶. *S.* Sumiyoshi school. *L & C.* Lived in Edo. Parting from the Tosas (which belonged to Edokoro of the Court), he established a new school of Sumiyoshi in Edo, and became

a painter of the Shogunate government. Painted many
pictorial scrolls. Gukei is his son. *Sp.* genre painting.
Repr. K. 143, 594.

Jōnin 成忍 (the beginning of 13th cent.) *N.* Jōnin 成忍 *Gō.*
Enichibō 惠日坊 *S.* Buddhistic painting. *L & C.* "Port-
rait of Priest Myōye" 明惠上人畫像 in Kōzanji Temple
is attributed to him.

Jorasanjin See Itsu-un.

Josetsu 如拙 (flourished at the beginning of 15th cent.) *Gō.*
Josetsu 如拙. *S.* Muromachi Suiboku school. *L & C.*
Lived in Shōkokuji Temple in Kyōto. Said to be a
pioneer of suiboku-painting in the Muromachi period.
Repr. B. 4, 77. K. 17, 162. N. 26, 61.

Jōshō See Mitsuoki.

Jozan 如山 (1817–1837) *N.* Watanabe Teiko 渡邊定固. *A.*
Shukuho 叔保. *F. N.* Gorō 五郎. *Gō.* Jozan 如山. *S.*
Nanga school. *L & C.* Younger brother of Kazan.

Jūgasei See Shunshō.

Ka-an See Busei.

Kagei 何帠 (18th cent.) *N.* Tatebayashi Rittoku 立林立德,
later Shirai Sōken 白井宗謙 *Gō.* Kagei 何帠 Tsurugaoka
Itsumin 鶴岡逸民 Kingyū-sanjin 金牛山人 Kiusai 喜雨齋
S. Kōrin school. Pupil of Kenzan. *L. & C.* Born in Kaga.
Physician serving the lord of Kaga. Later went to Edo
where studied under Kenzan and became famous. Lived
in Edo. Seems to have been in Kamakura for some
time. *Sp.* flowers. *Repr.* K. 65.

Kagen 嘉言 (1742–1786) *N.* Niwa Kagen 丹羽嘉言 *A.* Shōho
彰甫 *F. N.* Shinji 新治 *Gō.* Shūchindo 聚珍堂 Fukuzen-

sai 福善齋 Sha-an 謝菴 *S.* Nanga school. Followed the technique of paintings of the Ming dynasty. *L & C.* Born in Nagoya. Taiga was one of his intimate friends.

Kagetane 景種 (16th cent.) *N.* Kagetane 景種 *A.* Hyōbu 兵 部 *S.* Muromachi Suiboku school.

Kaikai See Kiitsu.

Kaioku 海屋 (1778–1863) *N.* Nukina Hō 貫名苞 *A.* Shizen 子 善 *F. N.* Yasujirō 泰次郎 *Gō.* Kaioku 海屋 Shūō 慈翁 *S.* Nanga school. *L & C.* Born in Awa and lived in Kyōto. Taught Confucianism, while painting and writing. *Sp.* landscape.

Repr. K. 153, 166, 196, 263, 295, 382. 447, 464, 526.

Kaiseki 介石 (1747–1828) *N.* Noro Ryū 野呂隆 *A.* Ryūnen 隆年 Daigoryū 第五隆 *F. N.* Kuichirō 九一郎 *Gō.* Kaiseki 介石 Waibai 矮梅 Shiheki-dōjin 四碧道人 Daigaku-shōsha 台嶽樵者 *S.* Nanga school. Pupil of Taiga. *L & C.* Born at Wakayama in Kii. Studied in Kyōto and later served the lord of Kii. His conception of painting is found in his book " Shihekisai Gawa " 四碧齋畫話. *Sp.* landscape. *Repr.* B. 71, K. 335, 353, 390, 453.

Kaisen 海僊 (1785–1862) *N.* Oda Ei 小田瀛 *A.* Kyokai 巨海 *F. N.* Ryōhei 良平. *Gō.* Hyakukoku 百谷 Kaisen 海僊 *S.* Nanga school. Pupil of Matsumura Goshun (painter of Shijō school). Later changed his style, and painted Nanga. *L & C.* Born in Nagato and lived in Kyōto. *Sp.* landscape, figures, flowers-and-birds.

Repr. B. 38, K. 387.

Kaji Tameya 加地爲也 (d. 1894) *N.* Kaji Tameya 加地爲也 *S.* Western style. *L. & C.* Born in Wakayama prefec-

ture, and lived in Tōkyō. In 1875 went to America and later to Germany where studied oil-painting. A hanging committee of the third Naikoku Kangyō Hakurankai Exhibition. *Sp*. portraits.

Kakei See Keibun.

Kakō 華香 (1877–1927) *N*. Tsuji Unosuke 辻宇之助 *Gō*. Tsuji Kakō 都路華香 *S*. Japanese style. Shijō school. Pupil of Kōno Bairei. *L & C*. Lived in Kyōto. Director of Kyōto Art school and principal of Kyōto Art Technological School. Member of Teikoku Bijutsu-in. *Sp*. flowers-and-birds, figures.
Repr. Kakō Bokujū 華香墨縦.

Kakumyō 覺明 (12th cent.) *N*. (priest name) Kakumyō 覺明 Shinga 信賀 *F. N*. Tayūbō 太夫坊 *Gō*. Saibutsu 西佛 *S*. Buddhistic painting. *L & C*. Founded Kōrakuji Temple in Shinano where painters gathered.

Kakushū 鶴洲 (1650–1731) *N*. Sumiyoshi Hirotsugu 住吉廣次 (later Hironatsu 廣夏) *F. N*. Kuranosuke 内藏允 Priest-name: Kakushū 鶴洲 *S*. Sumiyoshi school. *L. & C*. Son of Sumiyoshi Hiromichi. As a priest, he founded Shōfukuji Temple at Takamatsu in Iyo. *Repr*. K. 131.

Kakushū 鶴洲 (1778–1830) *N*. Watanabe Shūjitsu 渡邊秀實 *A*. Gensei 元成 *Gō*. Kakushū 鶴洲 *S*. Nagasaki school. Pupil of his father Shūsen. *Sp*. landscape, figures, flowers-and-birds.

Kakutei 鶴亭 (d. 1785) Priest Name: Jōkō 淨光 *A*. Kaigen 海眼 Etatsu 惠達 *Gō*. Kakutei 鶴亭 Jubeiō 壽米翁 Gojian 五字菴 Hakuyōsanjin 白羊山人 Nansōō 南窓翁 Baisō 梅窓 *S*. Nagasaki school. Pupil of Yūhi. *L & C*. Zen-priest

of Shi-un-in Monastery in Ōbakusan Temple near Kyōto.
Died in Edo.

Kakuyū 覺猷 (1053–1140) *N.* Kakuyū 覺猷 *F. N.* Toba Sōjō
鳥羽僧正 *S.* Buddhistic painting. *L & C.* Son of Mina-
moto Takakuni. Scholar of the religious doctrine of
Tendai sect. As he lived in Toba he was called Priest
Toba-sōjō. The most distinguished priest-painter of
that time. Said to have painted the famous scroll,
" Chōjū Giga " 鳥獸戲畫 (coll. Kōzanji Temple).

Repr. K. 10, 22, 43, 115, 129, 133, 213, 263. N. 55, 72.

Kamei Shiichi 龜井至一 (1843–1905) *N.* Kamei Shiichi 龜井至
一 *S.* Western style. Pupil of Yokoyama Matsusaburō.
L & C. Born and lived in Tōkyō. *Sp.* figures.

Kampo 寛畝 (1831–1915) *N.* Araki Kampo 荒木寛畝 *Gō.*
Kampo 寛畝 *S.* Japanese style. Pupil of Araki Kankai.
L. & C. Lived in Tōkyō. Member of Nippon Bijutsu
Kyōkai. Professor of Tōkyō Art school. Member
of Imperial Art Committee. *Sp.* flowers-and-birds.

Repr. Kampo Gashū 寛畝畫集.

Kanaoka 金岡 (flourished in the latter half of 9 th cent.)
N. Kose Kanaoka 巨勢金岡 *S.* Yamatoye school. *L & C.*
Painted in 888 portraits of great Confucians. Famous as
a painter of that time, but none of his works remains.

Kangan 寒巖 (d. 1801) *N.* Kitayama Mōki 北山孟熙 or Ba
Mōki 馬孟熙 *A.* Bunkei 文奎 *F. N.* Gonnosuke 權之助
Gō. Kangan 寒巖 *S.* Teacher of Bunchō. *L & C.* Lived
in Edo. His father was also a painter. *Sp.* landscape,
figures. *Repr.* B. 54.

Kangetsu 關月 (1747–1797) *N.* Shitomi Tokki 蔀德基 *A.* Shion 子溫 *F. N.* Genji 原二 *Gō.* Iyōsai 羮揚齋 Kangetsu 關月 *S.* Pupil of Tsukioka Settei. Later learned the technique of old Japanese and Chinese paintings. Loved the art of Sesshū. *L & C.* Born in Ōsaka. Excelled in making poems and calligraphy. Nominated to Hokkyō.

Kankai 寬快 (1786–1860) *N.* Araki Shun 荒木舜 *A.* Kyokō 舉公 *Gō.* Kankai 寬快 Hōseigajin 蓬生書人 Tatsuan 達庵 Pupil of Ezaki Kansai 江崎寬齋 *L & C.* Lived in Edo.

Kankan 幹々 (1770–1799) *N.* Hayashi Hama 林波滿 *Gō.* Suiran 翠蘭 Kan'kan 幹々 *S.* Nanga school. Studied under her husband Bunchō. *L & C.* Lived in Edo. One of the famous lady painters in the Edo period. *Sp.* landscape, flowers-and-birds.

Kanrin 閑林 (1780–1849) *N.* Okada Bukō 岡田武功 (Ren 練) *A.* Shihō 子豐 (Sekiho 石圃) *Gō.* Kanrin 閑林 Tei-in 梯蔭 *S.* Nanga school. Pupil of Bunchō. *L & C.* **Lived** in Edo. *Sp.* flowers-and-birds.

Kansai 侃齋 (18th cent.) *N.* Ishikawa Ryūsuke 石川龍助 *A.* Kōjō 公乘 *Gō.* Kansai 侃齋 Nikyō-gaishi 二橋外史 Shinten-ō, 信天翁 Rōkōdō 老香堂 *S.* Nanga school. Pupil of Shummei. *L & C.* Born in Echigo. Intimate friend of Bōsai and Unzen. *Sp.* landscape, bamboos.

Kansai 寬齋 (1814–1894) *N.* Mori Kōshuku 森公肅 *A.* Shiyō 子容 *F. N.* Naotarō 尚太郎 *Gō.* Kansai 寬齋 *S.* Japanese style. Pupil of Mori Tetsuzan. *L & C.* Lived in Kyōto. Member of the Imperial Art Committee. *Sp.* landscape.

Repr. K. 344, 432, 461, 467, 511. Kansai Gafu 寛齋畫譜, Kansai Ihō 寛齋遺芳.

Kantankyo See Fuyō.

Kantei 鑑貞 (flourished in the latter half of 15th cent.) *N.* Kantei 鑑貞 *F. N.* Nara Hōgen 奈良法眼 *S.* Muromachi Suiboku school. *L & C.* Unknown.

Repr. K. 105, 167, 346, 544, 561.

Kan-yōsai See Ryōtai.

Kanzan 觀山 (1873–1916) *N.* Shimomura Seizaburō 下村晴三郎 *Gō.* Kanzan 觀山 *S.* Japanese style. Pupil of Kanō Hōgai and Hashimoto Gahō. Graduated from Tōkyō Art School. *L & C.* Lived in Yokohama. Professor of Tōkyō Art School. Member of Nippon Bijutsu-in. Member of the Imperial Art Committee. *Sp.* figures, flowers-and-birds.

Repr. B. 11. Kanzan Isakushū 觀山遺作集

Kaō 可翁 (flourished in 14th cent.) *Gō.* Kaō 可翁 *S.* Muromachi Suiboku school. *L & C.* Zen-priest.

Repr. K. 48, 115, 324, 474, 541, 556. N. 77.

Kashō See Taiga.

Katada Tokurō 片多德郎 (1889–1934) *N.* Katada Tokurō 片多德郎 *S.* Western style. *L & C.* Born in Ōita prefecture, and lived in Tōkyō. Graduated from the department of oil-painting at Tōkyō Art School. A hanging committee of Teiten Exhibition.

Repr. Katada Tokurō Gashū. 片多德郎畫集

Katei 果亭 (1841–1913) *N.* Kodama Michihiro 兒玉道弘 *A.* Shiki 士毅 *Gō.* Katei 果亭 *S.* Japanese style.. Nanga school. Pupil of Tanomura Chokunyū. *L & C.* Lived in

Nagano prefecture. *Sp.* landscape, flowers-and-birds.

Repr. Katei Gafu 果亭畫譜, Katei Gashū 果亭畫集, Katei Iboku 果亭遺墨.

Katei 和亭 (1830–1901) *N.* Taki Ken 瀧謙 *A.* Shichoku 子直 *Gō.* Katei 和亭 *S.* Japanese style. Nanga school. Pupil of Araki Kankai, Ōoka Umpō. *L & C.* Lived in Tōkyō. Member of the Imperial Art Committee. *Sp.* flowers-and-birds.

Repr. K. 15, 188. Katei-shū 和亭集.

Katen 花顛 (1730–1794) *N.* Mikuma Shikō 三熊思孝 *A.* Kaidō 海棠 *F. N.* Shukei 主計 *Gō.* Katen 花顛 *S.* Nagasaki school. Pupil of Gekko, painter in Nagasaki. *L & C.* Born in Kyōto. *Sp.* cherry-blossoms. *Repr.* B. 28, 51.

Katsumochi see Matabē.

Katsushige 勝重 (d. 1673) *N.* Iwasa Katsushige 岩佐勝重 *F. N.* Gembē 源兵衞 *S.* Pupil of his father, Katsumochi. *L & C.* Lived in Fukui. Painted many cranes on the sliding doors in Fukui Castle which was repaired in 1669.

Repr. K. 357, 478.

Kawakami Kan 川上寛 (1827–1881) *N.* Kawakami Kan 川上寛 *A.* Shiritsu 子栗 *F. N.* Mannojō 萬之丞 *Gō.* Tōgai 多崖 *S.* Western style. Studied Shijō school under Ōnishi Chinnen, and learned oil-painting by himself. *L & C.* Born in Nagano prefecture, and lived in Tōkyō. Professor at the former Imperial University. Attached to the General Staff Office. A hanging committee of the first Naikoku Kangyō Hakurankai Exhibition.

Repr. B. 79. Seiga-shinan 西畫指南.

Kawakita Michisuke 河北道介 (1850–1907) *N.* Kawakita Michisuke 河北道介 *S.* Western style. Pupil of Kawakami Tōgai. *L & C.* Lived in Tōkyō. Travelled in Europe, and studied paintings in Western style in Paris. Chosen a hanging committee of the International Exhibition at Paris in 1900. Professor at Military Academy of Japan.

Kawamura Kiyo-o 川村清雄 (1852–1934) *N.* Kawamura Kiyo-o 川村清雄 *S.* Western style. Pupil of Kawakami Tōgai. *L & C.* Born and lived in Tōkyō. Travelled in Europe and studied oil-painting at Art School in Venice. Never painted for any exhibition, but still wildly known as a distinguished painter. *Sp.* portraits.

Kawanari 河成 (782–853) *N.* Kudara Kawanari 百済河成 *L & C.* Said to be a descendant of a Korean naturalized as a Japanese. One of the distinguished painters of the Heian period. Said to have painted skilfully landscape, grass and trees, and figures as if they were real.

Kayō 華陽 (flourished in c. 1840) *N.* Shirai Kagehiro 白井景広 *A.* Shijun 子潤 *Gō.* Kayō 華陽 Baisen 梅泉 *S.* Pupil of Ganku. *L & C.* Born in Echigo. Wrote "Gajō Yōryaku" 畫乗要略. (one of the distinguished books on painting). *Sp.* birds and animals.

Kazan 華山 (1784–1837) *N.* Yokoyama Isshō 横山一章 *A.* Shunrō 舜朗 *Gō.* Kazan 華山 *S.* Pupil of Ganku. Influenced by Matsumura Gekkei. Developed his own style. *L & C.* Lived in Kyōto. *Sp.* figures.
Repr. K. 123.

Kazan 崋山 (1793–1841) N. Watanabe Sadayasu 渡邊定靜 A. Shian 子安 Hakuto 伯登 F. N. Nobori 登 Gō. Kazan 華山 崋山 Gūkaidō 寓繪堂 Zenrakudō 全樂堂 Sakuhi-koji 昨非居士 Kintonkyo 金暾居 Zuian-koji 隨安居士 S. Nanga school. Distinguished painter of the Edo period. Pupil of Bunchō. His pupils: Chinzan, Hanko, etc. Taking the good points of Nanga and Western styles, developed his own one. L & C. Born in Edo. Served lord Miyake, a samurai of the clan of Tawara. In 1179, falsely charged by Tokugawa government, he was confined to his home in Tawara and committed suicide there in 1841. Sp. flowers-and-birds, portraits.

Repr. B. 18, 64, 83, 86, 105, 106, 107. K. 100, 117, 137, 141, 210, 211, 225, 226, 230, 235, 239, 245, 252, 277, 288, 291, 297, 302, 311, 352, 383, 411, 431, 438, 443, 448, 452, 456, 484, 494, 500, 514, 532, 535, 541, 550, 557, 564, 579, 582, 587, 593, 600. N. 74. Kazan-sensei-gafu 崋山先生畫譜 Watanabe Kazan 渡邊崋山 Watanabe Kazan Ibokujo 渡邊崋山遺墨帖

Kazunobu 一信 (c. 1740) N. Kanō Kazunobu 狩野一信 F. N. Kumenosuke 久米之助 Gō. Chinshidō 珍止堂 Hakuchisō 白雉叟 **Hakusan**-yajin 薄散野人 Shōunsai-risshi 松雲齋立支 S. Kanō school. Pupil of his father, Shōun. L & C. Lived in Tsukushi and served lord of Tsukushi.

Keibun 景文 (1779–1843) N. Matsumura Keibun 松村景文 A. Shisō 子藻 F. N. Kaname 要人 Gō. Kakei 華溪 S. Shijō school. Studied under his brother. L & C. Lived in Kyōto. The youngest brother of Goshun. Associated

with Koishi Genzui, a Confucian. Versed in the art theory of the Ming and Ching dynasties. *Sp.* flowers-and-birds.

 Repr. K. 37, 50, 79, 124, 156, 169, 197, 237, 273, 357, 412, 455, 480, 496, 528, 573, 592, 595.

Keiga 慶賀 (c. 1890) *N.* Kawahara Keiga 川原慶賀. *L & C.* Lived in Nagasaki. He made many realistic paintings by Siebold's request. *Repr.* B. 12. 65

Keikoku 桂谷 (1842–1920) *N.* Gejō Masao 下條正雄 *Gō.* Keikoku 桂谷 *S.* Nanga School. Japanese style. *L & C.* Lived in Tōkyō. Member of Nippon Bijutsu Kyōkai. *Sp.* landscape.

 Repr. Keikoku Gashū 桂谷畫集.

Keinen 景年 (1845–1924) *N.* Imao Eikan 今尾永歡 *A.* Shiyū 子裕 *Gō.* Keinen, 景年 Yōsosai 養素齋 *S.* Japanese style. Pupil of Suzuki Hyakunen. *L & C.* Lived in Kyōto. Member of Imperial Art Committee and of Teikoku Bijutsu-in. *Sp.* flowers-and-birds.

 Repr. Keinen-bokka. 景年墨華.

Keinin 慶忍 (13th cent.) *N.* Sumiyoshi Keinin 住吉慶忍 *S.* Yamatoye school. *L & C.* The inscription at the last part of the scroll of "Kako-genzai Inga-kyō" 過去現在因果經 made in 1252 tells that it was painted by him and his son Shōju-maru. 聖衆丸. His name was mistaken as Keion 慶恩 by later painters and students of art history.

 Repr. K. 178. N. 46. (Keion K. 182, 222, 313)

Keiō See Unchiku.

Keion 慶恩 See Keinin.

Keisai 蕙齋 (1761–1824) *N.* Kuwagata Keisai 鍬形蕙齋 *F.N.*
Sanjirō 三次郎 *Gō.* Kitao Masami 北尾政美 Keisai 蕙齋
Shōshin 紹眞 *S.* Ukiyoye school. Pupil of Kitao Shi-
gemasa. *L & C.* Born and lived in Edo. He has done
sketches of many places in Edo, in Kanō style. Studied
under Kitao Shigemasa. Later served Lord Matsudaira.
Became a priest, and was called Kuwagata Shōshin. *Sp.*
genre (rather humorous).

Repr. K. 63, 110.

Keisai 圭齋 (c. 1820) *N.* Ōnishi In 大西允 *A.* Shukumei 叔
明 *Gō.* Yūkei 幽溪 Issa Enkaku 一簑烟客 Shōchidōjin
小痴道人 *S.* Nanga school. Pupil of Bunchō. *L & C.*
Lived in Edo. *Sp.* flowers-and-birds.

Keisen 溪仙 (1879–1935) *N.* Tomita Shigegorō 富田鎭五郎 *Gō.*
Keisen 溪仙 Keisanjin 溪山人 *S.* Japanese style. Pupil
of Tsuji Kakō. *L & C.* Lived in Kyōto. Member of the
Nippon Bijutsu-in and of the Teikoku Bijutsu-in. *Sp.*
landscape and flowers-and-birds.

Repr. Keisanjin Isaku-shū 溪山人遺作集

Keishoki See Shōkei.

Keishū See Hiromasa.

Keison 啓孫 (15th–16th cent.) *N.* Keison 啓孫 *Gō.* Kyūgetsusai
休月齋 *S.* Muromachi Suiboku school.

Repr. K. 422, 436.

Keizan 慶山 (d. 1723) *N.* Ohara Keizan 小原溪山 *Gō.* Keizan
慶山 Kakō 霞光 *S.* Nagasaki school. Studied Kanō
school when young. *L & C.* Born in Ohara in Yamashiro.
Lived in Nagasaki. His paintings were praised by Nan-
pin. *Sp.* flowrs-and-firds.

Ken See Chikuden.

Kenkadō See Sonsai.

Kensai 顯齋 (1802–1856) *N.* Hirai Shin 平井忱 *A.* Kimpu 欽夫 *F. N.* Jiroku 治六 *Gō.* Kensai 顯齋 Sankoku-Sanshō 三谷山樵 *S.* Nanga school. Pupil of Bunchō, Kazan and Aigai. *L & C* Born in Tōtōmi. When Kazan, his teacher, was placed in confinement by the Shognate government, he consoled him together with his friend Hankō.

Kenzan 乾山 (1663–1743) *N.* Ogata Shinsei 尾形深省 *A.* I-in 惟允 *F. N.* Kenzan 乾山 *Cō.* Shō o 尚占 Shūseidō 習靜堂 Shisui 紫翠 Reikai 靈海 Tōin 陶隱 *S.* Kōrin school. Studied under his elder brother, Kōrin. *L & C.* Lived in Kyōto. Often wrote inscriptions and poems on his works. Skilled in making pottery, versed in tea-ceremony, and pottery done by Kenzan is called Kenzan-yaki 乾山燒. *Sp.* flowers-and-birds.

 Repr. B. 85. K. 54, 69, 131, 170, 185, 189, 250, 420, 488.

Ki See Chikuseki.

Ki See Genki.

Kichi 幾馳 (15th cent?) *N.* Kichi 幾馳 *S.* Muromachi Suiboku school. Pupil of Sesshū (?) *L & C.* Life is unknown, but, his name is found in Kōtei's "Kogabikō."

Ki-en 淇園 (1706–1758) *N.* Yanagisawa Rikyō 柳澤里恭 *A.* Kōbi 公美 *F. N.* Gondayū 權太夫 *Gō.* Ki-en 淇園 Chikukei 竹溪 Gyokukei 玉桂 *S.* Nanga school. One of the founders of Nanga school. *L & C.* Lived in Yamato. Principal retainer of the clan of Kōriyama. Skilled in various arts. *Sp.* landscape, figures, flowers-and-birds.

 Repr. K. 119, 122, 203, 482.

Ki-en 淇園 (1734–1807) *N.* Minagawa Gen 皆川愿 *A.* Hakukyō 伯恭 *F. N.* Bunzō 文藏 *Gō.* Ki-en 淇園 Yūhisai 有非齋 Kyōsai 筇齋 Donkai 吞海 *S.* Pupil of Gyokusen. Later studied under Ōkyo. *L & C.* Lived in Kyōto. Confucian. Wrote many books. *Sp.* landscape, orchids and bamboos.

Kigyoku 龜玉 (d. 1756) *N.* Kurokawa Yasusada 黑川安定 *A.* Shiho 子保 *F. N.* Mangorō 萬五郎 *Gō.* Shōrakan 松蘿館 Shōzanshoshi 商山處士 *S.* Pupil of Kanō Kyūshin. Later followed Okamoto Zen-etsu. *L & C.* Born in Edo. Lived a characteristic life in Edo.

Kiitsu 其一 (1796–1858) *N.* Suzuki Motonaga 鈴木元長 *A.* Shi-en 子淵 *F. N.* Tamesaburō 為三郎 *Gō.* Kiitsu 其一 Kaikai 噲々 Seisei 齊々 *S.* Kōrin school. Pupil of Sakai Hōitsu. *L & C.* Lived in Edo. Adopted son of Suzuki Reitan. As his father was a *samurai* attached to the Sakais he served Hōitsu and studied under him. Found the technique of *Murasaki-zome* 紫染 (dyeing purple). *Sp.* figures, flowers-and-birds.

Repr. K. 79, 103, 359.

Kikumaro See Tsukimaro.

Kimitada 公忠 (flourished c. 950) *N.* Kose Kimitada 巨勢公忠 *S.* Yamatoye school. *L & C.* Seems to have been a son or grandson of Kanaoka. One of the distinguished Court-painters of the Heian period.

Kinkai See Gitō.

Kinkoku 金谷 (18th cent.) *N.* Yokoi Myōdō 横井妙憧 *Gō.* Kinkoku 金谷 *S.* Nanga school. Pupil of Buson. *L & C.* Lived at Ōtsu in Ōmi.

Kinkoku 琴谷 (1811–1873) *N.* Yamamoto Ken 山本謙 *A.*

Shijō 子讓 *Gō.* Chichisai 癡々齋 *S.* Nanga school. Pupil of Kazan. *L & C. Samurai* of Lord Kamei in Iwami. Went to Edo where he studied paintings under Kazan. *Sp.* landscape.

Kinryō 金陵 (d. 1817) *N.* Kaneko Inkei 金子允圭 *A.* Kunshō 君璋 *Gō.* Kinryo 金陵 Jitsu-u-tei 日雨亭 *S.* Nanga school. Pupil of Tani Bunchō. *L & C.* Lived in Edo. *Sp.* flowers-and-birds.

Kirei 規禮 (1770–1835) *N.* Kameoka 龜岡 *A.* Shikyō 子恭 *F. N.* Kijūrō 喜十郎 *Gō.* Kirei 規禮 *S.* Maruyama school. Pupil of Ōkyo. *L & C.* Lived in Kyōto. *Sp.* landscape, flowers-and-birds.

Kishida Ryūsei 岸田劉生 (1891–1929) *N.* Kishida Ryūsei 岸田劉生 *S.* Western style. Studied paintings in Hakuba-kai-kenkyūjo. *L & C.* Born and lived in Tōkyō. Founded Sōdosha 草土社; and later Shunyō-kai 春陽會 together with his friends. *Sp.* figures.

 Repr. Ryūsei-gashū-oyobi-geijutsukan 劉生畫集及藝術觀.

Kitsu See Hankō.

Kiusai See Kagei.

Kiyochika 清親 (1847–1915) *N.* Kobayashi Kiyochika 小林清親 *Gō.* Kiyochika 清親 *S.* Japanese style. Ukiyoye school. *L & C.* Lived in Tōkyō. *Sp.* genre (prints).

Kiyohara Tama 清原玉 (1861–1939) *N.* Kiyohara Tama 清原玉 *Gō.* Eleonora Ragusa. *S.* Western style. Studied painting in Japanese style first, and later painting in Western style under Vincenzo Ragusa. Travelled in Italy where studied under S. Lo Forte. *L & C.* Born in

Tōkyō. Lived at Palermo in Italy and later in Tōkyō.
Won the best prize in the International Exhibition in
New York and in the Exhibition at Venice. *Sp.* still-life.
Repr. Ragusa Tama-Jijoden ラグーザ玉自叙傳.

Kiyoharu 清春 (18th cent.) *N.* Kondō Kiyoharu 近藤清春 *F. N.*
Sukegorō 助五郎 *S.* Ukiyoye school. Pupil of Kiyonobu.
L & C. Lived in Edo. Illustrated many story-books.
Wrote humorous stories. *Sp.* female figures.

Kiyomasu 清倍 (1706–1763) *N.* Torii Kiyomasu 鳥居清倍 *F.*
N. Shōjirō 庄二郎 *S.* Ukiyoye school. Son (or brother)
of Kiyonobu. The second painter of Torii school. *L &*
C. Lived in Edo. Skilled in making Tanye, Urushiye,
Beniye.

Kiyomine See Kiyomitsu II.

Kiyomitsu I 清満 (1735–1785) *N.* Torii Kiyomitsu 鳥居清満 *S.*
Ukiyoye school. Pupil of his father, Kiyomasu. The
third of the Torii family. *Sp.* play-scenes female figures
(Beniye). *L & C.* Lived in Edo. *Repr.* K. 396.

Kiyomitsu II 清満 (1787–1868) *N.* Torii Kiyomitsu the second
鳥居清満 (二世) *F. N.* Shōnosuke 庄之助 *Gō.* Kiyominè
清峰 Seiryūken 青龍軒 *S.* Ukiyoye school. Pupil of
Kiyonaga. *L & C.* Lived in Edo. Made prints, when
young, under the name of Kiyomine. But later chiefly
painted actors and play-scenes under the name of Kiyo-
mitsu the second. *Sp.* play-scenes.

Kiyomoto 清元 (1645–1702) *N.* Torii Kiyomoto 鳥居清元 *S.*
Ukiyoye school. His teacher is unknown. *L & C.* Lived
in Ōsaka and died in Edo. *Sp.* play-scenes.

Kiyonaga 清長 (1752–1815) *N.* Seki Shinsuke 關新助 *F. N.*
Shirakoya Ichibē 白子屋市兵衛 *Gō.* Torii Kiyonaga
鳥居清長 *S.* Ukiyoye school. Pupil of Torii Kiyomitsu.
L & C. Born in Uraga. Went to Edo, where became
a pupil of Kiyomitsu. After the death of his teacher
he was adopted by his family, and inherited the estate
of Torii. *Sp.* female figures. *Repr.* K. 300, 456, 509.

Kiyonobu 清信 (1664–1729) *N.* Torii Kiyonobu 鳥居清信 *S.*
Ukiyoye school. Pupil of his father, Kiyomoto. Influ-
enced by Moronobu. *L & C.* Lived in Edo. Skilled in
making prints, Tanye, and Urushiye. *Sp.* play-scenes
and actors. *Repr.* K. 390, 418.

Kiyoshi See Shūkei.

Kiyoshige 清重 (c. 1720–c. 1760) *N.* Torii Kiyoshige 鳥居清重
S. Ukiyoye school. Pupil of Kiyonobu I. *L & C.* Lived
in Edo. *Sp.* portraits of actors.

Kiyotada 清忠 (18th cent.) *N.* Torii Kiyotada 鳥居清忠 *S.*
Ukiyoye school. Pupil of Kiyonobu. *L & C.* Lived in
Edo, where lived also Kiyotada II and Kiyotada III.

Kiyotsune 清經 (end of 18th cent.) *N.* Torii Kiyotsune 鳥居清
經 *F. N.* Nakajimaya Daijirō 中島屋大次郎 *S.* Ukiyoye
school. Pupil of Kiyomitsu. *L & C.* Born in Edo. Illu-
strated many story-books.

Kōanshōshi See Kyōsho.

Kōbi See Ki-en.

Kōchōro See Kunisada.

Kōetsu 光悦 (1558–1637) *N.* Hon-ami Kōetsu 本阿彌光悦 *F. N*
Jirosaburō 次郎三郎 *Gō.* Taikyoan 大虚庵 Jitokusai 自得
齋 Kūchūan 空中庵 Tokuyūsai 德友齋 *S.* Pupil of Eitoku

(or of Yūshō). Later accomplished his own style. *L & C.*
Lived at Takagamine in Kyōto. Skilled in the technique
of *makie* 蒔繪 and calligraphy. *Sp.* flowers-and-birds
(rather decorative).

Repr. K. 62, 207, 562. Kōetsu & Shōkadō 光悦・松花堂

Kōfuyō See Fuyō.

Kōgyō 廣業 (1866–1919) *N.* Terazaki Hironari 寺崎廣業 *Gō.*
Sōzan 宗山 Tenrai Sanjin 天籟散人 *S.* Japanese style.
Kanō school. Pupil of Komuro Hidetoshi. Later com-
pleted his own style. *L & C.* Lived in Tōkyō. Professor
of the Tōkyō Art School and member of the Imperial
Art Committee. *Sp.* landscape, figures and flowers-
and-birds.

Repr. B. 75. Kōgyō Gafu. 廣業畫譜.

Kōho 光甫 (1601–1682) *N.* Hon-ami Kōho 本阿彌光甫 *Gō.* Kū-
chūsai 空中齋 *S.* Studied under his father, Kōsa and
grandfather Kōetsu. *L & C.* Lived in Kyōto. Versed in
tea-ceremony and skilled in making potteries. Nominated
to Hōgen in 1641. Wrote " Hon-ami Gyōjōki " (the me-
mory of his grand-father) 本阿彌行狀記.

Repr. K. 5, 67.

Kohō See Shummei.

Kōi 與以 (d. 1636) *N.* Kanō Kōi 狩野與以 *A.* Chūri 中里 *S.*
Kanō school. Pupil of Mitsunobu. *L & C.* Served Lord
Tokugawa at Kii, educating Takanobu's three sons,
Tan-yū, Naonobu, Yasunobu, all of whom became great
painters of Kanō school in the early Edo period.

Repr. K. 29, 94, 103, 139, 235, 287, 340, 399, 423, 433, 598.
N. 20.

Koide Narashige 小出楢重 (1887–1931) *N.* Koide Narashige
小出楢重 *S.* Western style. Studied at Imperial Art
School. *L & C.* Lived in Tōkyō. Member of Nika-kai.
Repr. Koide Narashige Gashū 小出楢重畫集, Koide
Narashige Sōgashū. 小出楢重挿畫集

Kōin 孔寅 (1765–1849) *N.* Nagayama Kōin 長山孔寅 *A.* Shi-
ryō 子亮 *Gō.* Kōen 紅園 Gorei 五嶺 Bokusai 牧齋 *S*
Shijō school. Pupil of Gekkei. *L & C.* Born at Akita
in Dewa. Lived in Ōsaka, skilled in making comic
tanka (poem) as well as painting.

Kojima Torajirō 兒島虎次郎 (1881–1929) *N.* Kojima Torajirō
兒島虎次郎 *S.* Western style. Graduated from Tōkyō
Art School, and travelled in France where studied un-
der Edmond Aman-Jean. *L & C.* Lived in Okayama. A
member of hunging committee of Teiten Exhibition.

Kokan 古礀 (1653–1717) Priest name: Myōyo 明譽 *Gō.* Kyo-
shū 虚舟 Kokan 古礀 *S.* Kanō school. Pupil of Einō.
L & C. Chief priest of Hōonji Temple in Kyōto. *Sp.*
Buddhistic painting, cartoon.

Kōkan 江漢 (1747–1818) *N.* Shiba Shun 司馬峻 *A.* Kungaku
君嶽 *F. N.* Andō Kichijirō 安藤吉次郎 or Katsusaburō 勝
三郎 *Gō.* Kōkan 江漢 Fugen-dōjn 不言道人 Shumparō
春波樓 Rantei 蘭亭 Suzuki Harushige 鈴木春重 *S.* Yōga
school. Pupil of Sō-Shiseki, Suzuki Harunobu and Hiraga
Gennai. *L & C.* First painter in Japan who tried the
copperplate engravings. Wrote " Shumparō Hikki " 春
波樓筆記 (the memorandum of Kōkan) and " Nagasaki
Ken-monshi " 長崎見聞志 (the record of his travel in

Nagasaki). *Sp.* landscape, figures. (Ukiyoye prints and
painting in Western style.)

Repr. K. 219, 336, 385, 544, 570.

Kōkei 孝敬 (1769-1836) *N.* Yoshimura Kōkei 吉村孝敬 *A.*
Mui 無違 *F. N.* Yōzō 要藏 *Gō.* Ranryō 蘭陵 Ryūsen 龍
泉 *S.* Maruyama school. Pupil of Ōkyo. *L & C.* Lived
in Kyōto *Sp.* flowers-and-birds. *Repr.* K. 514.

Kon See Nanko.

Korehisa 惟久 (flourished in 14th cent.) *N.* Korehisa 惟久 *S.*
Yamatoye school. *L & C.* His life is unknown. But his
name is found in the inscription of the scroll of " Gosan-
nen Kassen Ekotoba " 後三年合戰繪詞 (The War at
Tōhoku district in late Fujiwara period) (Coll. Marquis
Ikeda)

Repr. K. 202. N. 2, 80.

Korenobu 伊信 (13th cent.) *N.* Fujiwara Korenobu 藤原伊信 *S.*
Yamatoye school. *L & C.* Lived in Kyōto. Grand-son of
famous Nobuzane.

Kōrin 光琳 (1633-1743) *N.* Ogata Koretomi 尾形惟富 *F. N.*
Kariganeya Tōjūro 雁金屋藤重郎 Katsuroku 勝六 *Gō.*
Hōshuku 方祝 Kōrin 光琳 Jakumei 寂明 Dōsū 道崇 Kan-
sei 澗聲 Iryō 伊亮 Seiseidō 青々堂 Chōkōken 長江軒 *S.*
Distinguished painter. Founder of Kōrin school. Stu-
died under Yamamoto Soken when young. Influenced
by Sōtatsu and Kōetsu. But later founded his original
style. *L & C.* Born in Kyōto and lived in Edo. Excelled
in calligraphy, painting and the technique of *makiye* 蒔繪.
And also good at making ink-stone boxes and tea

things. Was nominated to Hokkyō. *Sp.* flowers-and-birds (rather decorative).

Repr. B. 14, 25, 37, 59, 60, 66, 73, 76, 85. K. 32, 57, 70, 81, 88, 89, 102, 117, 125, 127, 142, 145, 155, 165, 172, 177, 181, 188, 197, 199, 201, 203, 216, 221, 225, 228, 233. 236, 241, 264, 289, 292, 299, 312, 315, 337, 340, 352, 377, ·382, 417, 430, 436, 472, 518, 533, 558. N. 44, 49, 59, 61. Kōrin-zuroku 光琳圖錄 Ogata Kōrin 尾方光琳.

Koryūsai 湖龍齋 (flourished in the latter half of 18th cent.) *N.* Isoda Masakatsu 磯田政勝 *F. N.* Shōbē 庄兵衞 *Gō.* Koryūsai 湖龍齋 *S.* Ukiyoye school. Pupil of Shigenaga. Influenced by the techniqne of Harunobu. *L & C.* Lived in Edo. Nominated to the rank of Hokkyō in 1731. *Sp.* female figures. *Repr.* K. 100, 317.

Kōsai See Itsuun.

Kōseidō See Chūan.

Kōsetsu 浩雪 (1800–1853) *N.* Sakamoto Chokudai 坂本直大 *A.* Ōu 櫻宇 *F. N* Kōzen 浩然 *Gō.* Kōsetsu 浩雪 Shōsōrinsho 嘗草林處 Kōson 香邨 *S.* Studied Kanō school. *L & C.* Doctor in the clan of Kii. Learned botany and painting. In his late years, disliked minute paintings and was fond of painting orchids roughly. *Sp.* cherry-blossoms.

Koson 孤村 (1801–1866) *N.* Ikeda Sanshin 池田三辰 *A.* Shūji 周二 *Gō.* Koson 孤村 Gasen-ken 畫戰軒 Kyūshōken 舊松軒 *S.* Pupil of Hōitsu. *L & C.* Born in Echigo. At an early age went to Edo where he learned the technique of Hōitsu, but later, changed his style as he studied Chinese pictures of the Ming dynasty. Lived in Edo.

Repr. K. 275.

Kōsuisai See Shigemasa.

Kōtei 興禎 (1800–1856) *N.* Asaoka Kōtei 朝岡興禎 *F. N.* San-
jirō 三次郎 *Gō.* Heishū 平洲 Sanraku 三樂 *S.* Kanō
school. Pupil of his father, Isen-in *L & C.* Lived in
Edo. Wrote " Koga-bikō " 古畫備考 (the most famous
biography of Japanese painters of the Edo period. This
index is indebted to his biography for much of its data.)

Kōun 高雲 (flourished c. 1670) *N.* Kōtari Kōun 神足高雲
F. N. Zen-emon 善右衞門 *Gō.* Yūsan 幽讃 Jōan 常庵 *S.*
Kanō school. Pupil of Tan-yū. *L & C.* Served Lord
Uesugi.

Kōunsai 耕雲齋 (1803–1865) N. Takeda Seisei 武田正生
F. N. Iganokami 伊賀守 *Gō.* Kōunsai 耕雲齋 Jo-un 如雲
L & C. Royalist of the clan of Mito. Painted as a hobby.

Kōya 興也 (d. 1672) *N.* Kanō Kōya 狩野興也 (Hakuho 伯甫)
F. N. Ri-emon 利右衞門 Gyōbu 刑部 *S.* Kanō school.
Pupil of his father Kōi. *L & C.* Lived in Edo (?) Se-
cond son of Kōi. Served Lord Mito. Appointed to
Hokkyō..

Repr. K. 42

Koyama Shōtarō 小山正太郎 (1857–1916) *N.* Koyama Shōtarō
小山正太郎 *Gō.* Senraku 先樂 *S.* Western style. Pupil
of Kawakami Tōgai. Later studied under Antonio Fon-
tanesi in Technological Art School. *L & C.* Lived in
Tōkyō. Founded a private art school called Fudōsha
and educated many pupils. Lecturer at Tōkyō Higher
Normal School. A hanging committee of former Bunten
Exhibition.

Repr. Koyama Shōtarō-sensei 小山正太郎先生.

Kōyō 高陽 (1717–1780) *N.* Nakayama Kiyoshi 中山清 *A.*
Jogen 汝玄 *F. N.* Sei-emon 清右衞門 *Gō.* Kōyō 高陽
Suiboku-sanjin 醉墨山人 Gansei-dōjin 玩世道人 Shō-
sekisai 松石齋 *S.* Nanga school. Said to be a pupil of
Hyakusen. *L & C.* Born in Tosa. Lived in Tosa and later
in Edo. Fond of painting from his youth. Went to Edo
to study painting and calligraphy. Associated with such
famous calligraphers as Kinga or Tōkō. *Sp.* landscape
and figures. *Repr.* B. 32.

Kōzen See Unshitsu.

Kūchūsai See Kōho.

Kūkai 空海 (774–835) Priest name: Kūkai 空海 *F. N.* Kōbō-
daishi 弘法大師 *L & C.* Very famous priest who founded
Shingon-sect. Excelled in calligraphy and also in
Buddhistic Painting.

Kume Keiichirō 久米桂一郎 (1866–1934) *N.* Kume Keiichirō
久米桂一郎 *S.* Western style. Pupil of Fuji Gazō and
of Raphael Collin. *L & C.* Born in Saga prefecture,
and lived in Tōkyō. Professor of Tōkyō Art School.
Founded Tenshin-dōjō with Kuroda Seiki and educated
many followers. Also founded Hakubakai. Was very
active in the field of art as a manager of Teiten Exhibi
tion. *Sp.* landscape.

Repr. Kume Keiichirō Sakuhin-shū. 久米桂一郎作品集

Kuni See Beisanjin.

Kunimaru 國丸 (1794–1830) *N.* Utagawa Kunimaru 歌川國丸
F. N. Iseya Ihachi 伊勢屋伊八 *Gō.* Ichi-ensai 一圓齋 Go-
sairō 五彩樓 Honchōan 翻蝶庵 Keiun-tei 輕雲亭 Saikarō
彩霞樓 *S.* Ukiyoye school. Pupil of Toyokuni. *L & C.*

Lived in Edo. Fond of *haikai* (short poems). Associated with people of the upper class. Spent a free life unhampered by the common cares of the world. *Sp.* portraits of actors.

Kunimasa 國政 (1773–1810) *N.* Utagawa Kunimasa 歌川國政 *F. N.* Jinsuke 甚助 *Gō.* Ichijusai 一壽齋 *S.* Ukiyoye school. Pupil of Toyokuni. *L & C.* Born in Aizu. Lived in Edo. Known as a portrait-painter. *Sp.* portraits of actors (print).

Kuninao 國直 (1793–1854) *N.* Utagawa Kuninao 歌川國直 *F. N.* Taizō 鯛藏 *Gō.* Ukiyo-an 浮世庵 Ichi-ensai 一煙齋 Dokusuisha 獨醉舍 Enryūrō 煙柳樓 Shashinsai 寫眞齋 *S.* Ukiyoye school. Pupil of Toyokuni. Followed the technique of Hokusai. *L & C.* Born in Shinano. Went to Edo where studied under Toyokuni. Illustrated many story-books.

Kunisada 國貞 (1786–1864) *N.* Tsunoda Kunisada 角田國貞 *F. N.* Shōzō 庄藏 *Gō.* Utagawa Kunisada 歌川國貞 Utagawa Toyokuni the third 歌川豐國 (三代) Shōzō 肖造 Ichiyūsai 一雄齋 Gototei 五渡亭 Kōchōrō 香蝶樓 Kinraisha 琴雷舍 Gepparō 月波樓 *S.* Ukiyoye school. Pupil of Toyokuni the first. Later influenced by the technique of Itchō. *L & C.* Born at Katsushika in Musashi and lived in Edo. When 15 years old, became a pupil of Toyokuni, and painted illustrations in story-books and portraits of actors. Later he studied under Ikkei loving the technique of Ikkei's great-grand-father Itchō.

Kunisawa Shinkuro 國澤新九郎 (1847–1877) *N.* Kunisawa Shinkurō 國澤新九郎 *S.* Western style. Studied pain-

ting in Western style in London. *L & C.* Born in Kōchi prefecture and lived in Tōkyō. Founded a private art school called Shōgi-dō-gajuku and taught oil-painting to his pupils.

Kunishige See Toyokuni II.

Kuniyoshi 國芳 (1797–1861) *N.* Igusa Kuniyoshi 井草國芳
F. N. Magosaburō 孫三郎 Tarōemon 太郎右衛門 *Gō.* Utagawa Kuniyoshi 歌川國芳 Ichiyūsai 一勇齋 Chōōrō 朝櫻樓 *S.* Ukiyoye school. Pupil of Toyokuni. Studied Tosa, Kanō and Maruyama schools, founded his own style. *L & C.* Lived in Edo. Made many prints. As his style suited the taste of young men of that time, they often asked him to tattoo his paintings on their bodies. *Sp.* figures (actors, *samurai*).

Kurata Hakuyō 倉田白羊 (1881–1938) *N.* Kurata Shigeyoshi 倉田重吉 *Gō.* Hakuyō 白羊 *S.* Western style. Pupil of Asai Chū. Graduated from Tōkyō Art School. *L & C.* Born in Saitama prefecture, lived in Nagano prefecture. Member of Nippon Bijutsu-in and of Shunyōkai *Sp.* landscape.

Kuroda Seiki 黒田清輝 (1866–1924) *N.* Kuroda Seiki 黒田清輝 *Gō.* Seiki 清輝 *S.* Western style. Studied under Raphael Collin. *L & C.* Lived in Tōkyō. Founded a private school called Tenshin-dōjō, and educated many pupils. Promoted the development of painting in Western style. Member of the Imperial Art Committee. President of Imperial Art Academy. Professor at Tōkyō Art School. *Sp.* figures and landscape.

Repr. B: 6, 24, 88, 101, 102. Kuroda Seiki Sakuhin-zenshū

黒田清輝作品全集 Kuroda Seiki Sakuhin-shūzō-mokuroku
黒田清輝作品收藏目錄.

Kyōden See Masanobu.

Kyoroku 許六 (1656–1715) *N*. Morikawa Hyakuchū 森川百仲 *A*.
Ukan 羽官 *F.N.* Gosuke 五助 *Gō*. Kyoroku 許六 Kikuabutsu,
菊阿佛 Ragetsudō 蘿月堂 Josekishi 如石子 Rokurokusai
碌々齋 *S*. Pupil of Yasunobu. *L & C*. As a painter he
served Lord Ii in Hikone. Studied *haikai* (short poem)
under Bashō. His paintings were said to have been
loved by the *haikai* poets.

 Repr. K. 168, 389, 480

Kyōsho 杏所 (1785–1840) *N*. Tachihara Nin 立原任 *A*. Enkei
遠卿 *F.N.* Jintarō 甚太郎 *Gō*. Kyōsho 杏所 Tōken 東軒
Gyokusōsha 玉璅舍 Kōanshōshi 杏案小史 *S*. Nanga
school. Pupil of Tani Bunchō. *L & C. Samurai* of the
clan of Mito. Son of a confucian, Suiken. Kazan
and Chinzan were his intimate friends. *Sp.* landscape,
flowers-and-birds.

 Repr. B. 96. K. 373, 393, 420, 423, 440, 458, 476, 487, 509,
 531, 548, 553, 562, 584, 598. Kyōsho & Chinzan 杏所・椿
 山.

Kyō-u 杏雨 (1810–1884) *N*. Hoashi En 帆足遠 *A*. Chitai 致大
F.N. Yōhei 庸平 *Gō*. Kyō-u 杏雨 *S*. Japanese style.
Pupil of Tanomura Chikuden and of Uragami Shunkin.
L & C. Lived in Ōita. *Sp.* landscape.

 Repr. K. 418, 468. Kyō-u Yoteki. 杏雨餘滴.

Kyūhaku 休白 (1577–1654) *N*. Kano Naganobu 狩野長信 *F*.
N. Genshichirō 源七郎 *Gō*. Kyūhaku 休白 *S*. Kano
school. Pupil of his father, Shōei. Painter under the

patronage of the Tokugawa government. *L & C.* Lived
in Suruga B. 37. K. 423, 504, 583. N. 46.

Kyūjo 九如 (1744–1802) *N.* Ido Kōryō 井戸弘梁 (Naomichi 直
道) *A.* Chūgyo 仲漁 *Gō.* Tōkyūjo 董九如 Kōsenkoji 廣
川居士 Kōro-en 黄蘆園 Tonkashitsu 遯窩室 Tonsai 遯齋
S. Nagasaki school. Pupil of Sō Shiseki. *L & C.* Lived
in Edo. *Samurai* attached the Shogunate Government.

Kyūjōsenshi See Chikuden.

Kyūkasanjin See Chūan.

Kyūkasanshō See Taiga.

Kyūrōsanjin See Baitei.

Kyūtokusai See Shun-ei.

Kyūyoku See Mitsuyoshi.

Kyūzō 久藏 (1568–1593) *N.* Hasegawa Kyūzo 長谷川久藏 *S.*
Hasegawa school. Pupil of his father, Tōhaku.

 Repr. K. 16, 48, 521, 564.

Maeda Kanji 前田寛治 (1896–1930) *N.* Maeda Kanji 前田寛治
S. Western school. *L & C.* Born in Tottori prefecture,
and lived in Tōkyō. Graduate of the Tōkyō Art
School. Went to France where studied painting in
western style. Member of Hanging committee of Teiten
Exhibition. *Sp.* figures, landscape.

 Repr. Maeda Kanji Gashū. 前田寛治畫集.

Masaaki See Ganku.

Masakatsu See Koryūsai.

Masami See Keisai.

Masanobu 正信 (1434–1530) *N.* Kanō Masanobu 狩野正信 *F.*
N. Shirojirō 四郎次郎 *Gō.* Yūsei 祐勢. *S.* Kanō school.

L & C. Lived in Kyōto. Son of Kagenobu. Founded Kanō school.

Repr. K. 1, 4, 5, 38, 56, 112, 125, 434, 586. N. 73.

Masanobu 政信 (1690–1768) *N.* Okumura Masanobu 奥村政信 *F. N.* Genroku 源六 Genhachi 源八 *Gō.* Hōgetsudō 芳月堂 Tanchō-sai 丹鳥齋 Bunkaku 文角 Shimmyō 親妙 Baiō 梅翁 *S.* Ukiyoye school. Pupil of Kiyonobu. *L & C.* Lived in Edo. Contributed much to the promotion of Beniye, as he was a copyright holder of Ukiyoye print.

Repr. K. 67.

Masanobu 政演 (1761–1816) *N.* Iwase Sei 岩瀬醒 (Haida Sei 灰田醒) *A.* Yūsei 酉星 *F. N.* Denzō 傳藏 *Gō* Kitao Masanobu 北尾政演 Santō Kyōden 山東京傳 Rissai 葎齋 *S.* Ukiyoye school. Pupil of Shigemasa. *L & C.* Lived in Edo. Wrote several stories and illustrated them.

Masanobu See Tōun.

Masanobu See Shōsen-in.

Matabē 又兵衞 (1578–1650) *N.* Iwasa Matabē-no-jō Shōi 岩佐又兵衞尉勝以 *Gō.* Dōun 道蘊 Unnō 雲翁 Hekishōkyū 碧勝宮 Shōi 勝以 *S.* Tosa school. Believed to be a pioneer of Ukiyoye school, but judging from his works he seems to have belonged to Tosa school. *L & C.* Lived in Fukui. Served Lord Matsudaira in Fukui. Went to Edo. His works: " Thirty-six Great Poets " 三十六歌仙 in Tōshōgū Shrine in Kawagoye city, " Portraits of Hitomaro 人麿 and Tsurayuki 貫之 " (Coll. Mr. Takeoka) " Selfportrait " (Coll. Mr. Takeoka) etc. Died in Edo. *Sp.* classical genre painting.

R(pr. K. 1, 2, 16, 104, 106, 132, 269, 283, 295, 303, 307, 391, 450, 477, 484, 491, 505. N. 17. Hoshigaoka Gashū 星岡畫集

Matora 眞虎 (1794–1833) *N.* Ōishi Matora 大石眞虎 *F. N.* Koizumi Monkichi 小泉門吉 later Ōishi Komonta 大石小門太 *Gō:* Tomonoya 柄舍 Matora 眞虎 Sŧ.ōkoku 樵谷 *S.* Pupil of Gesshō. *L & C.* Lived in Nagoya. *Sp* illustrations.

Minchō 明兆 (1352–1431) *N.* Kitsuzan 吉山 *F. N.* Chōdensu 兆殿㕔 *Gō.* Minchō 明兆 Hasōai 破草鞋 *S.* Muromachi Suiboku school. *L & C.* Lived in Tōfukuji Temple in Kyōto. A distinguished suiboku-painter of that time.

Repr. K. 30, 37, 82, 104, 177, 187, 259, 495, 540, 554. N. 35.

Minenobu 峯信 (1662–1708) *N.* Kanō Minenobu 狩野峯信 *Gō.* Zuisen 隨川 Kakuryūsai 覺柳齋 *S.* Kanō school. *L & C.* Member of the Kano's at Kobikichō in Edo.

Mitsuaki 光顯 (flourished in the latter half of 14th cent.) *N.* Tosa Mitsuaki 土佐光顯 *S.* Tosa school. Called himself a son of Mitsumasa. *L & C.* Lived in Kyōto. Appointed to Tosa *Gonnokami*, rose to Lord of Echizen. Associated with many high officials of his time.

Repr. K. 84.

Mitsukore See Ijū.

Mitsumochi 光茂 (c. 1550) *N.* Tosa Mitsumochi 土佐光茂 *S.* Tosa school. Pupil of his father Mitsunobu. *L & C.* The scroll-painting " Kuwanomi-dera Engi " 桑實寺緣起 (painted in 1534) is one of his excellent works. *Sp.* genre. *Repr.* K. 54, 73, 92, 120. N. 17.

Mitsumoto 光元 (1530–1569) *N.* Tosa Mitsumoto 土佐光元 *S.* Tosa school. Pupil of his father Mitsumochi. *L & C.* Chief painter of Edokoro.

Mitsunaga 光長 (flourished in c. 1173) *N.* Tokiwa Mitsunaga 常盤光長 *S.* Yamatoye school. *L & C.* Painter who attended Court. "Hirano Gyōkei" 平野行啓 (The Visit of the Empress to Hirano Shrine) "Hiye Gyokō" 日吉行幸 (The Visit of the Emperor to the Hiye Shrine) are his good works. "Tomo-no-dainagon Ekotoba" 伴大納言繪詞 (The pictorial scroll of the anecdotes of the distinguished official called Tomo no Dainagon) is also ascribed to him.
Repr. K. 1, 51, 55, 70, 81, 176, 182, 205, 210. N. 52.

Mitsunobu 光信 (c. 1430–c. 1521) *N.* Tosa Mitsunobu 土佐光信 *S.* Tosa school. *L & C.* The chief painter in Edokoro. Painted many scrolls. "Kiyomizudera Engi" 清水寺繰起 (Coll. Tōkyō Imperial Household Museum) "Kitano Tenjin Engi" 北野天神繰起 (Coll. Kitano-jinja Shrine) are his remaining works.

Repr. B. 100, 101, 103. K. 3, 75, 96, 118, 181, 488. N. 64.

Mitsunobu 光信 (1565–1608) *N.* Kanō Mitsunobu 狩野光信 *F. N.* Ukyōnoshin 右京進 *S.* Kanō school. Pupil of his father Eitoku. *L & C.* Lived in Kyōto.

Mitsunori 光則 (1583–1638) *N.* Tosa Mitsunori 土佐光則 Priest-name: Sōjin 宗仁 *S.* Tosa school. Pupil of his father Mitsuyoshi (Kyūyoku). *L & C.* Lived at Sakai in Izumi. Mitsuoki was his son. *Sp.* genre (miniature). *Repr.* K. 56, 518.

Mitsunori 光教 (the beginning of 17th cent.) *N.* Kanō
Mitsunori 狩野光教 *F. N.* Shurinosuke 修理亮 *S.* Kanō
school. Pupil of his father Sanraku.

Mitsuoki 光起 (1617–1691) *N.* Tosa Mitsuoki 土佐光起 *Gō.*
Jōshō 常昭 (as a priest) Shunkaken 春可軒 *S.* Distin-
guished painter of Tosa school. Pupil of his father,
Mitsunori. *L & C.* Lived in Sakai, and went to Kyōto
where he was appointed to *Sakonshōgen* and promoted
to the chief painter of Edokoro. Later, bacame a priest
and changed his name to Jōshō. Nominated to Hōgen
Sp. genre, flowers-and-birds.

Repr. K. 14, 45, 54, 61, 71, 118, 132, 260, 267, 276, 287,
326, 390, 440, 559. Tosa Mitsuoki 土佐光起

Mitsutani Kunishirō 滿谷國四郎 (1874–1936) *N.* Mitsutani
Kunishirō 滿谷國四郎 *S.* Western style. Pupil of
Koyama Shōtarō. *L & C.* Born in Okayama prefecture.
Lived in Tōkyō. Travelled to Europe twice. Member
of Taiheiyō-gakai, and of Teikoku Bijutsu-in.

Repr. Kunishirō Gashū. 國四郎畫集 Mitsutani-ō Gafu. 滿
谷翁畫譜

Mitsuyoshi 光吉 (1539–1613) *N.* Tosa Mitsuyoshi 土佐光吉
F. N. Gyōbu 刑部 *Gō.* Kyūyoku 休翌 Kyūyoku 久翌 *S.*
Tosa school. Pupil of his father, Mitsumochi. *L & C.*
Lived in Kyōto. Chief painter of Edokoro. Often painted
in the Court. Later, became a priest and moved to
Sakai in Izumi. *Sp.* genre (miniature).

Mōhyū See Fuyō.

Mōki See Kangan.

Mokuan 默菴 (d. c 1348) Priest Name: Reien 靈淵 *Gō.* Moku-

an 黙菴 *S.* Muromachi Suiboku school. Pioneer of sui-
boku-painting in the Muromachi period. *L&C.* Zen-priest.
About in the year 1326, went to China and died there.
Repr. B. 19, 70. K. 578.

Mokubei 木米 (1767–1833) *N.* Aoki Yasohachi 青木八十八
later Sahē 佐兵衞 *A.* Seirai 青來 *F. N.* Kiya Sahē 木
屋佐兵衞 *Gō.* Kukurin 九々鱗 Mokubei 木米 Rōbei 璧
米 Kokikan 古器觀 Teiunrō 停雲楼 Hyakurokusanjin 百
六散人 *S.* **Nanga** school. Studied Chinese paintings of
the Ming and Ch'ing dynasties. Influenced by Taiga.
L & C. Born and died in Kyōto. First studied casting,
but later learned the technique of making pottery. As
a potter he served the lord of Kii in 1801, and the
lord of Kaga in 1807. In 1808 founded Awatagama
pottery which belonged to Prince *Shōren-in-no-miya* 青
蓮院宮.
Repr. B. 89, 108. K. 320, 350, 395, 404, 450, 455, 466,
524, 534, 538, 553.

Morikage 守景 (c. 1700) *N.* Kusumi Morikage 久隅守景 *F.
N.* Hanbē 半兵衞 *Gō.* Mugesai 無下齋 Mugesai 無礙齋
S. **Kanō** school. Pupil of Tan-yū. *L & C.* Born in
Kaga and lived in Kyōto. His paintings are different
from those of Itchō who was also a good pupil of Tan-
yū. There is something elegant in his works. *Sp.*
landscape, figures.
Repr. B. 11. K. 24, 50, 66, 96, 106, 110, 121, 158, 172,
184, 186, 205, 221, 341, 359, 406, 426, 437, 541, 554, 568,
592. N. 76.

Morinobu See Tan-yū.

Morita Tsunetomo 森田恒友 (1881–1933)　*N.* Morita Tsune-
tomo 森田恒友　*S.* Western style. Pupil of Koyama
Shōtarō and Nakamura Fusetsu.　*L & C.* Born in
Saitama prefecture and lived in Tōkyō. Graduate of
the Tōkyō Art School, and became a member of
Shun-yō-kai. *Sp.* landscape. (in oil and suiboku).

　Repr. Morita Tsunetomo Gashū.　森田恒友畫集

Moromasa 師政 (18th cent.)　*N.* Furuyama Moromasa 古山
師政　*S.* Ukiyoye school. Pupil of Moroshige.　*L & C.*
Lived in Edo. *Sp.* female figures.

Moronobu 師宣 (d. c. 1694)　*N.* Hishikawa Moronobu 菱川師宣
F. N. Kichibē 吉兵衞　*Gō.* Yūchiku 友竹　*S.* Ukiyoye
school. Distinguished painter. Founded Utagawa
school.　*L & C.* Born in Awa and died in Edo. The
scroll-painting " Gay Quarters and Theatres " 北樓及演
劇圖卷 (Coll. the Imperial Household Museum) is one
of his good works. *Sp.* female figures.

　Repr. K. 17, 62, 74, 174, 219, 229, 363, 378.

Moroshige 師重 (c. 1700)　*N.* Furuyama Moroshige 古山師重
F. N. Tarobē 太郎兵衞　*S.* Ukiyoye school. Pupil of
Moronobu.　*L & C.* Lived in Edo. *Sp.* female figures.

　Repr. K. 479.

Motohide 元秀 (flourished in the beginning of 16th cent)　*N.*
Kanō Motohide 狩野元秀　*F. N.* Jinnojō 甚之丞　*Gō.* Shin-
setsu 眞説　*S.* Kanō school. Pupil of his father Munehide,
Eitoku's younger brother.

　Repr. B. 36. K. 574, 597. N. 69.

Motonobu 元信 (1476–1559)　*N.* Kanō Motonobu 狩野元信
F. N. Shirojirō 四郎次郎　*Gō.* Eisen 永仙 Gyokusen 玉川

S. Kanō school. Pupil of his father Masanobu. Improved the technique of Kanō school taking good points of Tosa school. *L & C*. Lived in Kyōto. Served Shōgun Ashikaga.

Repr. B. 88. K. 5, 38, 73, 81, 110, 113, 116, 137, 142, 146, 150, 155, 161, 166, 170, 171, 175, 179, 183, 198, 204, 213, 218, 231, 245, 337, 372, 388, 431. N. 3, 11, 27, 58, 81, 84. Motonobu Gashū 元信畫集

Muchūan See Ritsuō.

Mugesai See Morikage.

Munenobu 宗信 (1514–1562) *N*. Kanō Munenobu 狩野宗信 *F. N.* Shirojirō 四郎次郎 *Gō.* Yūsei 祐清 Yūsetsu 祐雪 *S*. Kanō school. Pupil of his father Motonobu. *L & C*. Served the Shōgun Ashikaga.

Repr. K. 359.

Murayama Kaita 村山槐多 (1896–1919) *N*. Murayama Kaita 村山槐多 *S*. Western style. Studied under Kosugi Misei in Nippon Bijutsu-in. *L & C*. Born in Yokohama and lived in Tōkyō. The works exhibited in Nippon Bijutsu-in Exhibition and Nika-kai Exhibition were much praised. Excelled in painting both in oil and watercolour, but died young.

Repr. Kaita Gashū 槐多畫集.

Musashi 武藏 (1584–1645) *N*. Miyamoto Musashi 宮本武藏 *Gō.* Niten 二天 *S*. Muromachi Suiboku school. *L & C*. Born in Harima. Son of Shimmen Munisai. Succeeded Miyamotos (*samurai*) that served Katō Kiyomasa. Excelled in military arts, especially in using two swords (*Nitōryū*). So, there is something keen in his picture.

Repr. B. 58; 74. K. 62, 117, 183, 194, 251, 267, 318, 358, 485, 579, 581. N. 67, 75, 84. Miyamoto Musashi Iboku-shū 宮本武藏遺墨集

Mutō See Shūi.

Myōtaku 妙澤 (1308-1388) Priest Name: Ryūshū Shūtaku 龍 湫周澤 *Gō.* (Koken) Myōtaku (古劍) 妙澤 *S.* Muro-machi Suiboku school. *L & C.* Priest who lived in Kokuseiji Temple. *Sp.* Buddhistic subjects (Acala).
Repr. K. 435.

Nagahara Kōtarō 長原孝太郎 (1864-1930) *N.* Nagahara Kōtarō 長原孝太郎 *Gō.* Shisui 止水 *S.* Western style. Pupil of Koyama Shōtarō. *L&C.* Born in Gifu prefecture, and lived in Tōkyō. Professor at Tōkyō Art School. Member of hanging committee of Teiten Exhibition.

Naganobu See Kyūhaku.

Nagataka 長隆 (flourished in the latter half of 13th cent.) *N.* Fujiwara Nagataka 藤原長隆 Name as priest: Kaishin 快心 (or Kaikan 快閑) *S.* Yamatoye school. Pupil of his father Iyenobu. *L & C.* Lived in Kyōto.
Repr. K. 49, 53, 240, 247, 272, 320. N. 72.

Nahiko 魚彦 (1723-1782) *N.* Inō Nahiko 伊能魚彦 *F. N.* Mo-emon 茂右衞門 *Gō.* Seiran 青藍 *S.* Nanga school. Pupil of Yūhi and Ryōtai *L & C.* Born at Katori in Shimo-osa. Excelled in making *haikai* (short poem). Studied classics under Kamo Mabuchi. Called himself Katori Nahiko 楫取魚彦 after the name of his native place. *Sp.* plum-blossoms and carp.

Nakagawa Hachirō 中川八郎 (1877-1922) *N.* Nakagawa Hachirō 中川八郎 *S.* Western style. Pupil of Matsubara

Sangorō and of Koyama Shōtarō. *L & C.* Born in Ehime prefecture and lived in Tōkyō. Travelled in Europe and America where studied painting. Member of hanging committee of former Bunten Exhibition. *Sp.* landscape.

Nakamaru Seijūrō 中丸精十郎 (1841–1896) *N.* Nakamaru Seijūrō 中丸精十郎 *Gō.* Kimpō 金峰 *S.* Western style. Studied painting in Japanese style under Hine Taizan, painting in western style under Kawakami Tōgai and Antonio Fontanesi. *L & C.* Born in Yamanashi prefecture and lived in Tōkyō. Connected with the War Office. *Sp.* portraits.

Nakamura Tsune 中村彝 (1888–1923) *N.* Nakamura Tsune 中村彝 *S.* Western style. Studied in Hakubakai Kenkyūjo and in Taiheiyō-gakai. Later studied under Nakamura Fusetsu and Mitsutani Kunishirō. *L & C.* Born in Mito, and lived in Tōkyō. Member of hanging committee of Te'ten Exhibition. *Sp.* portraits.

Repr. Nakamura Tsune Sakuhinshū. 中村彝作品集

Nammei 南溟 (1795–1878) *N.* Haruki Shūki 春木秀熙 (later Ryū 龍) *A.* Keiichi 敬一 (later Shishū 子緝) *F. N.* Unosuke 卯之助 *Gō.* Nammei 南溟 Kōun-Gyosha 耕雲漁者 *S.* Japanese style. Pupil of his father, Nanko. *L & C.* Lived in Tōkyō. *Sp.* landscape, flowers-and-birds.

Nangaku 南岳 (1767–1813) *N.* Watanabe Iwao 渡邊巖 *A.* Iseki 維石 *F. N.* Isaburō 猪三郎 Kozaemon 小左衞門 *Gō.* Nangaku 南岳 *S.* Maruyama school. Pupil of Ōkyo. *L & C.* After studying under Ōkyo, followed the Kōrin style. So his style is a little different from

that of Maruyama school. Lived in Kyōto. *Sp.* fishes
(carp), female figures.

Repr. K. 278.

Nankai 南海 (1677–1751) *N.* Gi-on Yu 祇園瑜 *A.* Hakugyoku
白玉 *F. N.* Yoichirō 與一郎 *Gō.* Nankai 南海 Tekkan-
dōjin 鐵冠道人 Shōun 湘雲 *S.* Nanga school. Distingu-
ished founder of Nanga school in Japan. Studied
Chinese technique from picture-books which came
from China. *L & C.* Lived in Wakayama in Kii.
Confucian of the clan of Kii. Excelled in writing prose
and poetry. *Sp.* landscape, bamboos.

Repr. K. 223, 416.

Nanko 南湖 (1759–1839) *N.* Haruki Kon 春木鯤 *A.* Shigyo
子魚 *F. N.* Monya 門彌 *Gō.* Enka-chōsō 烟霞釣叟 Yūse-
kĭtei 幽石亭 Donbokuō 呑墨翁 *S.* Nanga school. Pupil
of Sensai. Learned the technique of Chinese paintings
of the Ming dynasty. *L & C.* Lived in Edo. Famous
painter of that time. Contemporary with Bunchō. *Sp.*
landscape.

Naohiko 直彦 (1828–1913) *N.* Kumagaya Naohiko 熊谷直彦
Gō. Tokuga 篤雅 *S.* Japanese style. Pupil of Okamoto
Shigehiko. *L & C.* Member of the Imperial Art
Committee. *Sp.* landscape, portraits.

Repr. Kumagaya Naohiko Gafu. 熊谷直彦畫譜

Naokata 直賢 (flourished c. 1810) *N.* Shirai Naokata 白井直
賢 *A.* Shisai 子齋 *F. N.* Chūhachirō 仲八郎 *Gō.*
Bunkyo 文擧 *S.* Maruyama school. Pupil of Ōkyo.
L & C. Lived in Kyōto. *Sp.* animals.

Repr. K. 81, 98, 122.

Naonobu 尚信 (1607–1650) *N.* Kanō Naonobu 狩野尚信, formerly
　　Kazunobu 一信 or Iyenobu 家信 *F. N.* Shume 主馬 *Gō.* Ji-
　　tekisai 自適齋 *S.* Kanō school. Studied under Kōi, his
　　father Takanobu, and his elder brother Tan-yū. *L & C.*
　　Lived in Edo. Founder of the Kanōs at Kobikichō.
　　Repr. K. 139, 159, 270, 274, 281, 304, 328, 340, 414, 422,
　　562, 580.

Naonobu See Shōei.

Naotake 直武 (1747–1780) *N.* Odano Naotake 小田野直武 *Gō.*
　　Uyō 羽陽 Gyokusen 玉泉 *S.* Yōga school. Pupil of
　　Gennai. *L & C.* Lived in Akita as a clansman. As
　　Gennai came to Akita being invited by the lord,
　　studied under him. Western technique became popular
　　in the clan of Akita. *Sp.* Western subjects (oil paint-
　　ing.)

Naotomo 直朝 (d. 1597) *N.* Isshiki Naotomo 一色直朝 *Gō.*
　　Getsuan 月菴 Rosetsu 蘆雪 *S.* Muromachi Suiboku school.
　　Said to have studied the technique of Sesshū. *L & C.*
　　Lived in Mikawa. *Samurai* of the family of Isshiki.
　　Repr. B. 12. K. 124, 276, 346. N. 12.

Narahōgen See Kantei.

Nichokuan 二直庵 (flourished in the middle of 17th cent.) *N.*
　　Soga Nichokuan 曾我二直庵 *F. N.* Sahē 左兵衛 *S.* Soga
　　school. Pupil of his father Chokuan. *L & C.* Lived
　　in Sakai. *Sp.* birds (hawk).
　　Repr. B. 66. K. 20, 92, 127, 138, 365, 400, 576, 599. N. 4.

Nichosai 耳鳥齋 (d. 1793) *N.* Matsuya Heisaburo 松屋平三郎
　　Gō. Nichōsai 耳鳥齋 *L & C.* Lived in Ōsaka. Said to
　　have been a curio-dealer. *Sp.* caricature.

Nin See Kyōsho.

Ninsei 仁清 (d. 1660 or 1666) *N.* Nonomura Seiemon 野々村清右衞門 *F. N.* Seibē 清兵衞 Seisuke 清助 *Gō.* Ninsei *S.* Pupil of a potter, Sōhaku. *L & C.* Born in Tamba. Lived in Kyōto. Studied the art of pottery under a Korean in Tosa and became a distinguished potter. Painting was his hobby.

 Repr. K. 208.

Niten See Musashi.

Nōami 能阿彌 (1397–1471) *N.* Nakao Shinnō 中尾眞能 *F. N.* Nōami 能阿彌 Gō. Ōsai 鷗齋 Shun-ō-sai 春鷗齋 *S.* Muromachi Suiboku school. Pupil of Shūbun. *L & C.* Skilled in *renga* 連歌 (verse capping), tea-ceremony and planning gardens. Excellent judge of paintings and calligraphy. Served the Shogun Ashikaga. Lived in Kyōto. *Sp.* landscape.

 Repr. B. 53. K. 41, 154, 261. San-ami 三阿彌

Nobori See Kazan.

Nobuharu See Tōhaku.

Nobukado 信廉 (d. 1582) *N.* Takeda Nobukado 武田信廉 *F. N.* Nobutsuna 信綱. *Gō.* Shōyōken 逍遙軒 (name as priest) Kaiten 海天 *L & C.* Fourth son of Takeda Nobutora. Painted the portaits of his parents.

 Repr. K. 573.

Nobutada 信尹 (1565–1614) *N.* Konoye Nobutada 近衞信尹 *Gō.* Sammyakuin 三藐院 *L & C.* Lived in Kyōto. Son of a courtier Maehisa. Nominated *Sadaijin* 左大臣. Excelled in calligraphy and founded Konoye school of calligraphy. Painted in simple style as a hobby.

Nobuzane 信實 (1176 – c. 1268) *N.* Fujiwara Nobuzane 藤原信
實 *Gō.* Jakusai 寂西 *S.* Yamatoye school. *L & C.* Son
of Takanobu. Said to have been an excellent portrait-
painter of the Kamakura period, but few of his geunine
works remain. *Sp.* portraits. *Repr.* K. 27, 36, 42, 86.

Ōju 應受 (1777–1815) *N.* Kinoshita Naoichi 木下直一 *A.*
Kunrai 君賚 *Gō.* Ōju 應受 Suiseki 水石 *S.* Maruyama
school. Pupil of his father Ōkyo. *L & C.* The second
son of Ōkyo, and the father of Ōshin. Succeeded Kino-
shitas. Lived in Kyōto.

Okada Saburōsuke 岡田三郎助 (1869–1939) *N.* Okada Saburō-
suke 岡田三郎助 *S.* Western style. Pupil of Soyama Sachi-
hiko and of Kuroda Seiki. *L & C.* Born in Saga pre-
fecture, and lived in Tōkyō. Travelled in Europe and lived
in France where he studied under Raphael Collin.
Member of the Imperial Art Committee, and of Teikoku
Geijutsu-in. Professor of Tōkyō Art School. *Sp.* figures.

Okin 王瑾 (17th or 18th cent.) *A.* Kōyu 公瑜 *Gō.* Tenryū-dōjin
天龍道人 *L & C.* Lived in Shinano. *Sp.* grapes.

Okurakyō 大藏卿 (13th cent.) *L & C.* Painter attending on
Priest Nichiren (1222–1282). The portrait of Nichiren
日蓮 (Coll. Myōhokkeji Temple in Shizuoka prefecture)
is attributed to him.

Ōkyo 應舉 (1733–1795) *N.* Maruyama Masataka 圓山應舉 *A.*
Chūsen 仲選 *F. N.* Iwajirō 岩次郎 Mondo 主水 *Gō.* Sen-
sai 僊齋 Isshō 一嘯 Ka-un 夏雲 Untei 雲亭 Senrei 仙嶺
Rakuyō-sanjin 洛陽山人 Seishūkan 星聚館 *S.* Distin-
guished painter. Pupil of Ishida Yūtei. Applying the
good points of Western pictures, achieved a realistic

style, and founded Maruyama school. *L & C.* Born in Tamba and lived in Kyōto. His skill was praised by the Court. Made many masterpieces. *Sp.* landscape, flowers-and-birds, etc.

Repr. B. 14, 21, 22, 33, 34, 91. K. 21, 28, 68, 88, 95, 100, 114, 116, 121, 128, 135, 143, 146, 149, 154, 171, 176, 181, 183, 193, 220, 235, 236, 239, 243, 248, 253, 255, 260, 270, 274, 279, 280, 283, 286, 288, 292, 295, 299, 303, 308, 313, 318, 331, 338, 343, 367, 375, 382, 397, 404, 424, 429, 430, 451, 458, 465, 502, 517, 527, 545, 555, 584, 591, 597. N. 2, 11, 19, 37, 43, 64, 77.

Ōshin 應震 (1790–1838) *N.* Maruyama Ōshin 圓山應震 *A.* Chūkyō 仲恭 *Gō.* Hyakuri 百里 Hōko 方壺 Seishūkan 星聚館 *S.* Maruyama school. Pupil of Ōju and Ōzui. *L & C.* Lived in Kyōto. Son of Ōju. Adopted by Ōzui as his son. *Sp.* landscape, flowers-and-birds.

Ōshita Tōjirō 大下藤次郎 (1870–1911) *N.* Ōshita Tōjirō 大下藤次郎. *S.* Western style. Pupil of Nakamaru Seijūrō and of Harada Naojirō. *L & C.* Born and lived in Tōkyō. In 1902 travelled in Europe. Founded Nippon Suisaiga Kenkyūjo (Institute of Water-colouring). Publishing the monthly "Mizuye" みづゑ, promoted the spread of paintings in water-colouring. *Sp.* landscape.

Repr. Ōshita Tōjirō Isakushū 大下藤次郎遺作集.

Ōzui 應瑞 (1766–1829) *N.* Maruyama Ōzui 圓山應瑞 *A.* Gihō 儀鳳 *F. N.* Ukon 右近 *Gō.* Ishindō 怡真堂 *S.* Maruyama school. Pupil of His father, Ōkyo. Followed his father's style faithfully. Used gold dust skilfully. *L. &. C.* Lived in Kyōto.

Rakuyōsanjin See Ōkyo.

Reien See Mokuan.

Reietsu 茘閲 (17th cent.) *N.* Reietsu 茘閲 *S.* Muromachi Sui-
boku school. *Sp.* figures (*Shōki*).

Reika 靈華 (1875-1929) *N.* Kikkawa Hitoshi 吉川凖 *F. N.*
Saburō 三郎 *Gō.* Reika 靈華 *S.* Japanese style. Pupil
of Kanō Ryōshin, and Hashimoto Gahō. Later, studied
Yamatoye by himself and established his own style.
L & C. Lived in Tōkyō. Member of the Kinrei-sha and
associate member of the Teikoku Bijutsu-in. *Sp.* port-
raits.

　Repr. Reika Gashū 靈華畫集, Reika Gashū Zokuhen 靈華
畫集續篇.

Reisai 靈彩 (flourished c. 1435) *Gō.* Reisai 靈彩 *S.* Muro-
machi Suiboku school. *L & C.* Unknown.
　Repr. B. 87. K. 264, 542.

Rengyō 蓮行 (flourished c. 1298) Priest name: Rengyō 蓮行
F. N. Rokurobē 六郎兵衞 *L & C.* Painted the scroll of
" Tōsei Eden " 東征繪傳 (The travell of the priest Ganjin
from China to Japan) (coll. Tōshōdaiji Temple).
　Repr. K. 207. N. 20.

Rikyō See Ki-en.

Rinken 琳賢 (flourished in the end of 16th cent.) *N.* Shiba
Rinken 芝琳賢 *Sp.* Buddhistic painting.

Rinkyō 林響 (1884-1930) *N.* Ishi-i Kisaburo 石井毅三郎 *Gō.*
Tempū 天風 Rinkyō 林響 *S.* Japanese style. Pupil of
Hashimoto Gahō. Later, devoted himself to Nanga
school. *L. &. C.* Lived in Tōkyō, and Chiba. *Sp.* figures,
landscape.

Ritsuo 笠翁 (1663–1747) *N.* Ogawa Kan 小川觀 *A.* Shōkō 尙
行 *F. N.* Heisuke 平助 *Gō.* Bōkanshi 卯觀子 Haritsu 破
笠. Muchūan 夢中庵 *S.* His style resembles to that of
Itchō. *L & C.* Born and lived in Edo. Excelled in
making *haikai* (short poem) and lacquerware.
 Repr. K. 13, 74, 273, 539.

Rōen 閭苑 (19 cent.) *N.* Hayashi Shin 林新 *A.* Nisshin 日新
 F. N. Shūzō 秋藏 *Gō.* Rōen 閭苑 Shōrei 章齡 *S.* Nanga
school. Pupil of Gogaku. *L & C.* Born in Ōsaka.

Rosetsu 蘆雪 (1755–1799) *N.* Nagasawa Gyo 長澤魚 *A.*
Hyōkei 氷計 *F. N.* Kazu-e 主計 *Gō.* Hyōkei 氷計 Kan-
shū 干州 Gyosha 漁者 Kanshū 干緝 *S.* Maruyama school.
Distinguished follower of Ōkyo. *L & C.* Clansman of
Yodo in Yamashiro. Studied under Ōkyo, excelled in
both rough and minute paintings. Minagawa Ki-en was
his intimate friend. Lived in Kyōto.
 Repr. B. 36. K. 34, 49, 94, 109, 111, 112, 167, 202, 238, 251,
 263, 271, 332, 360, 381, 401, 413, 464, 536, 537, 543, 560.
 565, 577.

Roshū 蘆洲 (1767–1847) *N.* Nagasawa Rin 長澤麟 *A.* Donkō
呑江 *Gō.* Roshū 蘆洲 *S.* Maruyama school. Pupil of his
father-in-law, Rosetsu. *L & C.* Lived in Kyōto. Clansman
at Yodo in Yamashiro. Adopted by Rosetsu as his son.

Roshū 蘆舟 (flourished in the beginning of 17th cent.) *Gō.*
Roshū 蘆舟 *S.* Sōtatsu school. Pupil of Sōtatsu. *L & C.*
Unknown.
 Repr. K. 168.

Ryōin See Umpo.

Ryōsen 良詮 (14th–15th cent.) *N.* Ryōsen 良詮 *S.* Muro-

machi Suiboku school. *L & C.* Unknown. *Sp.* Buddhistic
painting. *Repr.* K. 161. N. 50, 59.

Ryōsen 亮儼 (flourished in the former half of 16th cent.)
S. Muromachi Suiboku school. *L & C.* Lived in Echizen.
Repr. B. 61.

Ryōtai 凌岱 (1719–1774) *N.* Tatebe Mōkyō 建部孟喬 *F. N.*
Kingo 金吾 (name in childhood) *Gō.* Ryōtai 凌岱 Kan-
yōsai 寒葉齋 Ayatari 綾足 Kyūroan 吸露菴 *S.* Nanga
school. *L & C.* Born in Mutsu. Went to Kyōto where
became a priest of Tōfukuji Temple and lived in Kyōto.
Excelled in making *haikai* and *katauta* poems.

Ryōzen 良全 (14th–15th cents.) N. Ryōzen 良全 *S.* Muro-
machi Suiboku school. *L & C.* Unknown. Said to have
been the same person as Ryōsen *Sp.* Buddhistic paintings.
Repr. K. 393, 442.

Ryōzen See Kaō.

Ryūei 柳榮 (1647–1698) *N.* Momota Morimitsu 桃田守光 *F. N.*
Buzaemon 武左衞門 *Gō.* Ryūei 柳榮 Yūkōsai 幽香齋 *S.*
Kanō school. Pupil of Tan-yū. *L & C.* Lived in Edo.

Ryūho 立圃 (1599–1669) *N.* Nonoguchi Chikashige 野々口親重
(Hinaya) Ryūho (雛屋) 立圃 *Gō.* Shōō, 松翁 *S.* His teacher,
unknown. *L & C.* Lived in Kyōto. Studied *haikai*
(short poem) under Teitoku and known as a poet.
Painting is his hobby.

Ryūho 柳圃 (1820–1889) *N.* Fukushima Nei 福島寧 *A.* Shi-
choku 子直 *F. N.* Shigejirō 重次郎 *Gō.* Ryūho 柳圃
Mokudō 默堂 *S.* Japanese style. Pupil of Shibata
Zeshin. Later studied Nanga school by himself. *L & C.*
Lived in Tōkyō. *Sp.* landscape, flowers-and-birds.

Ryūko 隆古 (1801–1859) *N.* Takaku 高久 *A.* Jutsuji 述而
F. N. Onoshirō 斧四郎 *Gō.* Ryūko 隆古 *S.* Fukko
Yamatoye school. *L & C.* Born in Shimotsuke. Adopted
by Aigai as his son. At his middle age went to Kyōto
where studied Yamatoye painting under Kiyoshi and
Ikkei. *Sp.* historical subjects. *Repr.* K. 87.

Ryūrikyō See Ki-en.

Ryūsai See Hiroshige.

Saeki Yūzō 佐伯祐三 (1898–1928) *N.* Saeki Yūzō 佐伯祐三
S. Western style. Graduated from Tōkyō Art School
in 1923. Later travelled in France where studied under
Vlamink. *L & C.* Born at Ōsaka. Lived in Tōkyō. Ex-
hibited his works in Nika-kai Exhibitions. *Sp.* landscape
(especially fond of painting buildings).
 Repr. Saeki Yūzō Gashū 佐伯祐三畫集.

Sahitsuan See Shunkō.

Sai-an 柴庵 (16th cent.) *Gō.* Sai-an 柴庵 *S.* Muromachi
Suiboku school. *L & C.* Lived in Shōkokuji Temple
in Kyōto. *Repr.* B 47. K. 128, 257, 504.

Saikō 細香 (1787–1861) *N.* Ema Tahoko 江馬多保子 *A.* Ryo-
kugyoku 綠玉 *Gō.* Saikō 細香 Kizan 箕山 Shōmu 湘夢
S. Nanga school. *L & C.* Born in Mino. Daughter of
doctor Ransai. Associated with painters and writers
in Kyōto. *Sp.* flowers.

Sakon 左近 (flourished in the former half of 17th cent.) *N.*
Hasegawa Sakon 長谷川左近 *S.* Hasegawa school.
L & C. Said to be a son of Tōhaku.

Samboku 山卜 (17th–18th cent.) *N.* Kanō Ryōji 狩野良次 *Gō.*
Samboku 山卜 Fukyūshi 不及子 *S.* Kanō school. *S*esms

to have followed the style of Sanraku. *L & C.* Lived in Kyōto.

Sammyakuin See Nobutada.

Sangyōan See Tangen.

Sanjūroppōgaishi See San-yō.

Sanraku 山樂 (1559–1635) *N.* Kanō Mitsuyori 狩野光賴 *F. N.* Heizō 平三 Shuri 修理 *Gō.* Sanraku 山樂 *S.* Kanō school. Pupil of Eitoku. *L & C.* Born in Ōmi. Lived in Kyōto. Served Toyotomi Hideyoshi. Son of Kimura Nagamitsu. Distinguished painter of that time. Adopted by his teacher Eitoku, and succeeded the house of Kanō in Kyōto, after other clans of Kanō went to Edo. *Sp.* flowers-and-birds, figures (excelled in painting on sliding doors and screens).
Repr. B. 1, 52. K. 32, 37, 49, 98, 111, 117, 209, 212, 239, 242, 260, 460, 508. N. 63.

Sansetsu 山雪 (1590–1651) *N.* Kanō Heishirō 狩野平四郎 *F. N.* Nui-no-suke 縫殿助 *Gō.* Sansetsu 山雪 Dasokuken 蛇足軒 Shōhaku-sanjin 松柏山人 Tōgen-shi 桃源子 *S.* Kanō school. Pupil of his adoptive father, Sanraku. *L. & C.* Born in Hizen, and lived in Kyōto. Son of the Chigas, adopted by his teacher Sanraku and inherited the house of Kanō in Kyōto.
Repr. K. 10, 21, 25, 26, 44, 72, 101, 130, 180, 510, 520.

San-yasanshō See Kensai.

San-yō 山陽 (1780–1832) *N.* Rai Jō 賴襄 *A.* Shisei 子成 *F. N.* Kyūtarō 久太郎 *Gō.* San-yō 山陽 Sanjūroppō-gaishi 三十六峰外史 *S.* Nanga school. *L & C.* Born in Aki. Son of Rai Shunsui (famous Confucian in Hiroshìma). Lived

in Kyōto. Stood foremost among the writers at that age. Wrote many books. Associated with Chikuden, Chikutō, Baiitsu, Shunkin, etc. *Sp.* landscape.

Repr. K. 246, 290, 365, 406, 421, 451, 459, 470.

Sasa See Shunsa.

Sasuiō See Itchō.

Seigai 青厓 (1786–1851) *N.* Sakurama Shin 櫻間咸 *A.* Zentotsu 善訥 *Gō.* Utei 迂亭 Seigai 青厓 *S.* Nanga school. Pupil of Katagiri Tōin. *L & C.* Lived in Edo. Served Honda Nakatsukasa Dayū, the lord of Okazaki Castle in Mikawa. Lived a very happy life though poor. Kazan was his intimate friend.

Repr. B. 67. K. 136, 342, 531.

Seigan 星巌 (1789–1858) *N.* Yanagawa Mōi 梁川孟緯 *A.* Kōto 公圖 Mushō 無象 *F. N.* Shinjūrō 新十郎 *Gō.* Seigan 星巌 Tenkoku 天谷 Hyakuhō 百峯 Rōryūan 老龍庵 Ōseki- shōin 鴨涯小隱 *S.* Nanga school. *L & C.* Born in Mino. Lived in Edo and Kyōto. Known as a poet. Travelled in many places.

Seigyō 性暁 (Muromachi period) *Gō.* Seigyō 性暁 *S.* Muro- machi Suiboku school. *L & C.* Unknown.

Seiki 清暉 (1792–1864) *N.* Yokoyama Kizō 橫山暉三 later Seiki 清暉 *A.* Seibun 成文 *F. N.* Shōsuke 詳介 Shume 主馬 *Gō.* Gogaku 五岳 Kibun 奇文 Kajō 霞城 *S.* Shijō school. Good pupil of Keibun. *L & C.* Born in Kyōto. Painted in the Court when it was built in 1855. Lived in Kyōto. *Sp.* flowers-and-birds.

Seiko 晴湖 (1837–1913) *N.* Okuhara Setsuko 奧原節子 *Gō.* Seiko 晴湖 *S.* Japanese style. Nanga school. Pupil of

Hirata Shisei. Later developed her own style. *L & C.*
Lived in Tōkyō and Kumagaya in Saitama prefecture.
Sp. landscape, flowers-and-birds.

 Repr. Okuhara Seiko Gashū. 奧原晴湖畫集.

Seisai See Ichiga.

Seisei See Kiitsu.

Seiseidō See Kōrin.

Seisen-in 晴川院 (1796–1846) *N.* Kanō Yōshin 狩野養信 *F. N.*
 Shōzaburo 庄三郎 *Gō.* Seisen-in 晴川院 Kaishinsai 會心
 齋 Gyokusen 玉川 *S.* Kanō school. Pupil of his father,
 Eishin. *L & C.* Succeeded the Kanō estate at Kobikichō
 in Edo.

Seishō See Chikutō.

Seitei 省亭 (1851–1918) *N.* Watanabe Yoshimata 渡邊義復
 F. N. Ryōsuke 良助 *Gō.* Seitei 省亭 *S.* Japanese style.
 Pupil of Kikuchi Yōsai. *L & C.* Lived in Tōkyō. *Sp.*
 flowers-and-birds.

Seitoku 井特 (1781–1829) *N.* Izutsuya Tokuemon 井筒屋德右
 衞門 *Gō.* Gi-on Seitoku 祇園井特 *S.* Ukiyoye school.
 L & C. Lived in Kyōto. Painting was his hobby. *Sp.*
 female figures.

Seki-en 石燕 (1712–1788) *N.* Sano Toyofusa 佐野豐房 *Gō.* Tori-
 yama Seki-en 鳥山石燕 Reiryō 零陵 *S.* Ukiyoye school.
 Pupil of Kanō Gyokuen. Later painted Ukiyoye. *L & C.*
 Lived in Edo. Painted many votive tablets which were
 devoted to temples. One in Sensōji Temple in Edo
 is one of his good works. Made several illustrations in
 story-books. *Sp.* female figures (original).

Sekiho 石圃 (flourished in the latter half of 18th cent.) *N.*

Okano Tōru 岡野亭 *A.* Genshin 元震 *Gō.* Sekiho 石圃 Unshin 雲津 *S.* Nanga school. One of the pioneers of Nanga school in Japan. His teacher is unknown. *L & C.* Born in Ise. Lived in Kyōto in c. 1768. Though he is said to have written two or three books, all are lost. *Sp.* landscape. *Repr.* B. 42, 60.

Sekine Shōji 關根正二 (1899–1919) *N.* Sekine Shōii 關根正二 *S.* Western style. Though studied in Taiheiyō-gakai Kenkyūjo for a short time, learned Western style paint-ing almost by himself. *L & C.* Born and lived in Tōkyō. His works exhibited in Nika-kai Exhibition were praised as good in symbolism. Died young. *Sp.* figures.

Repr. Shinkō-no-kanashimi 信仰の悲み.

Sekisō See Aigai.

Sekkei 雪溪 (1644–1732) *N.* Yamaguchi Sōsetsu 山口宗雪 *Gō.* Sekkei 雪溪 Baian 梅庵 Hakuin 白隱. *S.* Followed the technique of Sesshū and Mu-ch'i (Mokkei). *L & C.* Lived in Kyōto.

Repr. K. 255.

Sekkei See Shiseki.

Sen See Shunkin.

Sengai 仙崖 (1751–1837) Priest name: Gibon 義梵 *A.* Sengai 仙崖 *L & C.* Born in Mino. Zen-priest of Seifukuji Temple in Chikuzen. Painted suiboku-painting in very simple style.

Senka 僊可 (flourished in the beginning of 16th cent.) *Gō.* Senka 僊可 Sōsetsu-sai 巢雪齋 *S.* Muromachi Suiboku school. *L & C.* Lived in Kyōto.

Repr. B. 19. K. 127, 211.

Senkadō See Shigenaga.

Sensai See Ōkyo.

Senzan 茜山 (1820–1862) *N.* Nagamura Kan 永村寛 *A.* Saimō 濟猛 *Gō.* Juzan 壽山 Senzan 茜山 *S.* Nanga school. Pupil of Kazan. *L & C.* Lived in Kanaya. When young, he was considered a genius, but his skill did not develope, as he was too much interested in worldly affairs.

Repr. K. 149.

Sessai 雪齋 (d. 1839.) *N.* Tsukioka Shūei 月岡秀榮 *A.* Taikei 大溪 *Gō.* Sessai 雪齋 *S.* Ukiyoye school. Pupil of his father, Settei. *L & C.* Lived in Ōsaka. Nominated to Hokkyō, and later promoted to Hōgen. *Sp.* genre painting (original).

Sessai 雪齋 (1755–1820) *N.* Masuyama Masakata 增山正賢 *A.* Kunsen 君選 *Gō.* Sessai 雪齋 Gyokuen 玉淵 Kan-en 灌園 Setsuryo 雪旅 Chōshū 長洲 Sekiten-dōjin 石顚道人 *S.* Nagasaki school. Studied the technique of Nan-p'in. *L & C.* Lord of Nagashima in Ise. Later lived in Edo. Skilled in writing prose and poetry. *Sp.* flowers-and-birds.

Repr. K. 107.

Sesshū 雪舟 (1420–1506) *Imina* 諱: Tōyō 等揚 *Gō.* Sesshū 雪舟 Unkoku 雲谷 *S.* Muromachi Suiboku school. Pupil of Shūbun. One of the greatest masters of suiboku-painting in the Muromachi period. *L & C.* Born in Bitchū. Lived in Shōkokuji Temple in Kyōto when young. His *azana* or *gō* " Sesshū " was given to him when about forty years old. It is said that a painter called Sessō was young Sesshū. In 1467 or 1468 went to China and

he came back in 1469. After returning from China,
made many paintings in Bungo and Suō.

 Repr. B. 3, 14, 48, 52, 106. K. 2, 9, 12, 18, 52, 60, 71, 90,
97, 102, 111, 122, 128, 138, 156, 184, 185, 189, 200, 210,
214, 279, 290, 310, 390, 399, 410, 414, 444, 471. N. 2, 20,
47, 65, 71, 78. Sesshū 雪舟.

Sesson 雪村 (1504–1589) *N.* Satake (?) 佐竹 (?) *Gō.* Sesson 雪
村 Shūkyosai 舟居齋 Shūkei 周繼 Kakusen-rōjin 鶴仙老人
S. Muromachi Suiboku school. *L & C.* Lived at Hetari
in Hitachi. Later at Aizu and at Tamura in Iwashiro.
Sp. landscape.

 Repr. B. 87. K. 3, 22, 58, 65, 74, 89, 109, 121, 129, 134,
137, 148, 208, 212, 240, 400, 546, 591. N. 28. Sesson 雪村.

Setsuzan 雪山 (16th cent.) *N.* Kōto Setsuzan 廣渡雪山 *S.*
Muromachi Suiboku school. Said to have been a
pupil of Sesson. *L & C.* Born in Hizen (?)

 Repr. K. 76.

Settan 雪旦 (1778–1843) *N.* Hasegawa Sōshū 長谷川宗秀 *F. N.*
Gotō Mo-emon 後藤茂右衞門 *Gō.* Settan 雪旦 Gangakusai
巖岳齋 Ichiyōan 一陽菴 *S.* Ukiyoye school. *L & C.*
Lived in Edo. Illustrated in "Edo Meisho Zuye" 江戸名所
圖繪 (famous places in Edo) and "Tōto-saijiki" 東都歳
事記 (The annual regular functions of Edo)

Settei 雪鼎 (1710–1786) *N.* Tsukioka Masanobu 月岡昌信 (Kida
Masanobu 木田昌信) *F. N.* Tange 丹下 *Gō.* Settei 雪鼎
Shinten-ō 信天翁 *S.* Ukiyoye school. Pupil of Takada
Keiho. *L & C.* Nominated to Hokkyō. Born in Ōmi and
lived in Ōsaka. *Sp.* Ukiyoye, and illusration of storybooks.
 Repr. K. 519.

Shabaku 遮莫 (flourished in the latter half of 16th cent.) *N.*
Shabaku 遮莫 *Gō.* Gessen 月船 *S.* Muromachi Suiboku
school. Said to be a pupil of Shūbun. *Repr.* K. 539.

Shachōkō See Buson.

Sha-in See Buson.

Sharaku 寫樂 (flourished in 1794 & 1795) *N.* Tōshūsai
Sharaku 東洲齋寫樂 *F. N.* Saitō Jūrobē 齋藤十郎兵衞 *Gō.*
Tōshūsai 東洲齋 Sharaku 寫樂 *S.* Ukiyoye school
L & C. Lived in Edo. Said to be a *nō*-actor in the
employ of Lord of Awa. *Sp.* portrait of actors.

Shashunsei See Buson.

Shazanrō See Bunchō.

Shibutsu 詩佛 (1766–1837) *N.* Ōkubo Gyō 大窪行 *A.* Temmin
天民 *F. N.* Ryūtarō 柳太郎 *Gō.* Shibutsu 詩佛 Shiseidō
詩聖堂 Kōzan-sho-oku 江山書屋 *S.* Nanga school. Friend
of Bunchō. *L & C.* Born in Hitachi. Lived in Edo.
Known as a poet.

Shiden 芝田 (1871–1917) *N.* Kosaka Tamejirō 小坂爲次郎 *A.*
Shijun 子順 *Gō.* Shiden 芝田 Kanshōkyo 寒松居 *S.*
Japanese style. Nanga school. Pupil of Kodama Katei.
L & C. Lived in Nagano and Tōkyō. Member of the
Nippon Bijutsu Kyōkai. *Sp.* landscape.

Shigemasa 重政 (1738–1820) *N.* Kitao Shigemasa 北尾重政
F. N. Kyūgoro 久五郎 *Gō.* Kōsuisai 紅翠齋 Karan 花藍
Tairei 台嶺 Ichiyōsei 一陽井 Kōsuifu 紅醉夫 Suihō Itsujin
醉放逸人 *S.* Ukiyoye school. Founder of so-called
Kitao school. *L & C.* Lived in Edo. Illustrated many
story-books of the time. *Sp.* female figures (beniye,
nishikiye, ukiye). *Repr.* K. 250.

Shigenaga 重長 (1697–1756) *N*. Nishimura Shigenaga 西村重
長 *F. N.* Magosaburō 孫三郎 Magojirō 孫二郎 *Gō*. Senkadō
仙花堂 *S*. Ukiyoye school. Influenced by Kiyonobu and
Masanobu. *Sp*. female figures (urushiye, beniye, ukiye).

Shigenari See Chikukei.

Shihekidōjin See Kaiseki.

Shijō See Impo.

Shikō See Katen.

Shikō 始興 (1683–1755) *N*. Watanabe Shikō 渡邊如興 *F. N.*
Motome 求馬 *S*. Studied Kanō school when young, later
followed Kōrin. *L & C*. Lived in Kyōto. Served Lord
Konoye. Studied under Kōrin and was influenced by
Naonobu. Made suiboku-paintings in light colour.
Ōkyo praised his works thirty years after his death.

Repr. K. 80, 85, 215, 240, 269, 282, 542.

Shikō 紫紅 (1880–1916) *N*. Imamura Jusaburō 今村壽三郎
Gō. Shikō 紫紅 *S*. Japanese style. Pupil of Matsumoto
Fūko. *L & C*. Lived in Tōkyō. Member of the Saikō
Nippon Bijutsu-in. *Sp*. landscape.

Repr. Shikō Gashū 紫紅畫集.

Shin-en See Hyakusen.

Shingei See Geiami.

Shinkai 信海 (c. 1282) Priest-name: Shinkai 信海 *L & C*. Priest
having some relation with Daigoji Temple. Among his
many pictures kept in the temple, several have his
signature. *Sp*. Buddhistic painting.

Repr. K. 339, 383. N. 8.

Shinken 深賢 (1179–1261) *S*. Buddhistic painting. *L & C*.
Shingon priest. Learned the doctrine of Esoteric

Buddhism from Seiken. Founded Jizōin Monastery in Daigoji Temple where remain some of his works. *Sp.* Buddhistic painting. *Repr.* N. 79.

Shinkō See Chūan.

Shinkō See Itchō.

Shinnō See Nōami.

Shinsetsu See Motohide.

Shinsō See Sōami.

Shin-yō 晉陽 (d. 1801) *N.* Ba Dōryō 馬道良 *Gō.* (Kitayama) Shin-yō (北山) 晉陽 *S.* Nanga school. *L & C.* Lived in Edo. Kangan is his son.

Shinzaburō See Gibokusai.

Shinzui See Aiseki.

Shisan See Gyokushū.

Shisei See San-yō.

Shiseki 紫石 (1712-1786) *N.* Kusumoto Shiseki 楠本紫石 Sō Shiseki 宋紫石 *A.* Kunkaku 君赫 *Gō.* Sekkei 雪溪 Katei 霞亭 Sōgaku 宗岳 *S.* Nagasaki school. Pupil of Tzu-yen (Chinese painter of the Ch'ing dynasty who stayed at Nagasaki at his time). *L & C.* Lived in Edo. *Sp.* flowers-and-birds, bamboos.

Repr. K. 162, 272, 372.

Shizan 紫山 (1733-1805) *N.* Kusumoto Hakkei 楠本白圭, Sō Shizan 宋紫山 *A.* Kunshaku 君錫 *Gō.* Taikei 苔溪 Sekko 雪湖 *S.* Nagasaki school. Studied under his father, Shiseki. *L & C.* Lived in Edo.

Shōan 性安 (15th–16th cent.) *N.* Shōan 性安 *Gō.* Baian 梅菴 *S.* Muromachi Suiboku school. Said to be a pupil of Kei Shoki. Zen-priest. *L & C.* Lived in Ōta village in Hitachi.

Shōei 松榮 (1519–1592) *N.* Kanō Naonobu 狩野直信 *F. N.* Genshichirō 源七郎 Ōinosuke 大炊助 *Gō.* Shōei 松榮 (on becoming a priest) *S.* Kanō school. Studied under his father, Motonobu. *L & C.* Lived in Kyōtō. Served the Shōgun Ashikaga.

Repr. K. 30, 80, 168, 331.

Shōga 勝賀 (flourished in c. 1191) *N.* Takūma 詫摩 *Gō.* Shōga 勝賀 *S.* Buddhistic painting. *L & C.* Lived in Kyōto. " Jūniten " 十二天 (coll. Kyōōgokokuji Temple) is his remaining work.

Repr. K. 212. N. 18.

Shōhaku 蕭白 (d. 1781) *N.* Soga Kiyu 曾我暉雄 *Gō.* Shōhaku 蕭白 Joki 如鬼 Ranzan 鸞山 Dasokuken 蛇足軒 Kishinsai 鬼神齋 Hiran 飛鸞 *S.* Studying Kanō school and the style of Sesshū, originated his unique style. *L & C.* Lived in Kyōto.

Repr. B. 53. K. 4, 39, 60, 118, 125, 138, 279, 509.

Shōhin 小蘋 (1847–1917) *N.* Noguchi Chika 野口親 *Gō.* Shōhin 小蘋 *S.* Japanese style. Nanga school. Pupil of Hine Taizan. *L & C.* Woman painter. Lived in Tōkyō. Member of the Imperial Art Committee and the Nippon Bijutsu Kyōkai. *S.* landscape.

Repr. Shōhin Iboku-shū 小蘋遺墨集.

Shōi See Matabē.

Shōjō 昭乘 (1584–1639) *N.* Nakanuma Shōjō 中沼昭乘 *F. N.* Shikibu 式部 *Gō.* Seisei-ō 惺々翁 Shōkadō 松花堂 *S.* Studied the Chinese paintings of Sung and Yüan dynasties and made his own style. *L & C.* Born at Sakai. Became a priest of Shingon sect and lived at the Otoko-

yama Hachimangū Temple in Yamashiro. Skilled in both painting and calligraphy, which is called Shōkadō style. *Sp.* flowers-and-birds.

 Repr. B. 63. K. 32, 69, 144, 176, 185, 195, 257, 454, 459, 498, 501, 503, 552, 557, 595.

Shōka 松窠 (the beginning of 18th cent.) *N.* Naka-e Tochō 中江杜徵 *A.* Chōkō 徵公 *Gō.* Shōka 松窠 Katei-dōjin 華亭道人 Goteki 五適 *S.* Nanga school. Pupil of Kyūjo. *L & C.* Born in Ōmi. An engraver of seals, travelled in Echigo, Shinano, Edo and other places. Later lived in Kyōto. Called himself Goteki which means a man excelling in five arts such as seal-engraving, painting, making poems, calligraphy and playing *koto*, for he excelled in such arts. *S.* landscape.

Shōka 小華 (1835–1887) *N.* Watanabe Kai 渡邊諧 *A.* Shōkei 韶卿 *Gō.* Shōka 小華 *S.* Japanese style. Nanga school. *L & C.* Lived in Tōkyō. Son of Kazan. *Sp.* landscape and flowers-and-birds.

Shōkadō See Shōjō.

Shokatsukan 諸葛監 (1719–1790) *N.* Shimizu 淸水 *A.* Shibun 士文 *F. N.* Matashirō 又四郎 *Gō.* Seisai 靜齋 Ko-gadō 古畫堂 Shokatsukan 諸葛監 *S.* Studied by himself, taking good points of Chinese pictures of the Yüan, Ming and Ch'ing dynasties. *L & C.* Lived in Edo. *Sp.* flowers-and-birds.

Shōkei 祥啓 (flourished from the end of 15th cent. to the beginning of 16th cent.) *F. N.* Sekkei 雪溪 *Gō.* Hinrakusai 貧樂齋 Shōkei 祥啓 *S.* Muromachi Suiboku school. Said to be a pupil of Chūan Shinkō. Zen-priest. *L & C.* Lived at Kenchōji Temple in Kamakura.

Repr. K. 6, 33, 39, 50, 60, 84, 91, 100, 113, 118, 133, 149, 165, 222, 248, 285, 302. N. 18.

Shōkei 松谿 (14th cent.) *N.* Unknown, said to be the same as Eiga 榮賀(See Eiga). *S.* Muromachi Suiboku school. Life is also unknown.

Repr. K. 66, 266.

Shōnen 松年 (1849–1918) *N.* Suzuki Matsutoshi 鈴木松年 *Gō.* Shōnen 松年 *S.* Japanese style. Studied under Suzuki Hyakunen. *L & C.* Lived in Kyōto. *Sp.* landscape.

Repr. Shōnen Gafu 松年畫譜.

Shōō See Ryūho.

Shōrakan See Kigyoku.

Shōsai See Itsu-un.

Shōsen 紹仙 (the beginning of 16th cent.) *N.* Soga Shōsen 曾我紹仙 *S.* Muromachi Suiboku school. Pupil of his father Sōyo.

Shōsen-in 勝川院 (1823–1880) *N.* Kanō Masanobu 狩野雅信 *Gō.* Shōsen-in 勝川院 Soshōsai 素尚齋 Shōko 尚古 *S.* Kanō school. Pupil of his father, Yōshin. *L & C.* Succeeded to the Kanō estate at Kobikichō in Edo.

Shō-un 昌運 (1637–1702) Iwamoto Suenobu 岩本季信 *F. N.* Ichi-emon 市右衞門 *Gō.* (Kanō) Shōun (狩野) 昌運 Chō-shin-sai 釣深齋 *S.* Kanō school. Pupil of Yasunobu. *L & C.* Lived in Edo.

Shōun See Nankai.

Shōunsai See Kazunobu.

Shōyōken See Nobukado.

Shūbun 周文 (flourished in the former half of 15th cent.) *N.* Shūbun 周文 *A.* Tenshō 天章 *Gō.* Ekkei 越溪 *S.*

Muromachi Suiboku school. Said to have been a pupil of Josetsu. *L & C.* Lived in Kyōto, but once in Shōkokuji Temple.

Repr. B. 55, 80. K. 6, 17, 43, 70, 145, 177, 197, 252, 287, 304, 305, 313.

Shūbun 秀文 (flourished in the middle of 16th cent.) *Gō.* Shūbun 秀文 *S.* Muromachi Suiboku school. *L & C.* Lived in Hida (?)

Repr. B. 83. K. 366.

Shūgetsu 秋月 (d. c, 1510) *N.* Tōkan 等觀 *F. N.* Takashiro Gōnnokami 高城權頭 *Gō.* Shūgetsu 秋月 *S.* Muromachi Suiboku school. Pupil of Sesshū. *L&C.* Travelled in China. Lived in Yamaguchi in Suō. *S.* flowers-and-birds, landscape.

Repr. B. 60. K. 8, 61, 73, 194, 232, 333, 359, 386. N. 63.

Shūhō 秀峰 (flourished in 19th cent.) *N.* Ishida Shūhō 石田 秀峰 *L & C.* Born in Ōmi. Said to be a good painter under Shirai Kayō's teaching.

Repr. K. 411.

Shūi 周位 (flourished c. 1349) *N.* Shūi 周位 *Gō.* Mutō 無等 *S.* Muromachi Suiboku school. *L & C.* Zen-priest. Lived in Kyōto. Said to be one of the disciples of Priest Musōko-kushi, famous Zen-priest. *Sp.* portrait of *zen*-priests.

Repr. B. 75. K. 317.

Shūkei See Sesson.

Shūkei 周溪 (1778–1861) *N.* Watanabe Kiyoshi 渡邊淸 *F. N.* Daisuke 代助 *Gō.* Shūkei 周溪 Setchōsai 雪朝齋 *S.* Fukko Yamatoye school. Studied under Hidenobu and later Mitsusada and Totsugen. *L & C.* Lived in Nagoya.

Shūki 秋暉 (1767–1862) *N.* Okamoto Shūki 岡本秋暉 *F. N.*
Sukenojō 祐之丞 *Gō.* Shūō 秋翁 Fujiwara Ryūsen 藤原
隆仙 *S.* Nanga school. Pupil of Kuwagata Keisai.
After his teacher's death, followed the style of Kazan.
L & C. Born in Edo. Served Lord Ōkubo in Odawara.
Sp. flowers-and-birds. *Repr.* K. 181, 371, 544.

Shukō 珠光 (1422–1502) *N.* Shukō 珠光 *F. N.* Murata
Mokichi 村田茂吉. *Gō.* Kōrakuan 香樂庵 Nansei 南星
Dokuryoken 獨廬軒 *S.* Muromachi Suiboku school. Pupil
of Gei-ami. *L & C.* Lived at Daitokuji Temple in
Kyōto. Versed in tea ceremonials. Painting was his
hobby. *Repr.* K. 244.

Shūkō 周耕 (flourished in the latter half of 15th cent.) *Gō.*
Shūkō 周耕 *S.* Muromachi Suiboku school. Said to be
a pupil of Shūbun. *L & C.* Lived in Tōnomine in
Yamato (?). *Sp.* Shōki (god who beats demons).
Repr. K. 13, 53, 163.

Shuku See Hankō (Okada)

Shukuya 夙夜 (flourished in the latter half of 18th cent.)
N. Aoki Shummei 青木俊明 *A.* Shukuya .夙夜 *F. N.*
Sōemon 莊右衞門 *Gō.* Shuntō 春塘 Hachigaku 八岳 Yo-
shukuya 徐夙夜 *S.* Nanga school. Pupil of Taiga.
L & C. Born in Ise, and lived in Kyōto. Adopted by Kan
Tenju as son. Lived in Taiga's house after his death.
Sp. landscape. *Repr.* B. 28. K. 351, 513, 580.

Shumman 春滿 (1757–1820) *N.* Kubo Shumman 窪俊滿 *F. N.*
Kubota Yasubē 窪田安兵衞 *Gō.* Kubo Shumman 窪春滿
Shumman 春滿 Issetsu Senjō 一節千杖 Kōzandō 黄山堂
Nandakashiran 南陀伽紫蘭 Shōsado 尚左堂 Sashōdō 左尚

堂 *S*. Ukiyoye school. Pupil of Nahiko and Shigemasa.
L & C. Lived in Edo. *Sp*. female figures (both original
and printed). *Repr*. K. 127, 358.

Shummei 淡明 (1700–1781) *N*. Igarashi Shummei 五十嵐淡明
A. Hōtoku 方徳 *Gō*. Kohō 弧峯 Chikuken 竹軒 Bokuō
穆翁 *Gō*. Go Shummei 吳淡明 *S*. Kanō school. Pupil of
Ryōshin. Later influenced by Liang K'ain, Chang P'ing-
shan and others. *L & C*. Born and lived in Niigata.
Later went to Kyōto where studied Confucianism under
Yamazaki Ansai. *Sp*. figures.

Shumparō See Kōkan.

Shun See Kōkan.

Shunboku 春朴 (1680–1763) Ōoka Aiyoku 大岡愛翼 *Gō*. Shum-
boku 春朴 Jakushitsu 雀吒 *S*. Kanō school. *L & C*. Lived
in Edo. Wrote " Gashi-kaiyō " 畫史會要.

Shunchō 春潮 (flourished in the end of 18th cent.) *N*. Katsu-
kawa Shunchō 勝川潮春 *F. N*. Kichizaemon 吉左衞門
Gō. Yūbundō 雄文堂 Tōshien 東紫園 Chūrinsha 忠林舍
Kichisadō 吉左堂 *S*. Ukiyoye school. Pupil of Shunshō.
Influenced by Kiyonaga. *L & C*. Lived in Edo. Later
stopped painting and wrote novels. *Sp*. female figures
(murasakizuri 紫摺).

Shunchō 春町 (1744–1789) *N*. Kurahashi Kaku 倉橋格 *Gō*. Juhei
壽平 Kakuju-sanjin 格壽山人 Sakenoueno-furachi 酒上不
埒 Shunchōbō 春町坊 Koikawa Harumachi 戀川春町 *S*.
Ukiyoye school. Pupil of Sekien. *L & C*. Lived in Edo.
Novelist and illustrater.

Shun-ei 春英 (1762–1819) *N*. Isoda 磯田 *F. N*. Kyūjirō 久次
郎 *Gō*. Katsukawa Shun-ei 勝川春英 Kyūtokusai 九德齋

S. Ukiyoye school. Pupil of Shunshō. *L & C*. Lived in Edo. Illustrated in many story books. *Sp*. actors, play-scenes.

Shunga 俊賀 (flourished in the former half of 13th cent.) Priest name: Shunga 俊賀. *S*. Buddhistic painting. *L & C*. Lived in Kyōto. Painted at Jingoji Temple and Kōzanji Temple.

Shungyōsai 春曉齋 (d. 1823) *N*. Hayami Tsuneaki 速水恒章 *F. N*. Genzaburō 彦三郎 *Gō*. Shungyōsai 春曉齋 *S*. Ukiyoye school. Followed the technique of Gyokuzan. *L & C*. Born in Ōsaka. Illustrated story-books.

Shunkin 春琴 (1779–1846) *N*. Uragami Sen 浦上選 *A*. Haku-kyo 伯擧 *Gō*. Shunkin 春琴 Suian 睡庵 Bunkyōtei 文鏡 亭 *S*. Nanga school. Studied under his father, Gyokudō. *L & C*. Born in Bizen. Lived in Kyōto. But his style differs from that of his father's, because he studied Chinese paintings of the Yuan and Ming dynasties. *Sp*. landscape, flowers-and-birds.

Repr. B. 38. K. 376, 408, 479.

Shunkō 春好 (d. c. 1827) *N*. Katsukawa Shunkō 勝川春好 *Gō*. Sahitsuan 左筆庵 *S*. Ukiyoye school. Pupil of Shunshō. *L & C*. Lived in Edo. *Sp*. female figures.

Shunkyo 春擧 (1871–1933) *N*. Yamamoto Kin-emon 山元金右 衞門 *Gō*. Shunkyo 春擧 *S*. Japanese style. Pupil of Nomura Bunkyo, and Mori Kansai. *L & C*. Lived in Kyōto. Professor of the Kyōto Art School. Member of Imperial Art Committee and Teikoku Bijutsu-in. *Sp*. landscape, flowers-and-birds.

Repr. K. 244, Shunkyo Ihō 春擧遺芳.

Shunrō See Hokusai.

Shunsa 春沙 (1818–1858) *N.* Tachihara Kuri 立原栗 or Kuri 久里 *A.* Sasa 沙々 Shunsa 春沙 *S.* Nanga school. Studied under her father, Kyōsho. Later, pupil of Kazan. *L & C.* Daughter of Kyōsho. Served lady Maeda in Kaga. *Sp.* flowers-and-birds. *Repr.* K. 588

Shunsei See Buson.

Shunshō 春章 (1726–1792) *N.* Katsukawa Shunshō 勝川春章 *F. N.* Yūsuke 勇助 *Gō.* Jūgasei 縦畫生 Ririn 李林 Kyoku-rōsei 旭朗井 Yūji 酉爾 Rokurokuan 六々庵 *S.* Ukiyoye school. Pupil of Shunsui. *L & C.* Lived in Edo. His former family name was Katsumiyagawa 勝宮川 *Sp.* female figures (both original and printed).

Repr. K. 19, 24, 51, 87, 170, 231, 281, 530, 531.

Shunsō 春草 (1874–1907) *N.* Hishida Mioji 菱田三男治 *Gō.* Shunsō 春草 *S.* Japanese style. Graduate of the Tōkyō Art school. *L & C.* Lived in Tōkyō. Member of the Nippon Bijutsu-in. *Sp.* flowers-and-birds, figures. *Repr* B. 101. Hishida Shunsō 菱田春草.

Shunsui 春水 (flourished in the former half of 18th cent.) *N.* Miyagawa Shunsui 宮川春水 *F. N.* Tōshirō 藤四郎 *S.* Ukiyoye school. Studied under his father, Chōshun. *L & C.* His family name was Miyagawa, but he later changed his name to Katsukawa. *Repr.* K. 129.

Shuntō See Shukuya.

Shunzan 春山 (flourished in the end of 18th cent.) *N.* Katsukawa Shunzan. 勝川春山 *S.* Ukiyoye school. Pupil of Shunshō. Influenced by Kiyonaga.

Shūō See Kaioku.

Shūseki 秀石 (1639–1707) *N.* Watanabe Shūseki 渡邊秀石 *A.*
 Genshō 元章 *Gō.* Jinjusai 仁壽齋 Randōjin 嬾道人 Enka
 烟霞 Chikyū 池丘 *S.* Nanga school. Pupil of Itsunen.
 L & C. Lived in Nagasaki. *Sp.* landscape. *Repr.* B. 12.

Shūtoku 周德 (flourished in the latter half of 15th cent.)
 N. Shūtoku 周德 *Gō.* Ikei 惟馨 *S.* Muromachi Suiboku
 school. *L & C.* Lived in Tōfukuji Temple in Kyōto (?)
 Repr. B. 54. K. 65.

Sōami 相阿彌 (d. 1525) *N.* Shinsō 眞相 *F. N.* Sōami 相阿彌 *S.*
 Muromachi Suiboku school. Pupil of his father, Geiami.
 L & C. Lived in Kyōto. Served Shogun Ashikaga. Fa-
 mous as a gardener as well as a painter. *Sp.* landscape.
 Repr. B. 53. K. 2, 20, 64, 85, 135, 159, 169, 199, 249.

Sōen 宗淵 (flourished c. 1500) *N.* Sōen 宗淵 *A.* Josui 如水
 S. Muromachi Suiboku school. Pupil of Sesshū. *L & C.*
 Lived in Enkakuji Temple in Kamakura. *Repr.* K. 37.

Sōhei 草坪 (1804–1834) *N.* Takahashi U 高橋雨 *A.* Sōhei 草
 坪 *S.* Nanga school. Pupil of Chikuden. *L & C.* Born
 in Bungo. Became a home-pupil of Chikuden at nineteen.
 Studied also the technique of the old Chinese paintings.
 Travelled with his teacher in Kyōto. Died young, though
 he was a good painter. *Sp.* landscape. flowers-and-
 birds. *Repr.* K. 319, 397, 409, 437, 503, 576, 588.

Sōjun See Ikkyū.

Soken 素絢 (1759–1818) *N.* Yamaguchi Soken 山口素絢 *A.*
 Hakugo 伯後 *F. N.* Takejirō 武次郎 *Gō.* Sansai 山齋 *S.*
 Maruyama school. Pupil of Ōkyo. *L & C.* Lived in
 Kyōto. *Sp.* female figures.
 Repr. K. 166, 221, 266, 282, 307, 311, 374, 391, 415.

Sōken See Goshun.

Sompaku See Gekkei.

Sonsai 巽齋 (1736–1802) *N.* Kimura Kōkyō 木村孔恭 *A.* Sei-
shuku 世肅 *Gō.* Sonsai 巽齋 Kenkadō 蒹葭堂 *S.* Nanga
school. *L & C.* Born and lived in Ōsaka, His paintings
were later valued by Chikuden. *Sp.* landscape.

Sōri 宗理 (flourished in the latter half of 18th cent.) *N.*
Tawaraya Sōri 俵屋宗理 *F. N.* Mototomo 元知 *Gō.* Ryū-
ryūkyo Hyakurin 柳々居百琳 *S.* Kōrin school. Pupil
of Sumiyoshi Hiromori. Later influenced by Kōrin style.
Repr. K. 438.

Soringaishi See Aigai.

Sōritsu 宗栗 (16 cent.) *N.* Oguri Sōritsu 小栗宗栗 *S.* Muro-
machi Suiboku school. Pupil of his father, Sōtan. *L & C.*
Lived in Daitokuji Temple in Kyōto. *Sp.* animals (horse).
Repr. K. 125, 157, 199.

Sosen 狙仙 (1747–1821) *N.* Mori Shushō 森守象 *A.* Shukuga
叔牙 *F. N.* Hanaya Hachibē 花屋八兵衞 *Gō.* Sosen 狙仙,
祖仙 Jokansai 如寒齋 Reimeian 靈明菴 Reibyōan 靈猫菴
S. Studied Kanō school under Yamamoto Joshunsai. Later
changed his style to that of Maruyama Shijō school.
L & C. Born in Nagasaki. Lived in Ōsaka. His paintings
of animals were highly valued by Ōkyo. His pupils:
Rokō, Sosetsu, Shunkei, Gyokusen etc.
Repr. K. 18, 46, 110, 131, 416, 498.

Sōsetsu 相說 (flourished in the middle of 17th cent.) *N.* Kita-
gawa Sōsetsu 喜多川相說 *S.* Sōtatsu school. Pupil of
Sōtatsu. *L & C.* Said to be born at Kanazawa.

Sōsetsu 宗雪 (flourished in the middle of 17th cent.) *N.* (No-

nomura) Sōsetsu (野々村) 宗雪 *Gō.* Inen 伊年. Probably the same person with Sōsetsu 宗説 *S.* Sōtatsu school. Pupil of Sōtatsu. *L&C.* Lived at Sakai in Izumi (?) *Sp.* flowers.

Repr. K. 505.

Sōsetsusai See Senka.

Sōshū 宗周 (1551–1601) *N.* Kanō Suenobu 狩野季信 *F. N.* Jin-no-suke 甚之助 *Gō.* Sōshū 宗周 *S.* Kanō school. Pupil of his father, Shōei and his elder brother Eitoku. *L & C.* Lived in Kyōto. *Repr.* K. 56.

Sōtan 宗湛 (1413–1481) *N.* Oguri Sōtan 小栗宗湛 Sōtan 宗丹 *Gō.* Jiboku 自牧 *S.* Muromachi Suiboku school. Said to be a pupil of Shūbun. *L & C.* Served Ashikaga Shōgun as a painter. Seems to have been one of the greatest painters in the Muromachi period. But none of his works remains. Lived in Kyōto.

Repr. K. 21, 82, 120, 132.

Sōtatsu 宗達 (flourished in the beginning of 17th cent.) *N* Nonomura Sōtatsu 野々村宗達 *A.* (Inen 伊年) *Gō.* Taisei-ken 對青軒 (Tawaraya) Sōtatsu (俵屋) 宗達 *S.* Distin-guished painter who founded Sōtatsu school (a new style of old yamatoye). *L & C.* Lived in Kyōto and had some relation with Daigoji Temple. Kōetsu seems to have been one of his intimate friends. *S.* classical figures (rather decorative).

Repr. B. 2, 10, 20, 23, 73, 90, 98, 101. K. 14, 33, 40, 62, 101, 143, 192, 196, 205, 280, 309, 348, 357, 363, 364, 368, 373, 453, 461, 469, 483, 492, 497, 545, 562. N. 13, 82.

Sōtatsu Gashū 宗達畫集

Sōtei 宗庭 (1590–1662) *N.* Kanda Nobusada 神田信定 (Mune-nobu 宗信) *F. N.* Shōshichi 庄七 *Gō.* Sōtei 宗庭 *L & C.* The *gō* of Sōtei succeeded to his descendants. *Sp.* Buddhistic subject.

Sōun 草雲 (1815–1898) *N.* Tazaki Un 田崎芸 *Gō.* Şōun 草雲 *S.* Japanese style. Pupil of Kanai Ushū, Haruki Nammei and Tani Bunchō. Nanga school. *L & C.* Lived at Ashi-kaga in Tochigi prefecture. *Sp.* landscape.

Repr. Tazaki Sōun-sensei Iboku Tenrankai Zūroku 田崎草雲先生遺墨展覽會圖錄.

Soyama Sachihiko 曾山幸彦 (1859–1892) *N.* Sōyama Sachihiko 曾山幸彦 later Ōno Sachihiko 大野幸彦 *S.* Western style. Pupil of San Giovanni. *L & C.* Born in Kagoshima, and lived in Tōkyō. Assistant professor of the department of Engineering in Tōkyō Imperial University. Taught followers at his private school. *Sp.* landscape (in oil and water-colour).

Sōyo See Dasoku.

Sōyū 宗祐 (flourished in 16th cent.) *Gō.* Sōyū 宗祐 *S.* Kanō school. *L & C.* Unknown. Said to have been the same person with Gyokuraku.

Repr. K. 317, 442, 510, 594.

Suian 穗庵 (1844–1890) *N.* Hirafuku Un 平福芸 *F. N.* Junzō 順藏 *Gō.* Bunchi 文池 Suian 穗庵 *S.* Japanese style. Shijō school. Pupil of Takemura Bunkai. *L & C.* Lived in Tōkyō and Akita. *Sp.* animals.

Repr. Hirafuku Suian Gashū 平福穗庵畫集.

Suian See Shunkin.

Suibokusai 醉墨齋 (15th cent.) *N.* An-ei 安榮 *A.* Tōrin 桃林

Gō. Suibokusai 醉墨齋 *S*. Muromachi Suiboku school. *L & C*. Lived in Kyōto. *Repr*. K. 51.

Suibokusanjin See Kōyō.

Suichikuan See Chikuō.

Suiō 水鷗 (flourished in the former half of 18th cent.) *N*. Tamura Suiō 田村水鷗 *Gō*. Suiō 水鷗 *S*. Ukiyoye school. *S*. female figures.

Repr. K. 44, 126, 142, 413, 435.

Suiran See Kankan.

Suishinsai See Dainen.

Sukenobu 祐信 (1671–1751) *N*. N. Nishikawa Yūsuke 西川祐助 later Sukenobu 祐信 *F. N.* Ukyō 右京 *Gō*. Jitokusai 自得齋 Bunkadō 文華堂 *S*. Ukiyoye school. Pupil of Kanō Einō, Tosa Mitsusuke. Influenced by Hishikawa style. *L & C*. Lived in Kyōto. Painted many illustrations in story-books such as " Yamato-hiji " 倭比事 (10 volumes). *Sp*. figures.

Repr. K. 37, 75, 480, 515.

Sukeyasu 相保 (floruished c. 1500) *N*. Kaida Sukeyasu 海田相保 *F. N.* Unemenosuke 釆女祐 *S*. Tosa school. *L & C*. Famous as a painter of the scroll of " Saigyō Monogatari " 西行物語 (not remained). *Repr*. K. 76.

Sūkoku 嵩谷 (1730–1804) *N*. Kō Kazuo 高一雄 *A*. Shiei 子盈 *Gō*. Sūkoku 嵩谷 Toryūō 屠龍翁 Suiundō 翠雲堂 Korensha 湖蓮舍 Rakushisai 樂只齋 *S*. Pupil of Hanabusa Itchō. Later studied the technique of Tosa school. *L & C*. Lived in Edo. *Sp*. genre, historical subjects.

Repr. K. 80, 155, 523.

Tadamoto See Hōitsu.

Taiga 大雅 (1723-1776) *N.* Ikeno Arina 池野無名 (Tsutomu
勤) *A.* Taisei 貸成 *F. N.* Shūhei 秋平 *Gō.* Taiga
大雅 Kashō 霞樵 Kyūka-sanshō 九霞山樵 Fukochōsō
鳧潯釣叟 Gyokukai 玉海 Chikukyo 竹居 Sangakudōja
三岳道者 Taikadō 待賈堂 Taigadō 大雅堂 *S.* Distin-
guished painter of Nanga school. Influenced by Ryū
Rikyō, Nankai and I Fuchiu. *L & C.* Born and lived
in Kyōto. Completed Japanese Nanga school. Excelled
in calligraphy and studied doctrine of Zen-sect. Lived
a free and easy life, travelling to many famous moun-
tains. Associated with many writers and painters. *Sp.*
landscape and figures.

Repr. B. 41, 49, 50, 57, 73, 94. K. 116, 150, 156, 179, 216,
271, 296, 330, 339, 344, 361, 367, 381, 392, 486, 515, 522,
528, 540, 553, 571, 582, 587. N. 33, 64, 68, 73, 84. Ike
Taiga-sensei Senji-yokō 池大雅先生鷹事餘光 Ike Taiga
Meigafu 池大雅名畫譜

Taigan 大含 (1773–1850) *N.* Taigan 大含 *Gō.* Unge 雲華
Unge-in 雲華院 Kōsetsu 鴻雪 Senkōjin 染香人 *S.* Nanga
school. Associated with Shōchiku, Kaioku, Chikuden,
etc, *L & C.* Born in Bizen, Priest. Went to Kyōto
where studied Confucianism. Promoted to a teacher of
Takakura-gakuryō 高倉學寮 (a college of Confucianism)
in Kyōto. *Sp.* bamboos, orchids.

Taikei See Shizan.

Tairō 大浪 (flourished in the beginning of 19th cent.)
N. Ishikawa Tairō 石川大浪 *F. N.* Shichizaemon 七左
衞門 *Gō.* Kunshōken 薰蒅軒 *S.* Kanō school. *L & C.*
Lived at Honjō.

Taiseiken See Sōtatsu.

Taito See Hokusai.

Taito II 載斗 (the beginning of 19th cent.) *N.* Katsushika
Taito 葛飾載斗 *F. N.* Kisaburō 喜三郎 *Gō.* Hokusen 北
泉 Taito 載斗 Beikasai 米花齋 Genryūsai 玄龍齋 *S.*
Ukiyoye school. Pupil of Hokusai. *L & C.* Born in
Edo. Master of a tea-house. After studying under
Hokusai, lived in Ōsaka.

Taizan 對山 (1814–1869) *N.* Hine Morinaga 日根盛長 *A.*
Shōnen 小年 *Gō.* Taizan 對山 *S.* Japanese style. Nanga
school. *L & C.* Lived in Kyōto. *Sp.* landscape.

Repr. K. 337, 358.

Takachika 隆親 (flourished in 12th cent.) *N.* Fujiwara
Takachika 藤原隆親 *S.* Yamatoye school.

Takahashi Yuichi 高橋由一 (1829–1894) *N.* Takahashi Yuichi
高橋由一 *Go.* Ransen 籃川 Kain-itsujin 華陰逸人 *S.*
Western style. Pupil of Kawakami Tōgai and of Charles
Wirgman. *L & C.* Born and lived in Tōkyō. Professor
at Imperial University. Founded private school called
Tenkaigakusha 天繪學舍, and taught his pupils there.
Sp. figures and still life.

Repr. B. 59. Kotohiragū Yuichi Gashū 金刀比羅宮由一畫集.

Takakane 隆兼 (flourished in the beginning of 14th cent.) *N.*
Takashina Takakane 高階隆兼 *S.* Yamatoye school.
L & C. Painted the scrolls of " Kasuga-gongen-kenki "
春日權現驗記 consisting of 20 volumes. Appointed
to the Chief painter of Edokoro. *Sp.* historical subjects.

Repr. K. 31, 164, 241. N. 64.

Takamitsu 隆光 (flourished in the beginning of 15th cent.)
N. Awataguchi Takamitsu 粟田口隆光 *S.* Yamatoye
school. *L & C.* Painted a part of the scroll of "Yūzū
Nembutsu Engi" 融通念佛緣起 (Coll. Seiryōji Temple
in Kyōto) in 1414. *Sb.* Buddhistic painting.
Repr. K. 246. N. 32, 64.

Takanobu 孝信 (1571–1618) *N.* Kanō Takanobu 狩野孝信
F. N. Ukonshōgen 右近將監 *S.* Kanō school. Pupil of
his father, Eitoku. *L & C.* Lived in Kyōto. Father of
Morinobu (Tan-yū), Naonobu, and Yasunobu (distin-
guished painters of Kanō school of early Edo period).
Repr. K. 31, 371.

Takanobu 隆信 (1143–1205) *N.* Fujiwara Takanobu 藤原隆信
S. Yamatoye school. *L & C.* Lived in Kyōto. Courtier.
Excelled in making poems as well as painting. The
portraits of Minamoto Yoritomo and Taira-no-Shigemori
(Coll. Jingoji Temple) are ascribed to him. Among
his descendants there are several yamatoye painters
excelling in painting portraits. *Sp.* figures, portraits.
Repr. B. 47. K. 162, 230, 248, 280. N. 1.

Takasuke 隆相 (14th cent.) *N.* Fujiwara Takasuke 藤原隆相
S. Yamatoye school. Pupil of his father Nagataka.
Repr. K. 107.

Takayoshi 隆能 (flourished in the middle of 12th cent.) *N.*
Fujiwara Takayoshi 藤原隆能 *S.* Yamatoye school *L
& C.* Served as a Court painter. Painted on doors of
temples and shrines, and also a portrait of ex-
Emperor Toba. The painting scrolls of " Genji Mono-

gatari" 源氏物語繪巻 (Coll. Baron Masuda and Marquis
Tokugawa) are attributed to him.

Repr. K. 17, 18, 180, 182.

Takuhō 卓峯 (1652–1714) *Gō.* Takuhō 卓峯 *S.* Kanō school.
Pupil of Tan-yū. *L & C.* Lived in Kyōto. Chief Zen-
priest of Bukkokuji Temple.

Repr. K. 135.

Takukadō See Chinzan.

Tambi 探美 (1840–1893) *N.* Kanō Moritaka 狩野守貴 *Gō.*
Tambi 探美 *S.* Japanese style. Pupil of his father,
Tan-en. *L & C.* Lived in Tōkyō. *Sp.* landscape and
flowers-and-birds.

Tamechika 爲恭 (1823–1864) *N.* Reizei Tamechika 冷泉爲恭
Okada Tamechika 岡田爲恭 *F. N.* Saburō 三郎 *Gō.*
Matsudono 松殿 *S.* Fukko Yamatoye school. Studied
Kanō school and later Yamatoye. Influenced by Ukita
Ikkei. *L & C.* Lived in Kyōto. Loyalist. Killed by a
lordless samurai at Tambaichi in Yamato. *Sp.* classical
figures, Buddhistic subjects.

Repr. B. 17. K. 64, 92, 112, 227, 284, 297, 327, 361, 466,
475, 486, 503, 533. N. 57. Tamechika Gashū 爲恭畫集

Tamenari 爲成 (11th cent.) *N.* Tamenari 爲成 *S.* Yamatoye
school. Distingushed painter of that time. *L & C.*
Lived in Kyōto. Said to have painted walls and doors
of Hō-ō-dō Hall in Byōdōin in 1053.

Repr. K. 3, 25.

Tamenobu 爲信 (1261–1304) *N.* Fujiwara Tamenobu 藤原爲信
(Hōshōji Tamenobu 法性寺爲信) Priest name: Jakuyū
寂融 *S.* Yamatoye school. *L & C.* Courtier. Painted

the scroll of " Festival of Kamo Shrine." 賀茂祭圖卷
Said to be a painter of the scroll " Sekkan Daijin Ei."
攝關大臣影圖卷 (portraits of courtiers).

Tametō 爲遠 (flourished in the middle of 12th cent.) *N.*
Takuma Tametō 詫摩爲遠 *Gō.* Shōchi 勝智 *S.* Yamatoye
school. *L & C.* Lived in Kyōto. Served Emperor
Konoe. *Sp.* Buddhistic subjects.

Tametsugu 爲繼 (d. 1266) *N.* Fujiwara Tametsugu 藤原爲繼
L & C. Courtier and poet. Son of Fujiwara Nobuzane.
Repr. K. 4.

Tamura Sōritsu 田村宗立 (1844–1918) *N.* Tamura Sōritsu 田
村宗立 *S.* Western style. Pupil of Takahashi Yuichi.
L & C. Born in Kyōto Prefecture, went to Tōkyō and
studied painting under Takahashi Yuichi. Lived at
Kyōto. Pioneer of painting in Western style of Meiji
era in Kyōto. Lecturer at Kyōto Art School.

Tan-an See Chiden.

Tangen 探元 (1679–1767) *N.* Kimura Tokikazu 木村時員 *F.N.*
Mura-emon 村右衞門 Morihiro 守廣 *Gō.* Sangyō-an 三
曉庵 Tangen 探元 Daini 大貳 *S.* Kanō school. Pupil
of Tanshin. *L & C.* Born in Satsuma. Went to Edo and
lived there.
Repr. B. 13.

Tan-yū 探幽 (1602–1674) *N.* Kanō Morinobu 狩野守信 *F. N.*
Shirojirō 四郎次郎 Uneme 釆女 *Gō.* Tan-yū 探幽 Byaku-
renshi 白蓮子 Hippōdaikoji 筆峯大居士 Seimei 生明 *S.*
One of the most distinguished painters of Kanō school.
Eldest son of Takanobu. Studied under Kōi. *L & C.* Lived
in Edo. Nominated to the chief painter of Edokoro of

Shogunate Government. Founded the Kanō school at
Kobikichō in Edo. *Sp.* landscape, figures.

 Repr. B. 4, 8. K. 8, 32, 51, 100, 113, 126, 139, 154, 162, 171,
181, 184, 190, 200, 203, 214, 216, 236, 241, 244, 278, 282,
294, 301, 305, 321, 327, 338, 358, 368, 389, 400, 409, 416,
428, 439, 446, 457, 462, 478, 491, 502, 531, 547, 553, 564,
588, 569, 578, 588, 596. N. 66, 71. Kanō Tan-yū 狩野探幽.

Tanzan 探山 (1655–1729) *N.* Tsuruzawa Kanenobu 鶴澤兼信
Gō. Tanzan 探山 Yūsen 幽泉 *S.* Kanō school. Pupil
of Tan-yū. *L & C.* Lived in Kyōto.

Tekkanshi See Tesseki.

Tenju See Dainen.

Tenkaikutsu See Ganku.

Terukata 輝方 (1883–1917) *N.* Ikeda Shintarō 池田信太郎 *Gō.*
Terukata 輝方 *S.* Japanese style. Pupil of Mizuno
Toshikata and Kawai Gyokudō. *L & C.* Lived in Tōkyō.
Sp. female figures.

Tessai 鐵齋 (1836–1924) *N.* Tomioka Hyakuren 富岡百錬 *Gō.*
Tessai 鐵齋 *S.* Japanese style. Nanga school. Studied
by himself. *L & C.* Lived in Kyōto. Member of the
Imperial Art Committee and the Teikoku Bijutsu-in.
Sp. landscape.

 Repr. B. 70, 106, 107. K. 399. Tessai-sensei Meigashū,
鐵齋先生名畫集 Tessai-sensei Ibokushū 鐵齋先生遺墨集.

Tesseki 鐵石 (1817–1863) *N.* Fujimoto Makane 藤本眞金
A. Chūkō 鑄公 *F. N.* Tsunosuke 津之助 *Gō.* Tesseki
鐵石 Tekkanshi 鐵寒士 Baisaiō 賣菜翁 Tomon 都門 *S.*
Nanga school. *L & C.* Lived in Kyōto. Clansman of

Bizen. Loyalist. Skilled in military arts, and calligraphy. *Sp.* landscape.

Tetsuō 鐵翁 (1791–1871) *N.* Hidaka 日高 *A.* Tetsuō 鐵翁 *Gō.* Somon 祖門 *S.* Japanese style. Pupil of Ishizaki Yūshi. Influenced by Chiang Chia-pu (Kō Kaho). *L & C.* Lived in Nagasaki. Priest of Shuntokuji Temple in Nagasaki. *Sp.* flowers-and-birds and landscape.

Repr. K. 497.

Tetsuzan 徹山 (1775–1841) *N.* Mori Shushin 森守眞 *A.* Shigen 子玄 *Gō.* Tetsuzan 徹山 *S.* Maruyama school. Pupil of Ōkyo. Painted in Western style, later. *L & C.* Lived in Kyōto. Son-in-law of Sosen. *Sp.* figures, flowers-and-birds.

Repr. K. 123, 316, 449.

Toba-sō-jō See Kakuyū.

Tobeian See Jakuchū.

Tōbun 洞文 (16 cent.) *N.* Doki Tōbun 土岐洞文 *S.* Muromachi Suiboku school. Followed the technique of Shūbun.

Repr. K. 178.

Tōeki 等益 (1591–1644) *N.* Unkoku Motonao 雲谷元直 *Gō.* Tōeki 等益 *S.* Unkoku school. Pupil of his father, Tōgan. *L & C.* Lived in Suō. Nominated to Hokkyō. Unkoku the third.

Repr. B. 82. K. 132.

Tōeki 洞益 (d. 1841) *N.* Kanō Harunobu 狩野春信 *Gō.* Tōeki 洞益 *S.* Kanō school. Pupil of his father-in-law, Tōhaku. *L & C.* Sixth painter of the Kanōs at Surugadai in Edo.

Tōetsu 等悦 (flourished in the latter half of 15th cent.) *Gō*. Tōetsu 等悦 *S*. Muromachi Suiboku school. Said to be a pupil of Sesshū. *Sp*. landscape, figures.

Tōgan 等顔 (1547–1618) *N*. Unkoku Tōgan 雲谷等顔 *F. N*. Jihei 治平 *S*. Unkoku school (founder). Followed Sesshū style. *L & C*. Lived in Hizen. Life is unknown for all his fame.

Repr. K. 87, 197, 262, 329, 551, 570, 575.

Tōhaku 等伯 (1539–1610) *N*. Hasegawa Tōhaku 長谷川等伯 *F. N*. Kyūroku 久六 *Gō*. Nobuharu 信春 Tōhaku 等伯 *S*. Hasegawa school. Influenced by Sesshū. *L & C*. Born at Nanao in Noto. Went to Kyōto where studied painting and became a distinguished painter. *Sp*. landscape, animals.

Repr. B. 25, 56. K. 47, 198, 337, 394, 445, 513, 529. N. 30, 66, 72.

Tōhan 等璠 (flourished in the former half of 17th cent.) *N*. Unkoku Tōhan 雲谷等璠 *S*. Unkoku school. Studied under his father, Tōeki. *L & C*. Succeeded the house of his elder brother Tōyo.

Repr. K. 64

Tōkan See Shūgetsu.

Tōkō 稲皐 (1787–1846) *N*. Kuroda Bunshō 黒田文祥 *F. N*. Rokunojō 六之丞 *Gō*. Tōyō 稲葉 Tōkō 稲皐 *S*. Pupil of Tōrei. *L & C*. Lived in Tottori, and later went to Edo. Younger brother of Hayashi Genzaburō (*samurai* of the clan of Tottori). Succeeded the Kurodas. Excelled in military arts. *Sp*. figures, flowers-and-birds.

Repr. K. 23, 27, 35, 293.

Tokusai 德済 (c. 1342) *N.* Tokusai 德済 *Gō.* Tesshū 鐵舟
 S. Pioneer of Suiboku school in the Muromachi period.
 L & C. Zen-priest. Pupil of Priest Musōkokushi. Went
 to China (Yüan dynasty).

Tomikage 富景 (flourished in the middle of 15th cent.) *N.*
 Doki Tomikage 土岐富景 *S.* Muromachi Suiboku
 school. Seems to have studied under Shūbun. *L & C.*
 Samurai of the family of Doki. (Said to be the same
 person with Tōbun.) Lived in Mino. *Sp.* birds (hawks).
 Repr. K. 516.

Tomoto 靹晋 (1864–1931) *N.* Kobori Tomoto 小堀靹晋 *F. N.*
 Keizaburō 桂三郎 *Gō.* Tsurunoya 弦酒舎 *S.* Japanese
 style. Tosa school. *L & C.* Lived in Tōkyō. Professor
 of the Tōkyō Art School. Member of the Teikoku
 Bijutsu-in and the Imperial Art Committee. *Sp.* his-
 torical subjects.
 Repr. Tomoto Ikyō 靹晋遺響, Tsurunoya Gaseki 弦酒舎畫
 迹.

Tōrei 稲嶺 (1735–1807) *N.* Gotō Hirokuni 後藤廣邦 (later
 Hirosuke 廣輔) *F. N.* Hijikata Tōrei 土方稲嶺 *Gō.*
 Tōrei 稲嶺 Gakoken 臥虎軒 *S.* Pupil of Bunchō. Studied
 the technique of Chinese painting of the Ming dynasty
 under Sō-Shiseki. His pupils: Tōkō etc. *L & C.* Born
 and lived in Tottori. Served Lord Ikeda of the clan
 of Tottori. *Sp.* carp.
 Repr. K. 44, 78.

Tōsai 東齋 (1784–1844) *N.* Sugai Gakuho 菅井岳輔 *Gō.* Tōsai
 東齋 Baikan-sanjin 梅關山人 *S.* Nanga school. Pupil
 of Nemoto Jōnan, Bunchō and Ch'ang Chia-pu (Kōkaho).

L & C. Born in Sendai. Loved travelling. Unmarried. Famous local painter like Un-zen. *Sp.* landscape, plum-blossoms.

Toshikata 年方 (1866–1908) *N.* Mizuno Kumejirō 水野粂次郎 *Gō.* Toshikata 年方 *S.* Japanese style. Pupil of Tsu-kioka Hōnen, Watanabe Seltei. *L & C.* Lived in Tōkyō. Member of the Nippon Bijutsu Kyōkai, Nippon Bijutsu-in etc. *Sp.* genre.

Toshun 洞春 (1747–1797) *N.* Kanō Yoshinobu 狩野美信 *F. N.* Sanshirō 三四郎 *Gō.* Tōshun 洞春 *S.* Kanō school. *L & C.* Fourth painter of the Kanōs at Surugadai in Edo.

Tōshun 洞春 (d. 1723) *N.* Kanō Fukunobu 狩野福信 *Gō.* Tōshun 洞春 Shuseisai 守靜齋 *S.* Kanō school. Pupil of his father-in-law Tōun. *L & C.* Lived in Edo. Second painter of the Kanōs at Surugadai in Edo. (Grandson of Kanō Tan-yū).

Tōshūsai See Sharaku.

Totsugen 訥言 (1768–1823) *N.* Tanaka Totsugen 田中訥言 (Chi 癡 Bin 敏) *A.* Kotō 虎頭 *Gō.* Daikōsai 大孝齋 Chiō 癡翁 Kahukyūshi 過不及子 Tokuchū 得中 Kimpei 均平 Kyūmei 求明 Kaison 晦存 *S.* Fukko Yamatoye school. Pupil of Ishida Yūtei. Later studied Tosa school under Mitsusada and founded New Yamatoye school. *L & C.* Born in Kyōto. Lived in Nagoya and died in Kyōto. Nominated to Hokkyō. Painted on the walls of the Imperial Palace in 1790. Became blind in his old age, and committed suicide. *Sp.* historical subjects.

Repr. K. 72, 83, 95.

Tōun 洞雲 (1625–1694) *N.* Kanō Masunobu 狩野益信 *F. N.*
Uneme 采女 *Gō.* Tōun 洞雲 Hakuyūken 溥友軒 Sōshin-
dōjin 宗深道人 Shōnshi 松蔭士: *S.* Kanō school. Pupil
of his father-in-law, Tan-yū. *L & C.* Lived in Edo.
Son of Gotō Ritsujō Mitsuyori. Adopted by Tan-yū as
son by whom his pictures were valued. As Tan-yū's
real sons, Tanshin, and Tansetsu were born, established
a branch family of the Surugadai Kanōs.

Repr. K. 145, 314, 472.

Tōyama Gorō 遠山五郎 (1888–1928) *N.* Tōyama Gorō 遠山
五郎 *S.* Western style. Graduated from Tōkyō Art
School in 1914. *L & C.* Born in Fukuoka prefecture,
and lived in Tōkyō. Travelled in America in 1914, and
in France in 1920 where studied in Academie Julien
and under Guerin C.

Repr. Tōyama Gorō Sakuhinshū 遠山五郎作品集.

Tōyo 等與 (flourished in the beginning of 17th cent.) *N.* Un-
koku Tōyo 雲谷等與 *S.* Unkoku school. Pupil of his
father, Tōeki. *L & C.* Lived in Hizen.

Repr. B. 32.

Tōyō See Sesshū.

Tōyō See Tōko.

Tōyō 東洋 (1755–1839) *N.* Azuma Tōyō 東 東洋 *A.* Taiyō 大
洋 *Gō.* Gyokuga 玉峨 *S.* Maruyama school. Studied
the technique of Kanō school under Baishō. Later his
style changed as he associated with Taiga, Ōkyo and
Gekkei. *L & C.* Born in Mutsu. Served the lord
of the clan of Sendai as a painter. *Sp.* landscape,
figures.

Toyoaki See Utamaro.

Toyoharu 豐春 (1735–1814) *N.* Utagawa Toyoharu 歌川豐春
F. N. Tajimaya Shōjirō 但馬屋庄次郎 Shin-emon 新右衞
門 Priest name: Shōju 昌樹 *Gō.* Ichiryūsai 一龍齋 Sen-
ryūsai 潜龍齋 Sen-ō 潜翁 *S.* Ukiyoye school. Pup'l of
Tangei and Seki-en. Influenced by Toyonobu. Founder
of Utagawa school. *L & C.* Born in Bungo, lived in
Kyōto and later in Edo. In 1796 became the head of the
painters who engaged in the repairing of Mausoleum in
Nikko. *Sp.* female figures.

Repr. K. 105.

Toyohiko 豐彦 (1773–1845) *N.* Okamoto Toyohiko 岡本豐彦
A. Shigen 子彦 *F. N.* Shiba 司馬 (or Shume 主馬) *Gō.*
Kōson 菘村 Rikyō 鯉喬 Chōshinsai 澄神齋 Tangaku-
sanjin 丹岳山人 *S.* Shijō school. Pupil of Ryōzan and
Goshun. *L & C.* Born in Bizen and there learned
painting under Ryōzan. Coming to Kyōto, became a
pupil of Goshun, and founded his own style. Lived in
Kyōto. *Sp.* landscape.

Repr. B. 43. K. 38, 223, 376, 402.

Toyohiro 豐廣 (1774–1829) *N.* Utagawa Toyohiro 歌川豐廣
F. N. Tōjirō 藤次郎 *Gō.* Ichiryūsai 一柳齋 *S.* Uki-
yoye school. Pupil of Toyoharu. Not satisfied with
being a Ukiyoye-painter, studied the technique of Kanō
school and others. His pupils: Hiroshige, famous lands-
cape painter, etc. *L & C.* Born and lived in Edo. Com-
peted against Toyokuni, but his paintings were not
welcomed by people. Illustrated in story books.

Repr. K. 122

Toyokuni 豐國 (1769-1825) *N.* Utagawa Toyokuni 歌川豐國 *F. N.* Kumakichi 熊吉 *Gō.* Ichiyōsai 一陽齋 *S.* Ukiyoye school. Pupil of Toyoharu. Influenced by Itchō, and Shun-ei. *L & C.* Lived in Edo. Said to be the originator of *Azuma Nishikiye* 東錦繪 (beautiful Nishikiye made in Edo). *Sp.* female figures, portraits of actors.

Toyokuni II 豐國(二代) (1777-1835) *N.* Utagawa Toyokuni 歌川豐國 *F. N.* Genzō 源藏 *Gō.* Kunishige 國重 Toyoshige 豐重 Ichiryūsai 一龍齋 Kōsotei 後素亭 Ichieisai 一瑛齋 Ichibetsusai 一鼈齋 *S.* Ukiyoye school. Pupil of Toyokuni. *L & C.* Excellent follower of Toyokuni I. Called himself Toyokuni II and was opposed by other followers of Toyokuni I. Changed his name to Kunishige. Lived at Hongō in Edo as a pottery dealer. Painted many nishikiye and illustrations for *kusazōshi* (story-books). *Sp.* female figures.

Toyokuni III See Kunisada.

Toyonobu 豐信 (1711-1785) *N.* Ishikawa Toyonobu 石川豐信 *F. N.* Nukaya Shichibei 糠屋七兵衞 *Gō.* Meijōdō Shūha 明篠堂秀葩 *S.* Ukiyoye school. Studied under Shigenaga. *L & C.* Lived in Edo. *Sp.* female figures.

Repr. B. 70. K. 115, 356.

Toyoshige See Toyokuni II.

Tsū 通 (1559-1616) *N.* Ono Tsū 小野通 *S.* Kanō school. Said to have been a pupil of Yukinobu. *L. & C.* A woman-painter. Lived in Kyōto. Served Oda Nobunaga, later Yodogimi (wife of Toyotomi Hideyoshi). Famous as a writer of *jōruri* 淨瑠璃 *Sp.* figures.

Tsukimaro 月麿 (flourished from 1801 to 1829) *N.* Kitagawa
Tsukimaro 喜多川月麿 [First name: Kitagawa Jun 喜多川
潤] *A.* Shitatsu士達 *F. N.* Rokusaburō六三郎 *Gō.* Bokutei
墨亭 Kansetsusai 觀雪齋 Kikumaro 喜久麿 *S.* Ukiyoye
school. Pupil of Utamaro. *L & C.* Lived in Edo. Illustrated
kusazōshi (story-books). Changed his name to Tsuki-
maro in 1804.

Tsunemasa 常正 (beginning of 18th cent.) *N.* Kawamata
Tsunemasa 川又常正 *S.* Ukiyoye school. *L & C.* Lived
in Edo. *Sp.* female figures. *Repr.* K. 43, 352

Tsunenobu 常信 (1636–1713) *N.* Kanō Tsunenobu 狩野常信
F. N. Ukon 右近 *Gō.* Yōboku 養朴 Seihakusai 青白齋
Kosensō 古川叟 Kōkan-sai 耕寛齋 Shibiō 紫微翁 Kan-
unshi 寒雲子 Bokusai 朴齋 Kōcho-sanjin 篁渚散人 Rōgō-
ken 弄毫軒 Sen-oku 潛屋 *S.* Kanō school. Pupil of his
father, Naonobu. *L & C.* Lived in Edo. Succeeded
the Kanō estate in Kobiki-chō. In December of 1709
painted on *shōji* (sliding doors) in the Imperial Court.
Attended Sentō Palace (Exemperor's palace) as a painter.
Repr. K. 22, 33, 57, 97, 115, 323, 335, 360, 418, 477, 552, 567

Tsunenori 常則 (the middle of 10th cent.) *N.* Asukabe Tsune-
nori 飛鳥部常則 *S.* Yamatoye school. *L & C.* Lived in
Kyōto. Court-painter and often painted by the Emperor
Murakami's order.

Tsunetaka 經隆 (flourished in the latter half of 12 cent.)
N. Fujiwara Tsunetaka 藤原經隆 *S.* Yamatoye school.
L & C. Grandson of Takayoshi. Seems to have served
the Court as a painter. Appointed to the official rank
of *Tosa-gonnokami. Repr.* K. 26, 146.

Tsuneyuki 常行 (17th–18th cent.) *N.* Kawamata Tsuneyuki 川又常行 *S.* Ukiyoye school. *L & C.* Lived in Edo. *Sp.* female figures.

Tsurana 貫魚 (1809–1892) *N.* Morizumi Sadateru 守住定輝 *A.* Shisai 士濟 *F. N.* Tokujirō 德次郎 *Gō.* Tsurana 貫名 *S.* Sumiyoshi school. Pupil of Watanabe Kōki. *L. & C.* Lived in Ōsaka. Member of the Imperial Art Committee. *Sp.* historical subjects.

Tsurayoshi 貫義 (1836–1902) *N.* Yamana Kangi 山名貫義 *Gō.* Tsurayoshi 貫義 *S.* Japanese style. Sumiyoshi school. Pupil of Sumiyoshi Hironuki. *L & C.* Lived in Tōkyō. Professor at Tōkyō Art School. Member of the Imperial Art Committee. *Sp.* historical subjects.

Umpo 雲甫 (15th cent.) *N.* Ryōin 良因 *Gō.* Umposai 雲甫齋 *S.* Muromachi Suiboku school. Pupil of Shūbun. *L & C.* Life is unknown. Lived in Chikuzen (?)
　　Repr. K. 44.

Umpō 雲峯 (1765–1848) *N.* Ō-oka Seikan 大岡成寬 *A.* Kōritsu 公栗 *F. N.* Jihē 次兵衞 *Gō.* Umpō 雲峯 *S.* Nanga school. Pupil of Fuyō. *L & C.* Lived in Edo. Was called a "Nan-p'in at Yotsuya in Edo."

Unchiku 雲竹 (1632–1703) *N.* Hayashi Kan 林觀 *F. N.* Hachi-rō-emon 八郎右衞門 *Gō.* Kitamuki Unchiku 北向雲竹 Keiō 溪翁 Gyokurandō 玉蘭堂 Taikyoan 大虚庵 *S.* Nanga school. *L & C.* Lived in Kyōto. *Sp.* bamboos.

Uneme See Tōun.

Un-en 雲烟 (d. 1852) *N.* Anzai Oto 安西於菟 *A.* San un 山君 *F. N.* Torakichi 虎吉 *Gō.* Un-en 雲烟 Shūsetsu 舟雪

S. Nanga school. Follower of Somon (pupil of Yūshi). *L & C.* Born in Edo and lived there. Versed in technique of old paintings and calligraphies. Wrote " Kinsei Shoga-dan " 近世書畫談.

Unge See Taigan.

Unkei 雲溪 (15th–16th cent.) *S.* Muromachi Suiboku school. Zen-priest.

Repr. K. 319.

Unkoku See Sesshū.

Unshin See Sekiho.

Unshitsu 雲室 (1753–1827) *N.* Kōzen 鴻漸 later Ryōki 了軌 *A.* Gengi 元儀 later Kōhan 公範 *Gō.* Unshitsu 雲室 *S.* Nanga school. *L & C.* Lived in Edo. Born in Kōrenji Temple in Shinshū. Studied Confucianism in Edo. As skilled in making prose and poetry, he founded a society of poets called Fukyūginsha 不朽吟社. His writings on art: " Sansui Cho," 山水徵 " Essay of Unshitsu " 雲室 隨筆.

Repr. K. 176.

Unsho 雲處 (1812–1865) *N.* Maita Ryō 蒔田亮 *A.* Kōhitsu 公弼 *Gō.* Unsho 雲處 *S.* Nanga school. *L & C.* Born at Fukui in Echizen. Travelled to Ōsaka, Kyōto and Edo. And returned to Fukui. *Sp.* bamboo.

Untan 雲潭 (1782–1852) *N.* Kaburagi Shōin 鏑木祥胤 *A.* Sankitsu 三吉 *Gō.* Untan 雲潭 Shōsasei 尙左生 *S.* Nanga school. Pupil of Bunchō. *L & C.* Lived in Edo. *Sp.* Landscape.

Unzan 雲山 (1761–1837) *N.* Yamazaki Ryūkichi 山崎龍吉 *A.*

Genshō 元祥　*Gō.* Unzan 雲山 Bunken 文軒　*S.* Nanga school. *L & C.* Born in Noto, lived in Kyōto. Sanyō and Geppō were his intimate friends. *Sp.* landscape, flowers-and-trees.

Unzen 雲泉 (1759–1811)　*N.* Kushiro Shū 釧就　*A.* Chūfu 仲孚　*F. N.* Bumpē 文平　*Gō.* Unzen 雲泉 Rikuseki 六石 Rairakukoji 磊落居士　*S.* Nanga school. Studied under a Chinese painter at Nagasaki, so his painting show the influence of Chinese style. *L & C.* Born at Shimabara in Hizen. Associated with many painters in Kyōto and Ōsaka. Later lived at Ni-igata in Echigo and became famous as a local painter. *Sp.* landscape. *Repr.* K. 297, 356, 403.

Usen 芋銭 (1868–1938)　*N.* Ogawa Mokichi 小川茂吉　*Gō.* Usen 芋銭　*S.* Japanese style. Studied Western style painting under Honda Kinkichirō and later learned Nanga school by himself. *L & C.* Lived in Ibaragi prefecture. Member of Nippon Bijutsu-in. *Sp.* landscape. *Repr.* Usen-shi Isaku Gasatsu 芋銭子遺作畫册.

Ushu 烏洲 (1796–1857)　*N.* Kanai Jibin (Tai) 金井時敏(泰)　*A.* Shishū 子修　*F. N.* Sachūta 左忠太 (Hikobē 彦兵衞)　*Gō.* Ushū 烏洲　*S.* Japanese style　Pupil of Haruki Nanko. *L & C.* Lived in Tōkyō. *Sp.* landscape. *Repr.* K. 460. Ushū-sensei Iboku-shū 烏洲先生遺墨集.

Utamaro 歌麿 (1754–1806)　*N.* Toriyama Shimbi 鳥山信美　*A.* Toyoaki 豐章　*F. N.* Yūsuke 勇助　*Gō.* Kitagawa Utamaro 喜多川歌麿　*S.* Ukiyoye school.　Distinguished painter. Pupil of Sekien. *L & C.* Lived in Edo.　Arrest-

Academy of New-York. Travelled also in England and France. Exhibited his works in Bunten and Teiten Exhibitions. *Sp*. portraits.

Yasunobu 安信 (1613–1685) *N*. Kanō Yasunobu 狩野安信 *F. N.* Shirojirō 四郎次郎 Genshirō 源四郎 *Gō*. Eishin 永真 Bokushinsai 牧心齋 Seikanshi 靜閑子 Ryōfusai 了浮齋 *S*. Kanō school. Studied under his elder brother Tan-yū. *L & C*. The founder of the Kanōs' at Naka-bashi in Edo.

Repr. K. 62, 139, 300, 350, 424, 442.

Yōboku See Tsunenobu.

Yōretsu 楊月 (flourished c. 1470) *Gō*. Yōgetsu 楊月 *S*. Muromachi Suiboku school. *L & C*. Born in Satsuma. Priest of Kasagi Temple in Yamashiro.

Repr. B. 43, 49. K. 164, 213.

Yōkoku 楊谷 (1675–1716) *N*. Katayama Sadao 片山貞雄 *F. N.* Sōma 宗馬 *Gō*. Yōkoku 楊谷 Gazen-kutsu 畫禪窟 *L & C*. Born in Nagasaki. Succeeded to the house of Kata-yama Sōha who was versed in tea ceremony. *Sp*. flowers-and-birds.

Yokoyama Matsusaburō 横山松三郎 (1838–1884) *N*. Yoko-yama Matsusaburō 横山松三郎 later Bunroku 文六 *S*. Western style. Pupil of a Russian artist who came to Japan in his younger days and of Shimo-oka Renjō. *L & C*. Born in Hokkaidō and lived in Tōkyō. Learned the technique of lithograph and photograph under Shimo-oka Renjō. Founded a private art school at Ikenohata in Tōkyō. Taught the technique of lithograph and photograph in the Military Academy. *Sp*. Por-traits.

Yorozu Tetsugorō 萬鐵五郎 (1885–1927) *N.* Yorozu Tetsugorō 萬鐵五郎 *S.* Western style. *L & C.* Lived in Tōkyō. Graduated from the Tōkyō Art School in 1912. Member of Shun-yō-kai 春陽會.

Yōsai 容齋 (1788–1878) *N.* Kikuchi Takeyasu 菊池武保 *F. N.* Ryōhei 量平 *Gō.* Yōsai 容齋 *S.* Japanese style. Pupil of Takada Enjō. Later established a style of his own. *L & C.* Lived in Tōkyō. Author of "Zenken Kojitsu." 前賢故實 *Sp.* historical subjects.

Repr. K. 104, 108, 116, 301 526.

Yoshimitsu 吉光 (beginning of 14th cent.) *N.* Tosa Yoshimitsu 土佐吉光 *S.* Tosa school. *L & C.* Nominated to the chief painter of Edokoro. *Repr.* K. 58.

Yoshinobu 吉信 (flourished in the beginning of 17 cent.) *N.* Kanō Yoshinobu 狩野吉信 *F.N.* Genzaburō 源三郎 *S.* Kanō school. Pupil of his father, Eitoku. *L & C.* Lived in Kyōto. *Repr.* K. 11, 290. N. 62.

Yoshinobu See Einō.

Yoshio 良雄 (1659–1703) *N.* Ōishi Yoshio 大石良雄 *F. N.* Kuranosuke 内藏之助 *L & C.* Leader of Akaho Shijū-shichi shi 赤穗四十七士 (47 samurai in Akaho who killed Lord Kira for the revenge of their dead lord). Painted as a hobby.

Yoshishige 吉重 (17th cent) *N.* Yano Yoshishige 矢野吉重 *F. N.* Rokurōbē 六郎兵衞 *S.* Unkoku school. *L & C. Samurai* serving Lord Hosokawa. "Battle" 一谷合戰圖 painted on a pair of screens in Marquis Hosokawa's collection is his famous work.

Yu See Nankai.

Yuasa Ichirō 湯淺一郎 (1868–1931) *N*. Yuasa Ichirō 湯淺一郎
S. Western style. Pupil of Yamamoto Hōsui and
Kuroda Seiki. Later studied painting in Western style
at the Tōkyō Art School. *L & C*. Born in Gumma
prefecture, and lived in Tōkyō. Travelled in Europe
for several years. Member of Nika-kai.
Repr. Yuasa Ichirō Gashū 湯淺一郎畫集.

Yūchiku 友竹 (1654–1728) *N*. Kaihō Gantei 海北元貞 later
Dōshin 道親 *A*. Yūchiku 友竹 *Gō*. Dōkō 道杳 *S*.
Kaihō school. Studied under his father Yūsetsu, and
later learned the Kaihō school. *L & C*. Lived in Kyōto.
As a painter, served the ex-Emperors Reigen 靈元
and Higashiyama 東山.

Yūchiku See Moronobu.

Yūen 祐圓 (flourished c. 1384) *Gō*. Yū-en 祐圓 *S*. Buddhistic
painting. *L & C*. Priest. " Image of Jizō " 地藏圖 (coll.
Hōju-in monastery) is his good work. *Sp*. Buddhistic
subjects. *Repr*. N. 20.

Yūga 幽峨 (1824–1866) *N*. Nemoto 根本 *Gō*. Yūga 幽峨 *S*.
Kanō school. Pupil of Ichiga. *L & C*. Born in Tottori.
Painter of the Tottori clan.

Yūhi 熊斐 (1712–1772) *N*. Kumashiro Hi 神代斐 *A*. Kitan 淇
膽 *Gō*. Yūhi 熊斐 Shukukō 繡江 *S*. Nagasaki school. A
distinguished follower of Nan-p'in. *L & C*. Born at
Nagasaki in Hizen. *Repr*. B. 44.

Yukihide 行秀 (the beginning of 15th cent.) *N*. Tosa Yukihide
土佐行秀 *S*. Tosa school. Seems to have been pupil
of his father Yukihiro.
Repr. K. 47, 169. N. 32.

Yukihiro 行廣 (the beginning of 15th cent.) *N.* Tosa Yukihiro 土佐行廣 *S.* Tosa school. *L & C.* Said to have been the eldest son of Yukimitsu or of Mitsukuni.

 Repr. N. 32.

Yukimitsu 行光 (flourished 1360–1371) *N.* Fujiwara Yukimitsu 藤原行光. *S.* Yamatoye school. *L & C.* The chief painter in Edokoro. Nominated to the lord of Echizen. In 1362 painted 6 volumes of " Jizō Reikenki " 地藏靈驗記. *Sp.* Buddhistic images.

Yukinaga 行長 (the beginning of 13th cent.) *N.* Fujiwara Yukinaga 藤原行長. *S.* Yamatoye school.

 Repr. K. 65.

Yukinobu 之信 (1513–1575) *N.* Kanō Yukinobu 狩野之信 *F. N.* Utanosuke 雅樂之助 *Gō.* Mōin 輞隱 *S.* Kanō school. Pupil of his father Masanobu. *L & C.* Lived in Kyōto.

 Repr. K. 20, 152, 189, 262. N. 6.

Yukinobu 雪信 (the middle of 17th cent.) *N.* Kiyohara Yuki 清原雪 *Gō.* Yukinobu 雪信 *S.* Kanō school. Pupil of Tan-yū. Distinguished lady painter. *Sp.* famale figures.

 Repr. K. 597.

Yūkoku 幽谷 (1827–1899) *N* Noguchi Minosuke 野口巳之助 *Gō.* Yūkoku 幽谷 *S.* Japanese style. Pupil of Tsubaki Chinzan. Nanga school. *L & C.* Lived in Tōkyō. Member of the Nippon Bijutsu Kyōkai and Member of the Imperial Art Committee. *Sp.* flowers-and-birds.

 Repr. Warakudō Gafu, 和樂堂畫譜. Yūkoku Gafu 幽谷畫譜.

Yūsei See Masanobu.

Yūsetsu 友雪 (1598–1677) *N.* Kaihō Dōki 海北道暉 *A.* Yūsetsu 友雪 Chūzaemon 忠左衞門 *Gō.* Dōkisai 道暉齋 *S.* Kaihō

school, Pupil of his father Yūshō. Influenced by Kanō
school. *L & C.* Favoured by Emperors, he painted in
the Court. Lived in Kyōto, later in Edo. *Sp.* landscape.
Repr. K. 19, 149.

Yūshi 融思 (1768–1846) *N.* Ishizaki Yūshi 石崎融思 *A.* Shisai
士齋 *F. N.* Keitarō 慶太郎 *Gō.* Hōrei 鳳嶺 Hōrei 放齡
S. Yōga school. Pupil of his father Gen-yū, and of
Gentoku. *L & C.* Lived in Nagasaki. Son of Araki.
Succeeded his teacher Ishizaki. Became a painter
and served the clan of Nagasaki. Excelled in engraving
seals and in making prose and poetry.
Repr. B. 12.

Yūshō 友松 (1533–1615) *N.* Kaihō Shōeki 海北紹益 *A.*
Yūshō 友松 *F. N.* Yūshō 友松 *S.* Kaihō school. Studied
the technique of Kanō school from Motonobu. Founded
Kaihō school, following the simple style Liang Ch'ian
(Ryōkai) in the Sung dynasty. *L & C.* Born in Ōmi. When
young, became service boy in Tōfukuji Temple. Lived
in Kyōto. Saitō Rizō, *samurai* served Akechi Mitsuhide,
was one of his intimate friends. Had character of
samurai. Served the Emperor Goyōzei 後陽成. Painted in
Jurakudai 聚樂第, being favoured by Hideyoshi. *Sp.*
landscape, figures, flowers.
Repr. B. 5, 79. K. 76, 159, 160, 168, 187, 221, 374, 590. N.
1, 15, 65.

Yūtei 幽汀 (1721–1786) *N.* Ishida Morinao 石田守直 *Gō.*
Yūtei 幽汀 *S.* Kanō school. Pupil of Tangei. *L & C.*
Lived in Kyōto. Known as the teacher of Ōkyo, who
founded Maruyama school.

Yūzen 友禪 (d. 1758) *N.* Miyazaki Yūzen 宮崎友禪 *L & C.*
Born in Kyōto. Lived in ·Kanazawa (?). Studied dra-
pery. Completed Yūzen dyeing 友禪染.
Repr. K. 285.

Zaichū 在中 (1750–1837) *N.* Hara Chien 原致遠 *A.* Shichō 子
重 *Gō.* Zaichū 在中 Gayū 臥遊 *S.* Learned the techni-
que of paintings in the Ming dynasty. *L & C.* Lived in
Kyōto. *Sp.* landscape, flowers-and-birds, historical sub-
jects.. *Repr.* K. 120.

Zaimei 在明 (1778–1844) *N.* Hara Chikayoshi 原近義 *A.*
Shitoku 子德 *Gō.* Zaimei 在明 Shashō 寫照 *S.* Nanga
school. Pupil of his father, Zaichū. *L & C.* Lived in Kyōto.

Zensetsu 善雪 (1591–1680) *N.* Tokuriki Yukikatsu 德力之勝
Priest name: Zensetsu 善雪 *S.* Kanō school. *L & C.* Lived
in Edo. Chief painter of Edokoro of Honganji Temple.
Repr. K. 53.

Zeshin 是眞 (1807–1891) *N.* Shibata Junzō 柴田順藏 *Gō.*
Zeshin 是眞 Tairyūkyo 對柳居 *S.* Japanese style. Shijō
school. Pupil of Suzuki Nanrei, Okamoto Toyohiko.
L & C. Lived in Tōkyō. Member of the Nippon Bijutsu
Kyōkai and the Imperial Art Committee. *Sp.* flowers-
and-birds (in makie 蒔繪).
Repr. K. 97, 131, 195, 215, 454. Zeshin-ō Gakan 是眞翁
畫鑑, Tairyūkyo Gafu 對柳居畫譜.

List of Albums of Reproductions

Buddhistic painting

Tōyō Bijutsu Kenkyū (Bukkyō Shiryō)

東洋美術研究（佛教資料）東洋美術研究會

Yamatoye school

Nippon Emakimono 日本繪卷物 大和繪同好會

Nippon Emakimono Shūsei 日本繪卷物集成 雄山閣

Yamatoye 大和繪 新古畫粹社

Fukko Yamatoye school

Fukko Yamatoye Shū 復古大和繪集 巧藝社

Ukiyoye school

Shoki Ukiyoye Senshū 初期浮世繪選集 聚樂社

Shoki Ukiyoye Shuhō 初期浮世繪聚芳 丹綠堂

Ukiyoye 浮世繪 新古畫粹社

Ukiyoye-ha Gashū 浮世繪派畫集 田島志一編

Yōga school

Hōsai Banka Daihō-kan 邦彩蠻華大寶鑑 創元社

Namban Byōbu Tenkan Zuroku 南蠻屏風展觀圖錄 便利堂

Nippon Yōga Shokō 日本洋畫曙光 岩波書店

Maruyama and Shijō schools

Maruyama-ha Gashū 圓山派畫集 審美書院

Maruyama Shijō Gakan 圓山四條畫鑑 國華社

Muromachi Suiboku School

Higashiyama Suiboku Gashū 東山水墨畫集 聚樂社

Kanō school

 Kanō-ha Taikan 狩野派大觀 狩野派大觀發行所

Nanga school

 Bunjinga San Taika Shū 文人畫三大家集 審美書院

 Bunjinga Sen 文人畫選 丹青社

 Nanga Jū Taika Shū 南畫十大家集 審美書院

 Nanga Shū 南畫集 國華社

 Nansō Meiga En 南宗名畫苑 審美書院

Bijutsu Senshū (Kaiga-Bu) 美術選集（繪畫部）美術選集刊行會

Bijutsu Shūei 美術聚英 審美書院

Enshūkai Tenkan Zuroku 遠州會展觀圖錄 審美書院

Fusumaye Senshū 襖繪選集 日本美術書院

Geien Shinshō 藝苑心賞 審美書院

Gemmei Wakan Meiga Hyakushu

 原名和漢名畫百種 東京印刷株式會社

Gunpō Seigan 群芳淸玩 藝海社

Honchō Sanjukka Meiga Shū 本朝三十家名畫集 國華社

Inshū Meiga Fu 因洲名畫譜 恩賜京都博物館

Kakuō Shū 鶴翁集 鶴山會

Kimpeki Sōshoku Gashū 金碧裝飾畫集 聚樂社

Kobijutsuhin Zuroku 古美術品圖錄 同好會

Kokka Sōkan Nijūgonen Kinen Tenkan Zuroku

 國華創刊二十五年記念展觀圖錄 國華社

Kokuhō Jō 國寶帖 審美書院

Kokuhō Jūyō Bijutsu-hin Kaiga Tenrankai Zuroku

 國寶重要美術品繪畫展覽會圖錄 報知新聞社

Kōso Ihō 後素遺芳 同好會

Kyōto Bijutsu Taikan 京都美術大觀 東方書院

Kyōto Hakubutsukan Kaikan Kinen Meihōten Zuroku

京都博物館開館記念名寶展圖錄 便利堂

Kyōto Shaji Meihō-kan　京都社寺名寶鑑 藝艸堂

Kyūka-Kyokurei　窮華極麗 審美書院

Meiga Hyakusen　名畫百選 東山書房

Meihin Sōran　名品綜覽 美術資料刊行會

Momoyama-jidai Kimpeki Shōhekiga

桃山時代金壁障壁畫 美術研究所

Momoyama-jidai Kimpeki Shōheiga Zushū

桃山時代障屏畫圖集 聚樂社

Nanto Shichidaiji Taikyō 南都七大寺大鏡 南都七大寺大鏡刊行會

Nippon Kobijutsu Tenrankai Shuppin Mokuroku

日本古美術展覽會出品目錄 ボストン美術館

Nippon Meiga Fu　日本名畫譜 便利堂

Nippon Meihōten Gashū 日本名寶展畫集 畫報社

Onshi Jusshūnen Kinen Tenkan Zuroku

恩賜十周年記念展觀圖錄 恩賜京都博物館

Ōsaka-shiritsu Bijutsukan Kaikan Kinen Meihōten Zuroku

大阪市立美術館開館記念名寶展圖錄 大阪市立美術館

Sai-un Jikō　彩雲慈光 東京帝室博物館

Seikadō Kanshō　靜嘉堂鑑賞 瀧精一編

Shimbi Taikan　眞美大觀 日本審美協會

Shinko Gasui　新古畫粹 新古畫粹社

Shōbi Shiryō　尚美資料 龜井唯二郎編

Shoga Taikan　書畫大觀 書畫大觀刊行會

Shōheki Meiga Taikan　障壁名畫大觀 審美書院

Tempō Rushin　天寶留眞 大岡堂

Tōyō Bijutsu Taikan　東洋美術大觀 審美書院

Zauhō　座右寶 座右寶刊行會

List of Names of Places

Pre-Meiji			Modern			
Aki	安	藝	Hiroshima(prefecture)	廣	島	(縣)
Awa	安	房	Chiba	,,	千	葉 ,,
Awa	阿	波	Tokushima	,,	德	島 ,,
Awaji	淡	路	Ōsaka	,,	大	阪 (府)
Bingo	備	後	Hiroshima	,,	廣	島 (縣)
Bitchū	備	中	Okayama	,,	岡	山 ,,
Bizen	備	前	Okayama	,,	岡	山 ,,
Bungo	豐	後	Ōita	,,	大	分 ,,
Buzen	豐	前	Fukuoka and Ōita (prefectures) 福 岡, 大 分 (縣)			
Chikugo	筑	後	Fukuoka (prefecture)	福	岡	,,
Chikuzen	筑	前	Fukuoka	,,	福	岡 ,,
Echigo	越	後	Nigata	,,	新	潟 ,,
Echizen	越	前	Fukui	,,	福	井 ,,
Edo	江	戶	Tōkyō		東	京 (市)
Etchū	越	中	Toyama, (prefecture)	富	山	(縣)
Harima	播	磨	Hyōgo	,,	兵	庫 ,,
Hida	飛	驒	Gifu	,,	岐	阜 ,,
Higo	肥	後	Kumamoto	,,	熊	本 ,,
Hitachi	常	陸	Ibaragi	,,	茨	城 ,,
Hizen	肥	前	Saga and Nagasaki (prefectures) 佐 賀, 長 崎 (縣)			
Hōki	伯	耆	Tottori (prefecture)	鳥	取	,,
Hyūga	日	向	Miyazaki	,,	宮	崎 ,,
Iga	伊	賀	Miye	,,	三	重 ,,
Iki	壹	岐	Nagasaki	,,	長	崎 ,,
Inaba	因	幡	Tottori	,,	鳥	取 ,,

Pre-Meiji		Modern			
Ise	伊 勢	Miye (prefecture)	三 重 (縣)		
Iwaki	磐 城	Fukushima and Miyagi (prefectures) 福 島, 宮 城 (縣)			
Iwami	石 見	Shimane (prefecture)	島 根	,,	
Iwashiro	岩 代	Fukushima	,,	福 島	,,
Iyo	伊 豫	Ehime	,,	愛 媛	,,
Izu	伊 豆	Shizuoka	,,	靜 岡	,,
Izumi	和 泉	Ōsaka	,,	大 阪 (府)	
Izumo	出 雲	Shimane	,,	島 根 (縣)	
Kaga	加 賀	Ishikawa	,,	石 川	,,
Kai	甲 斐	Yamanashi	,,	山 梨	,,
Kawachi	河 內	Ōsaka	,,	大 阪 (府)	
Kazusa	上 總	Chiba	,,	千 葉 (縣)	
Kii	紀 伊	Wakayama and Miye (prefectures) 和歌山, 三 重 (縣)			
Kōzuke	上 野	Gumma (prefecture)	群 馬	,,	
Mikawa	三 河	Aichi	,,	愛 知	,,
Mimasaka	美 作	Okayama	,,	岡 山	,,
Mino	美 濃	Gifu	,,	岐 阜	,,
Musashi	武 藏	Saitama, Tōkyō, Kanagawa (prefectures) 埼玉 (縣), 東京 (府), 神奈川 (縣)			
Mutsu	陸 奧	Aomori, Iwate, Akita (prefectures) 青森, 岩手, 秋田 (縣)			
Nagato	長 門	Yamaguchi (prefecture)	山 口	,,	
Noto	能 登	Ishikawa	,,	石 川	,,
Oki	隱 岐	Shimane	,,	島 根	,,
Ōmi	近 江	Shiga	,,	滋 賀	,,
Ōsumi	大 隅	Kagoshima	,,	鹿兒島	,,
Owari	尾 張	Aichi	,,	愛 知	,,

Pre-Meiji		Modern		
Rikuchū	陸 中	Iwate	(prefecture)	岩 手 (縣)
Rikuzen	陸 前	Miyagi and Iwate (prefectures)		宮 城, 岩 手 (縣)
Sado	佐 渡	Nigata	(prefecture)	新 潟 ,,
Sagami	相 模	Kanagawa	,,	神奈川 ,,
Sanuki	讃 岐	Kagawa	,,	香 川 ,,
Satsuma	薩 摩	Kagoshima	,,	鹿兒島 ,,
Settsu	攝 津	Ōsaka, Hyōgo (prefectures)		大 阪 (府) 兵 庫 (縣)
Shima	志 摩	Miye	(prefecture)	三 重 ,,
Shimōsa	下 總	Chiba, Ibaragi (prefectures)		千 葉, 茨 城 (縣)
Shimotsuke	下 野	Tochigi	(prefecture)	栃 木 ,,
Shinano	信 濃	Nagano	,,	長 野 ,,
Suō	周 防	Yamaguchi	,,	山 口 ,,
Suruga	駿 河	Shizuoka	,,	靜 岡 ,,
Tajima	但 馬	Hyōgo	,,	兵 庫 ,,
Tamba	丹 波	Kyōto, Hyōgo (prefectures)		京 都 (府), 兵 庫 (縣)
Tango	丹 後	Kyōto	(prefecture)	京 都 ,,
Tosa	土 佐	Kōchi	,,	高 知 ,,
Tōtōmi	遠 江	Shizuoka	,,	靜 岡 ,,
Tsushima	對 馬	Nagasaki	,,	長 崎 ,,
Ugo	羽 後	Akita	,,	秋 田 ,,
Uzen	羽 前	Yamagata	,,	山 形 ,,
Wakasa	若 狹	Fukui	,,	福 井 ,,
Yamashiro	山 城	Kyōto	,,	京 都 (府)
Yamato	大 和	Nara	,,	奈 良 (縣)

Explanation of Schools

Buddhistic Painting

The Buddhistic painting had its beginning, in Japan, in the *Asuka* 飛鳥 period by the introduction through Korea of the art of the Six Dynasties 六朝 in China. It flourished most powerfully in the *Nara* 奈良 period, and reached a high grade of elegance and refinement in the *Heian* 平安 period. In the *Kamakura* 鎌倉 period, a new element was added by the influence of the Sung 宋 painting, which arrived in Japan at that time. Thus the Buddhistic paintings of Japan are rich in variety and in style. But it is difficult to devide the works into schools. Moreover, as the Buddhistic painters seldom signed their names in their works few of their names are known. Therefore, we treat them collectively under the name of Buddhistic painting for the sake of convenience.

The words *Hōin* 法印, *Hōgen* 法眼, and *Hokkyō* 法橋 are frequently used in this Index. These were originally ecclesiastical ranks, *Hōin* being the highest, *Hōgen* the second, and *Hokkyō* the third. In the *Heian* period, these ranks were conferred on the Buddhistic painters according to their merits, and were considered as the ranks of painters. Later, they were often bestowed on artists outside the religious world.

Yamatoye 大和繪 and *Fukko Yamatoye* 復古大和繪 schools

The painting of the subject-matter of Japan in purely Japanese technique was developed in the *Heian* 平安 period, from the T'ang 唐 painting which was introduced in the *Nara* 奈良 period, and it flourished especially after the 10th century, at the demand of the aristocrats. This purely national school of painting is called *Yamatoye* 大和繪. The leading painters of this school were those who served the *Edokoro** 繪所 of the Court. The *Kose* 巨勢 and the *Takuma* 詫摩 were especially prominent as families of painters. Besides the painters of these hereditary families, there were many courtiers and priests who excelled in the *Yamatoye* painting. The works of this school are mainly screens, scrolls or illustrations of literature. Most of them took their subjects from Japanese poetry and romances, expressing the literary taste of the time and describing the dayly life of the period. Technically speaking, the works of *Yamatoye* are remarkable for the use of delicate lines and soft beautiful colours. This school began to paint portraits after the 12th century.

* *Edokoro* 繪所: *Edokoro* 繪所 is the office of painters at the Court. It was established in the 9th century and continued to be active until Muromachi period. The chief of the *Edokoro* was called *Edokoro azukari* 繪所預, under whose guidance other painters worked. Besides the *Edokoro* of the court, most powerful Buddhist temples, such as the *Kōfukuji* 興福寺 Temple and the *Kyōōgokokuji* 教王護國寺 Temple, had their own *Edokoro*.

After the *Muromachi* 室町 period the *Yamatoye* school declined with the growth of the *Suiboku* 水墨 and other new schools, which were opponents to the *Yamatoye* school. The technique became conventional and uninteresting, and its tradition was carried on by the painters of the *Tosa* 土佐 family. However, in the end of the *Edo* 江戸 period, in response to the Restoration Movement there was a revival of old traditions, and thus the " *Fukko Yamatoye* " 復古大和繪 school was established.

Tosa 土佐 school

The *Tosa* 土佐 school was originated in the early years of the *Muromachi* 室町 period, and its tradition was handed down from father to son in the *Tosa* family. This school painted literary subjects from Japanese classics and poetry with the traditional *Yamatoye* 大和繪 technique. The Painters of the family served at the Imperial Court, and their chief was appointed to *Edokoro azukari* 繪所預. Moreover they were patronized by the *Ashikaga Shōgun* 足利將軍. Though this school declined at one time in the latter part of the 16th century, it regained its power in the *Edo* 江戸 period. In artistic value, however, it always clung to the traditional technique and lacked in animation.

Sumiyoshi 住吉 school

At the beginning of the *Edo* 江戸 period a man of the *Tosa* 土佐 family, called *Hiromichi* 廣通 founded the *Sumiyoshi* 住吉

family. As a branch of the *Yamatoye* 大和繪 school he painted classical subject-ma ter and the genre. This was also an hereditary family. After *Hirozumi* 廣澄, son of *Hiromichi*, the family moved to *Edo* and was protected by the *Tokugawa-Shōgun* 德川將軍. In the 18th century two schools *Itaya* 板谷 and *Awataguchi* 粟田口 were derived from this *Sumiyoshi* school.

Sōtatsu 宗達 and *Kōrin* 光琳 schools

Both of these artists are purely Japanese in style following the tradition of the *Yamatoye* 大和繪 school, and at the same time showing a strong tendency to decorative art which is their special characteristic in the art history of Japan. In the beginning of the *Edo* 江戶 period, the *Sōtatsu* 宗達 school was founded by *Sōtatsu*, who painted classical subjects, flowers, figures, and birds with strong but sensitive lines and in gorgeous colours. In the middle of the same period, *Kōrin* 光琳 established the *Kōrin* school, the style of which was more decidedly decorative than that of *Sōtatsu*. These two schools, though having comparatively few painters following them, excelled other schools of the *Edo* period in artistic merit.

Ukiyoye 浮世繪 school

Ukiyoye 浮世繪 mainly means a block-print, representing the genre of the period, and it was much loved by the merchant class which began to flourish in the *Edo* 江戶 period. Al-though *Ukiyoye* painters used wood-block prints as their

principal means of expression they had first started their
peculiar style by painting with brushes. In the 17th
century, the feudal lords sometimes ordered artists to paint
the everyday life of the people and this was the origin of the
Ukiyoye school. Those *Ukiyoye* artists seem to have been
working with a belief that they were following the tradition
of *Yamatoye* 大和繪 in opposition to the tradition of the *Kanō*
school. As the popular nature of the works of this school
satisfied the taste of the common people, there arose the
necessity of mass production for this kind of painting. Thus
printing was adopted and much favoured by *Ukiyoye* painters
and they succeeded in giving an effect of beauty peculiar to
the technique. The processes of printing became more and
more complex, polychromatic and brilliant through the follow-
ing steps : (1)*Tanye* 丹繪, (2)*Beniye* 紅繪, (3)*Urushiye* 漆繪,
(4)*Nishikiye* 錦繪.

As this school was patronized by comparatively uncultured
people, the works of the school aimed at a simple and
unsophisticated expression, mostly beautiful and sometimes
even sensuous rather than deeply spiritual and scholarly.
So the favourite subjects of this school were beautiful women,
scenes from the theatre, or portraits of actors and sometimes
landscape. Strictly speaking, this school should be divided into
several schools such as *Hishikawa* 菱川, *Kaigetsudō* 懷月堂,
Torii 鳥居, etc. But in this Index, these are called the *Ukiyoye*
school in general.

　(1) *Tan-ye* 丹繪 : The block-print with key-outlines
 printed in black and a few simple colours such as ver-
 milion put on with brushes.

(2) *Beniye* 紅繪 : The block-print with a few simple colours put on with brushes or printed.

(3) *Urushiye* 漆繪 : A kind of Beniye print with the addition of the lustrous *sumi* 墨.

(4) *Nishikiye* 錦繪 : The block-print with polychromatic colours printed.

Muromachi Suiboku 室町水墨 School

The works of this school were for the most part done as *kakemono* 掛物 or screens (*byōbu* 屛風 and *fusuma* 襖) chiefly in *sumi* 墨 but often washed with light colours. The strength of brush-work and the nuances of black and white were considered particularly important in this school. The subjects are mostly taken from Chinese landscape and Chinese figures, sometimes elements being taken partially from various paint-ings. The predominance of Chinese subjects naturally gave something un-Japanese and rather a scholarly effect to the works of this school, making a contrast in conception and in technique to the *Yamatoye* 大和繪 school. In spite of these Chinese elements, however, it is interesting to notice that the paintings were not mere copies of Chinese works but contain-ed Japanese tone as a whole.

Historically speaking, this school was born as a result of the importation of Chinese paintings of Sung 宋 and Yüan 元 dynasties by *zen* 禪 priests in the 14th century. As *samurai* 侍 and *zen* priests of the *Muromachi* 室町 period highly valued Chinese art and literature, the works of this school were greatly appreciated by them. The school flourished in the

Muromcchi period and continued to hold its influence till the beginning of the *Edo* 江戸 period. *Sesshū* 雪舟 was the greatest master of this school.

On the paintings mounted as *kakemono* we often find *san* 讃 or inscriptions in prose or poetry which were composed in praise of the painting. Though we may observe various styles in the works of this school it does not seem necessary to make further divisions.

Kanō 狩野 School

This school started in the middle of the 15 th century, having inherited the tradition of the *Muromcchi Suiboku* 室町水墨 school, and also, added to it the Japanese sentiment of the *Tosa* 土佐 school. The real founder of the school was *Motonobu* 元信, son of *Masanobu* 正信, from whom a hereditary family school has flourished ever since. The early masters of this school mainly painted in black and white, but gradually colours were put into use. In the *Edo* 江戸 period the school was closely connected with the Shogunate as its official school, and took the lead in the art world all through the Shogunate period. In the *Muromcchi* 室町 and *Momoyama* 桃山 periods the leading masters of the school lived in *Kyōto* 京都. At the beginning of the *Edo* 江戸 period *Tanyū* 探幽 and his two brothers moved to *Edo*. After that the school was divided into *Kyō-Kanō* 京狩野 (*Kyōto-Kanō*) and *Edo-Kanō* 江戸狩野 (*Tōkyō-Kanō*). The *Edo-Kanō* was further divided into three sub-branches: *Nakahashi* 中橋, *Kajibashi* 鍛冶橋 and *Kobikichō* 木挽町 families. Afterwards from the *Edo-Kanō*

derived two more families: the *Surugadai* 駿河臺 and *Hamachō* 濱町. So the *Kanō* school came to have five sub-divisions. Though the *Edo-Kanō* school produced many painters in the early years, it gradually decayed having been superseded by other schools rising after the middle of the *Edo* period.

Kaihō 海北 School 派

This school was founded by *Yūshō* 友松, a painter of the *Momoyama* 桃山 period. Although *Yūshō* once studied the *Kanō* 狩野 school, he established his own manner learning from the Sung 宋 and Yüan 元 painting of China. The school held its own traditions to the end of the *Edo* 江戸 period.

Hasegawa 長谷川, *Soga* 曾我, ar.d *Unkoku* 雲谷 schools

All of these grew out of the *Muromachi Suiboku* 室町水墨 school and flourished in the *Momoyama* 桃山 period. The *Hasegawa* 長谷川 school was founded by *Tōhaku* 等伯, the *Soga* 曾我 school by *Chokuan* 直庵 and the *Unkoku* 雲谷 school by *Tōgan* 等顔. Though they had their own technical characteristics, yet they were all variations of the *Muromachi Suiboku* painting. Both *Hasegawa* and *Unkoku* schools claimed to be artistic heirs of *Sesshū* 雪舟.

Nanga 南畫 School

The *Nanga* 南畫 school, starting from the end of the 17th century, arrived at its full growth in the middle of the 18th

century. In contrast to the painters of the *Kanō* 狩野 and *Tosa* 土 佐 schools, the Nanga painters disliked to emphasize technique and artistry. Each painter had his own style according to his own temperament; therefore it is not altogether right to define this group as a *school*. However, in spite of their individual personality they had many points common in their attitudes and styles when compared with other schools in Japan, and it is rather convenient to take it as a school. Originally this school was derived from a literary movement of the poet-painters in China in the Yüan 元 dynasty, who boasted of their amateurish works as superior to the traditional ones. And later it had come to have a dignity and a high spiritual character rarely found elsewhere, as these *Nanga* paintings were mostly done by the people of high culture, not mere artist, but poets as well. Their favourite subjects were land-scape with figures, trees and flowers.

Therefore it may be said that the *Nanga* school stands opposite to the *Ukiyoye* 浮世繪 school or the art of the un-cultured people, as the former had particularly been favoured by the intellectual people of the *Edo* 江戸 period.

Nagasaki 長崎 school

In the 17 th century Chinese people who came to *Nagasaki* 長崎 brought with them a new sort of painting with a delicate technique of realistic tendency. Under this influence was born the *Nagasaki* school. At the same time influences of European painting were felt at *Nagasaki* and those seem to have pushed onward the realistic tendency of the school.

This school can be divided further into two groups: one which followed the tradition of *Nan-pin* 南蘋 and the other which followed the tradition of *Itsunen* 逸然, both representing the Painting of Ch'ing 清 dynasty of China. Although this school may not be very interesting in itself, it is worthy of note for its contribution to the technical development of the Japanese painting in modern times.

Maruyama 圓山 and *Shijō* 四條 Schools

Maruyama 圓山 school was established by *Maruyama Ōkyo* 圓山應舉 a great master of realistic paintings. While the *Kanō* 狩野 and *Tosa* 土佐 schools aimed at the traditional and historical subjects, this school emphasizing the importance of the direct study of nature, chiefly painted real birds and flowers and landscape with a new sensitive technique. It was developed by *Ōkyo* with his uncommon skill, getting hints from the influence of *Nan-pin* 南蘋, from realistic paintings of the *Sung* 宋 and *Yüan* 元 dynasties of China, and also from the Western technique of sketching.

Because of this new realism, this school has played an important part in the art history of modern times. But at the same time just because of its prepossession of realism, it was sometimes looked down upon by the art theorists and *Nanga* 南畫 painters of the time, as if it lacked something of a spiritual character. All the same the art of the *Maruyama* school, being easy to understand, gained great popularity among the citzens of *Kyōto* 京都 and *Ōsaka* 大阪 and produced many able painters.

The *Shijō* 四條 school was founded by *Goshun* 吳春, who was a pupil of *Maruyama Ōkyo*. It also educated many good painters, following after the *Maruyama* school.

Yōga 洋畫 School

Accompanying the international communication between Portugal and Japan, Western painting was introduced into our country, and a new school of Europian style, which we call the *Yōga* 洋畫 school for the sake of convenience, came into existence. This school first flourished in the *Momoyama* 桃山 period, then in the *Edo* 江戶 period and then again in the *Meiji* 明治 era.

The founding of the school was brought about by the Catholic missionaries who arrived in the *Momoyama* period. The painters of this period who were all Christians, made oil-paintings, paintings in distemper, and copper-plate prints. The subjects were principally Christian. With the suppression of Christianity by *Tokugawa* 德川 government however, the school was almost entirely wiped out. In the latter part of the 18th century it was revived. In this second period, the subjects were mostly profane figures and genre done with a new realistic technique which was learned from the illustrations of books imported from Holland.

The third period came with the Meiji era, when, with the importation of European culture in general, European painting began to be regularly studied and it continues to prosper evento this day (See the explanation of Western style).

It is to be noticed that *Nagasaki* 長崎, the principal residence

of foreigners throughout the *Edo* period, played an important part in the development of the *Yōga* school.

Japanese style

(The Contemporary Painting of Japanese style)

The contemporary Japanese painting since the *Meiji* 明治 Restoration can be divided into two kinds, the Japanese style and the Western style. The so-called Japanese style paintings those which are painted with traditional technique and

ne Japanese style painting can further be divided into two groups: the conservative and the progressive. The former is the one which faithfully maintains the traditional styles of such schools as *Tosa* 土佐, *Kanō* 狩野, *Maruyama* 圓山, and *Shijō* 四條. The latter is free from all traditional restrictions and strives for the expression of modern ideas and sentiments mainly using national materials, but introducing Western manners at the same time. The conservative school organized the [1]*Nippon Bijutsu Kyōkai* 日本美術協會 in 1887, and the progressive school the [2]*Nippon Bijutsu-in* 日本美術院 in 1898. The government decided, in 1907 to hold an annual exhibition (*Bunten* 文展) with the intention of combining the two opposing schools, which, however, rather led to a more decisive competition between the two. In 1914, *Nippon Bijutsu-in* was re-organized and the [3]*Saikō Nippon Bijutsu-in* 再興日本美術院 was established. This *Saikō Nippon Bijutsu-in* was very active and seems to have taken a strong initiative for the progress of contemporary Japanese art. At present, there are only few

157

artists who are really conservative and who strictly stick to traditional styles. The representative art-organization of the present day Japan are as follows.

(1) *Nippon Bijutsu Kyōkai* 日本美術協會: The *Ryūchi-kai* 龍池會 Society, which had been founded in 1878, was expanded and became the *Nippon Bijutsu-Kyōkai* in 1887.

Kyōto Bijutsu-kyōkai 京都美術協會: Organized in 1892.

(2) *Nippon Bijutsu-in* 日本美術院: Organized by the graduates of the *Tōkyō Art School* 東京美術學校 and others under the leadership of *Okakura Kakuzō* 岡倉覺三 in 1898, but became extinct in 1906.

(3) *Saikō Nippon Bijutsu-in* 再興日本美術院: Organized by *Yokoyama Taikan* 橫山大觀, *Shimomura Kanzan* 下村觀山 and others in 1914.

Teikoku Bijutsu-in 帝國美術院 (The Imperial Academy of Art): Organized by the Government in 1919 as the national institution of the most distinguished artists, but abolished in 1937 in order to make way for the *Teikoku Geijutsu-in* 帝國藝術院 (See below).

Kokuga Sōsaku-kyōkai 國畫創作協會: Organized by *Tsuchida Bakusen* 土田麥僊 and others in 1918. Became extinct in 1928.

Seiryūsha 青龍社: Organized by *Kawabata Ryūshi* 川端龍子 and others in 1929.

Teikoku Geijutsu-in 帝國藝術院 (The Imperial Academy of Art): Organized by the Government in 1937 as the practical continuation of the *Teikoku Bijutsu-in*, but this time including not only fine arts, but also nearly all liberal and literary arts.

Western Style

(The Contemporary Japanese Painting of Western Style)

Though the first introduction of the Western method of painting such as oil-painting and copper-plate printing goes back into the past, the definite study of it began in the *Meiji* 明治 era when Japan was officialy opened to Western countries at the time of the Restoration in 1868. Since then European painting has been studied with great enthusiasm, it occupies an important place in the contemporary art of Japan. *Gagaku-kyoku* 畫學局, or Bureau of Painting, established in 1816 as a part of the *Bansho-shirabedokoro* 蕃書調所 (the official institution for studying European science and art set up by the Tokugawa government from political necessity for national defence) played an important part in the official introduction of Western painting into Japan and this institution was continued by the Imperial Government after the Restoration. The leader was *Kawakami Tōgai* 川上冬崖 and among his pupils was *Takahashi Yuichi* 高橋由一. After the Restoration, private schools for oil-painting were founded by *Kawakami, Takahashi,* and *Kunisawa Shinkurō* 國澤新九郎, but the equipment for study was not very perfect. The regular study of European oil-painting was started in 1876, when the Government established an [1]Art School attached to the College of Engineering 工部美術學校, and invited A. Fontanesi, and A. San Giovanni from Italy to teach there. In this school were such prominent artists as *Asai Chū* 淺井忠 and *Koyama Shōtarō* 小山正太郎 etc. The *Meiji Bijutsukai* 明治美術會, the first organization of oil-

painting was founded in 1889, and from the beginning it was active and influencial. About 1887, *Yamamoto Hōsui* 山本芳翠 returned from France, *Harada Naojirō* 原田直次郎 from Germany, and *Matsuoka Hisashi* 松岡壽 from Italy, each bringing back the academic styles of the countries where they had studied. In 1893, *Kuroda Seiki* 黒田清輝 and *Kume Keiichirō* 久米桂一郎 returned from France and introduced into Japan the Impressionistic painting. Later, as *Kuroda* 黒田 and *Kume* 久米 joined the *Tōkyō Art School* 東京美術學校 and opened a new department of oil-painting, the education of Western style of painting became systematic and progressive. In 1896, *Kuroda* and *Kume* established the artists' society, *Hakubakai* 白馬會. From about that time on, more artists went abroad chiefly to study in France, and oil-painting flourished greatly in Japan. But on the other hand, with the growth of the national consciousness, consideration began to be paid to the creating of a new painting of Japanese character, painted with Western technique of oil. This tendency is making a gradual but steady progress. In 1907, when *Bunten* 文展, or the Government Exhibition, was organized, oil-painting was also represented. In recent times, Neo-Impressionism, Fauvism and other new movements have been imported into Japan one after another. Besides the annual Government Exhibition, there are many groups and organizations that give exhibitions every year, such as [3]*Nika-kai* 二科會, [4]*Shun-yō-kai* 春陽會 [5]*Dokuritsu Bijutsu-kyōkai* 獨立美術協會 [6]*Kokuga-kai* 國畫會, [7]*Issui-kai* 一水會 etc.

[1] Art School Attached to the College of Engineering 工部美術學校: Founded by the Government to educate artists

in European or Western style: was closed in 1883. There were many prominent painters among the graduates.

(2) *Tōkyō Art School* 東京美術學校: Founded by the Government in 1889, for the purpose of teaching Japanese style art. In 1896, the Western art department was added.

(3) *Nika-kai* 二科會: Organized in 1914, by the painters in opposition to the *Bunten* or the Government Exhibition.

(4) *Shun-yō-kai* 春陽會: Organized in 1912.

(5) *Dokuritsu Bijutsu-kyōkaı* 獨立美術協會: Organized in 1918, by the painters who left *Nika-kai.*

(6) *Kokuga-kai* 國畫會: Organized in 1918, by the Japanese style painters and was called *Kokuga-Sōsaku-kyōkai* 國畫創作協會. To this society a section of painting of Western style was added in 1926. When the society became extinct in 1928, only the section of Western style painting survived.

(7) *Issui-kai* 一水會: Organized in 1936, by the artists who were formerly prominent members of *Nika-kai.*